Hollywood Hoofbeats

Trails Blazed Across the Silver Screen

By Petrine Day Mitchum
with Audrey Pavia

BOWTIE PRESS

BOWTIE PRESS
A DIVISION OF BOWTIE, INC.
IRVINE, CALIFORNIA

Karla Austin, *Business Operations Manager*
Nick Clemente, *Special Consultant*
Jarelle S. Stein, *Editor*
Jennifer Perumean, *Assistant Editor*
Jill Dupont, *Production*
Deibra McQuiston, *Design*
Jane A. Martin , *Additional Photo Research and Permissions*
Melody Englund, *Index*

Library of Congress Cataloging-in-Publication Data

Mitchum, Petrine Day.
 Hollywood hoofbeats: trails blazed across the silver screen / by Petrine Day Mitchum with Audrey Pavia.
 p. cm.
 ISBN 1-931993-38-6
 1. Horses in motion pictures. 2. Western films—United States—History and criticism. I. Pavia, Audrey. II. Title.

PN1995.9.A5M56 2005
791.43'66296655—dc22 2005004090

BowTie Press®
A Division of BowTie, Inc.
3 Burroughs
Irvine, California 92618

Printed and bound in Thailand
10 9 8 7 6 5 4 3 2 1

Dedication

This book is dedicated to the memory of champion trick rider and stuntwoman Donna Hall who once said:

"They ought to build a monument to the picture horse."

Donna Hall 1928–2002

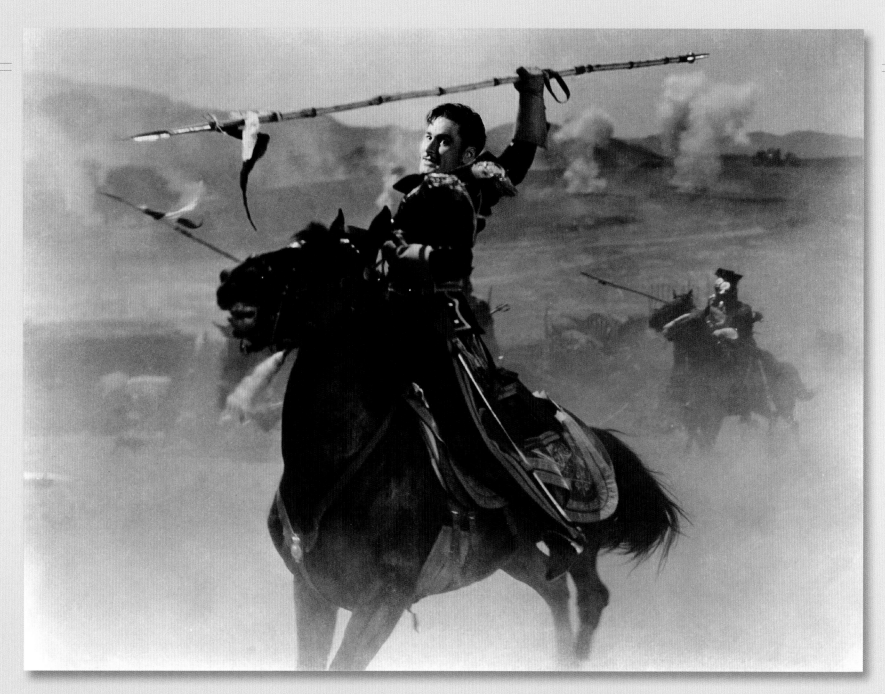

Humane advocate Erroll Flynn leads The Charge of the Light Brigade, *1936.*

Contents

Robert Mitchum rides Steel in their second film together,
West of the Pecos, *1945.*

Hollywood Hoofbeats began as research for a documentary film. A producer colleague hoped to show that in America's New Age animal friendly environment, today's movie horses receive gentler training and treatment than did those of yesteryear. But as I delved into the subject, it became clear that while partially true, this was too broad of a generalization and that things are not so black and white for horse actors.

Actors? *Actor* is not a word that usually springs to mind when contemplating the many roles horses have played in our history. Their contributions to mankind have been well chronicled and celebrated in the arts, yet we rarely think of horses as *entertainers*. Since the rise of the internal combustion engine, however, horses in developed nations have flourished primarily as sources of amusement rather than labor. Equestrian sports may be big business, but their real raison d'être is entertainment. Wild West and Civil War reenactments, medieval jousting exhibitions, and a variety of touring equestrian shows have been enthralling audiences for decades. So have horses in movies. But actors?

As my research of movie horses expanded, I discovered what I had long suspected: some horses are natural actors. In my childhood, my family owned a big bay Quarter Horse named Woody who feigned lameness to avoid work. One day he would be lame on his right foreleg, the next day on his left. There was nothing wrong with Woody besides a preference for his pasture over the saddle. Unlike Woody, movie horses, the good ones, love their jobs. Time and again, the men and women who have worked with equine actors—the trainers, wranglers, stunt performers, actors and directors—told me stories of horses who knew when the camera was running and took direction with uncanny awareness. I heard tales of specially trained stunt horses who loved to show off and lived long and pampered lives. I also heard about equine star tantrums and unruly performers whose diva behavior was tolerated because of their box office cachet.

Contrary to my colleague's hypothesis, the training of equine actors in decades past was often superior to some of the shortcut methods dictated by today's hurried production schedules. There were movie horse trainers working in the 1920s who today would be called "horse whisperers"—a moniker they would most likely mock and modestly reject. The best trainers currently working in the film industry utilize the same basic methods of those film pioneers.

It is true that stunt horses were sometimes subjected to cruelty in the past, but overall conditions for equine thespians have vastly improved in recent decades—thanks largely to the vigilance of the American Humane Association's Film and Television Unit. Yet there is still a great deal of work to be done to ensure the protection of animal actors.

There's that word again. *Actors*. In the course of researching *Hollywood Hoofbeats* (which quickly outgrew the constraints of an hour-long documentary and evolved into the book at hand), I watched scores of movies. Certain horses stood out from film to film, and I developed favorites: a black-and-white pinto named Dice, whose deadpan expressions belied his hilarious tricks; Highland Dale, a stunning black American Saddlebred stallion who, unlike old Woody, learned to limp on command and won numerous awards during his long career; Steel, a handsome chestnut gelding who supported numerous Hollywood stars. One of these was my father, Robert Mitchum, who lied to the producers of *Nevada* in 1943 and told them he could ride. He won his first starring role in that film and quickly took lessons. Fortunately for my father, the producers were smart enough to pair him with a talented horse actor, Steel.

Watching so many films of multiple genres, I began to realize that the movies as we know them would be vastly different without horses. There would be no Westerns—no cowboy named John Wayne!—no *Gone with the Wind*, no *Ben Hur*, no *Dances with Wolves*, no *Gladiator*, no *Seabiscuit* nor *The Black Stallion*. In fact, the movies might not exist at all since the entire motion picture industry evolved from an experiment with a camera and a horse. While it is virtually impossible to cite every horse who left his mark on celluloid, with *Hollywood Hoofbeats* I have attempted to pay tribute to the spirits of the marvelous equine actors who have traversed cinema's varied terrain since its inception.

Petrine Mitchum
Santa Ynez, California
March, 2005

The Long Riders, *1980*.

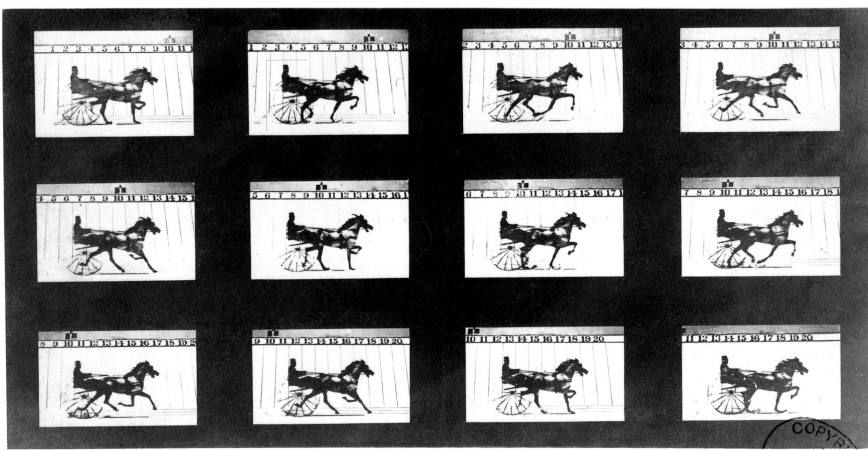

MORSE'S Gallery, 417 Montgomery St., San Francisco.

THE HORSE IN MOTION.

Illustrated by

MUYBRIDGE.

Patent for apparatus applied for.

AUTOMATIC ELECTRO-PHOTOGRAPH.

"ABE EDGINGTON," owned by LELAND STANFORD; driven by C. MARVIN, trotting at a 2:24 gait over the Palo Alto track, 15th June 1878.

The negatives of these photographs were made at intervals of about the twenty-fifth part of a second of time and twenty-one inches of distance; the exposure of each was about the two-thousandth part of a second, and illustrate one single stride of the horse. The vertical lines were placed twenty-one inches apart; the lowest horizontal line represents the level of the track, the others elevations of four, eight and twelve inches respectively. The negatives are entirely "untouched."

THE FIRST MOVIE STARS

"The horse, the horse! The symbol of surging potency and power of movement, of action, in man."

—D. H. Lawrence, *Apocalypse*

Abe Edgington and the twelve frames that changed the world.

HE FIRST MOVIE STAR WAS A HORSE. *Equus caballus*, that potent symbol of human aspiration, had been capturing the imaginations of painters, poets, songsmiths, and sculptors for centuries when he was finally captured in action by motion pictures on a fine June day in 1879. Before Thomas Edison and D. W. Griffith began their careers as film pioneers, before the first cowboy actor on a trusty steed galloped across a silent screen, before the entire film industry exploded to the sound of thundering hooves, there were a revolutionary series of motion pictures starring a Standardbred harness racer with the unlikely name of Abe Edgington. This equine performer blazed unchartered terrain by virtue of a bet that involved his hoofbeats.

It took half a second to take the twelve pictures, which clearly showed the high-stepping Abe Edgington's four legs suspended in midair. Stanford had his proof, and the world had the beginnings of a new art form: motion pictures.

Four days later, Muybridge successfully photographed Stanford's horse Occident being galloped under saddle. Excited by the results, Stanford—who adored his horses and forbade farmhands to speak harshly to them—funded more of Muybridge's photographic experiments. Within two weeks, Muybridge had produced six more sequential photographs of Stanford's horses, depicting them walking, trotting, and galloping. The pictures were published as *The Horse in Motion.*

This revolutionary series aroused international interest, and the University of Philadelphia commissioned Muybridge to take "moving pictures" of a number of animals, including horses. By the time he had completed this work, Muybridge had shot 20,000 pictures, many featuring randomly chosen horses, named Daisy, Eagle, Elberon, Sharon, Pandora, Billy, Annie G, and Bouquet. Along with Abe Edgington, Occident, and Stanford's other horses, these animals ranked among the world's first movie stars.

THE HORSE IN MOTION

Abe Edgington's place in history was guaranteed in 1879 when his owner, wealthy railroad magnate and one-time California governor Leland Stanford, hired British-born photographer Eadweard Muybridge to photograph his horses. Stanford hoped to prove that a racing trotter going full speed would, for a split second, be completely airborne. On a June day in Palo Alto, California, Muybridge began by shooting a series of photos of Abe Edgington pulling a sulky. Members of the press witnessed this historic event, which utilized twelve cameras with unique lenses and an electronically controlled mechanism designed to operate special shutters. Wires placed underneath the racetrack at 21-inch intervals triggered the release of the camera shutters as the sulky wheels made contact with the ground.

EDISON

In 1894, sixteen years after Muybridge began his unique way of photographing horses, inventor Thomas Alva Edison patented the first motion picture camera. Edison's Kinetograph camera and his film-viewing device, the Kinetscope, had admittedly been inspired by the work of Muybridge, who had invented the first film projector, the Zoopraxiscope, in 1879. Muybridge had shown Edison his invention in 1888 and proposed collaboration, but Edison declined the offer, having his own vision to pursue.

The train robbers made the mistake of dismounting their getaway horses as they are confronted by posse members in this shot from *The Great Train Robbery.*

Credited with starting the American motion picture industry, on April 14, 1894, Edison opened a Kinetograph Parlor in New York City, where awestruck audiences watched his short films. Perhaps again taking his cue from Muybridge, Edison turned to the visual excitement of horses to enliven many early films. A bucking horse, Sunfish, along with Colorado cowboy Lee Martin, starred in the aptly titled 1894 short *Bucking Bronco*, filmed at Buffalo Bill's Wild West show. That same year, Edison filmed Buffalo Bill himself putting his beautiful gray horse Isham through his paces while Wild West performers twirled lassos around them. Technically, these two films could be called the first Westerns.

An early Edison melodrama, *The Burning Stable* (1896), shows a real barn in flames. This nail-biter depicts four eye-catching white horses being led through the billowing smoke. In the sequel, *Fighting the Fire* (1896), two horses come to the rescue by pulling a fire engine to the burning stable. Perhaps the first film featuring "trick" horses was the Edison-produced *Trained Cavalry Horses* (1898), which shows Troop F's mounts lying down and scrambling to their feet on command. Another 1898 Edison film, *Elopement on Horseback*, featured a bride sneaking out a window to land behind her beloved on the back of a tall but short-tailed bay. The one-scene thriller was photographed by Edwin S. Porter, who was on the verge of making his own mark on cinema history with the first "feature" film, a twelve-minute Western.

Directed by Porter and released by the Edison Manufacturing Company in 1903, *The Great Train Robbery* told the story of four bandits in the Wild West. (The film was actually shot in New Jersey.) The train robbers made their getaway on horses, which provided a considerable level of action for the primitive film. The getaway mounts, two grays and two dark horses—it's difficult to distinguish browns and bays from chestnuts in early black-and-white films—in western bridles and cavalry saddles, don't appear until the second half of the movie. After the violent stick-up, the robbers leap from the train to mount their waiting horses and gallop into the woods; a posse of six sets off in hot pursuit. Thus Porter staged what would become one of the most enduring elements of cinema—the chase scene.

This crude but exciting Western enthralled naïve audiences, and moviegoers began demanding more narrative films. Movies-only theaters sprang up around the country, and a new form of entertainment was assured its place in American life.

Americans were not the only ones riveted by celluloid horses. France and Australia had their own developing movie industries, and horses played significant roles. The French Lumière brothers made a series of

Native Americans and their ponies reenact an encounter with cowboys in Buffalo Bill's Wild West Show, circa 1908.

minimalist films in the late nineteenth century. Called "actuality" films, these mini-documentaries were remarkably similar to Edison's earliest efforts. One such offering, *Dragoons Crossing the Saone*, consists entirely of eleven shirtless boys riding bareback into a river and swimming their horses to the other side. Another Lumière film, *Pack Train on the Chilkoot Pass*, filmed in the United States in 1898, shows huge pack mule teams being led by men on horseback through a rugged mountain pass.

In 1906, the Australian brothers John and Nevin Tait produced a full-length feature film, *The Story of the Kelly Gang*, which employed fifty circus horses and a team of roughriders. The success of the eighty-minute "bushranging" film, the Australian version of the Western, launched a series of wild and wooly Outback features that attracted audiences with authentic—and often dangerous—horse action. In 1912, the New South Wales Police Department banned the films for allegedly making a mockery of the law. The Australians consoled themselves with Westerns imported from America.

THE FATHER OF FILM

Not long after the success of *The Great Train Robbery*, another player emerged to forever change the fledgling motion picture business. D. W. Griffith, an actor working for a flourishing New York production studio called the Biograph Company, stepped behind the camera for the first time as a director in 1908. Griffith, who would eventually be lionized as "the father of film" for his innovative staging and editing techniques, was primarily interested in human drama. However, he also had an instinct for popular taste and understood the undeniable appeal of horses cavorting on screen. Griffith's first short for Biograph was *The Adventures of Dollie*, a gripping tale about a little girl kidnapped and hidden in a barrel by gypsies. In the melodrama's climactic sequence, the gypsy wagon crosses a river, and the barrel containing little Dollie falls into the drink, headed for nearby rapids. The two horses pulling the gypsy wagon, a flashy dapple-gray and a brown, are essential to the suspenseful action.

In 1908, *The Runaway Horse*, an immensely successful French film from the Pathé production company, was exported to the United States. This early "foreign film" inspired Griffith to copy its use of reverse motion to great comic effect in *The Curtain Pole*, which features a horse-drawn carriage as an integral part of the sight

gags. While his comic potential was just beginning to be exploited, the horse as sight gag, clown, and "straight man" would become a reliable laugh getter in the years to come.

A more sober subject, Custer's last stand, inspired Griffith's 1912 action drama *The Massacre*. Scores of horses stirred up the dust, particularly in scenes involving a "death circle" of Indians on cantering mounts, surrounding their subdued enemies in ever-shrinking circles. This dizzying use of equine action would become a staple of Westerns featuring confrontations between cowboys and Indians.

Another of Griffith's Biograph Westerns, *The Battle at Elderbush Gulch* (1913), employed a number of pinto horses, used mostly as mounts for Indian characters. During the climactic battle sequence, a gray horse ridden by an Indian rears and topples over in a stunning backward fall while another pinto horse hits the dirt in the background. This sequence is especially noteworthy as both these animals, as well as a brown horse in a later scene, appear to be trained falling horses.

By the end of 1913, Griffith had left Biograph to concentrate on realizing his dream of directing a full-length epic. While he was undoubtedly out to shake up the world, his landmark film would have an impact far beyond anything he could have imagined.

The 1915 release of *The Birth of a Nation* created a furor throughout the United States. Originally titled *The Clansman*, after the book upon which it was based, the controversial film incited charges of racism. In the film's most thrilling and incendiary sequence, Wagner's "Flight of the Valkyries" was played to accompany scores of hooded Ku Klux Klansmen, mounted aboard hooded and caped horses, as they gallop four abreast through the countryside and into town to avenge the

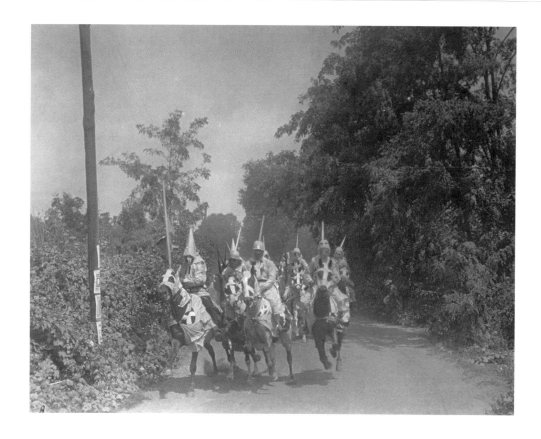

death of a white girl. Masterfully edited, the sequence is remarkable not only for its profound emotional impact but also for the preparation that must have been required to accustom the horses to performing in such elaborate gear. The powerful image of a hooded Klansman aboard a caped and hooded horse was used extensively in poster art and publicity photos for the film and undoubtedly fueled the emotional storm that raged around the movie's release.

Three years later, Griffith released a less-controversial extravaganza, *Intolerance*, a film that wove together four different stories of man's inhumanity throughout history. In the final crosscut race sequence, horses and chariots storm through ancient Babylon. While perhaps not as electrifying as the Klan sequence in *The Birth of a*

Ku Klux Klansmen
gallop down a road in *The Birth of a Nation* (1915); among the actors is future Western director John Ford.

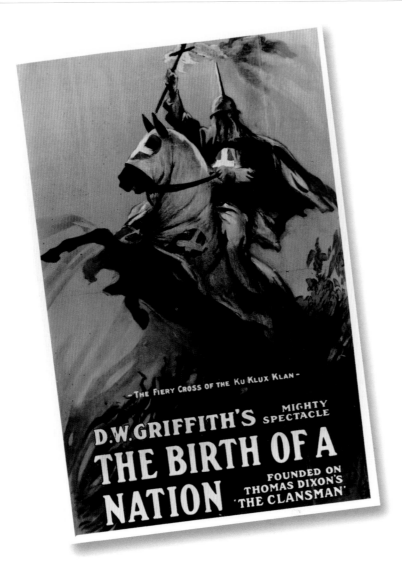

- THE FIERY CROSS OF THE KU KLUX KLAN -

D.W.GRIFFITH'S MIGHTY SPECTACLE

THE BIRTH OF A NATION

FOUNDED ON THOMAS DIXON'S 'THE CLANSMAN'

The frightening image of the hooded Klansman and horse drew audiences to see *The Birth of a Nation*.

Nation, this sequence is nevertheless an impressive example of early equine film action requiring sophisticated staging.

THE FIRST MOVIE COWBOY

The Great Train Robbery did more than establish the popularity of the Western. It also launched the career of an unlikely movie cowboy, Gilbert Max Anderson (née Aronson), who came to be known as Broncho (later "Bronco") Billy Anderson.

A former janitor at Edison's New Jersey studio, Anderson began his movie cowboy career with a lie. When asked by director Edwin S. Porter if he could ride, Anderson reportedly replied, "I was born in the saddle." The Arkansas-born Anderson had never been on a horse in his life and quickly proved it by falling off the mount he had been assigned for the shoot. The ambitious Anderson managed to convince Porter to cast him in several nonriding roles instead. Since close-ups were rare in early films, variously costumed actors could easily play multiple parts.

The financial success of *The Great Train Robbery*, rather than any great desire to work with horses, motivated Anderson to continue his career as a screen cowboy. Horses were merely a necessary part of the business of making Westerns, and he clearly understood their value in adding bankable excitement to a scene.

In 1907, Anderson and a partner started the Chicago-based Essanay Studios and began producing Westerns. The company eventually moved to California to capitalize on the scenic locations and agreeable weather. Pioneering the portrayal of a complex hero, both good and bad, Anderson starred in his own films as Broncho Billy. Although he created a considerable career for himself on horseback, the heavy-set actor never developed great riding skills and never became affiliated with a particular horse. He also had no illusions about his equestrian expertise—or that of his fellow thespians—and was the first actor to employ stunt doubles for the hard falls.

One spring day in 1911, a real cowboy, Jack Montgomery, stumbled upon a Broncho Billy production in northern California's rugged Niles Canyon. Montgomery, along with fourteen other cowhands looking for work, rode over a ridge to watch Anderson shooting a Western in the valley below. Recognizing a great opportunity for capturing genuine horse action,

Anderson offered Montgomery and his saddle pals a good day's pay for riding in the action sequences. Montgomery rode his own ranch horse, a blue roan gelding named Cowboy, in a number of shots until Anderson explained that he needed a stuntman to double an actor in a scene of a horse and rider falling. An excellent horseman, the unsuspecting Montgomery was selected for the honor.

Montgomery quickly discovered Anderson's attitude toward movie horses. Anderson's crew rigged a big bay with a crude version of the tripping device known as a Running W, a contraption designed to pull the horse's front feet out from under him at a full gallop. Piano wire attached to leather hobbles on the horse's fetlocks was threaded through a ring on his cinch and staked to a buried post. Montgomery was instructed to bail off the horse a split second before the animal was yanked to the ground. Both horse and rider miraculously endured the brutal incident without apparent injury, but Montgomery, who went on to become a top Hollywood stuntman and double for the great cowboy star Tom Mix, found the horse's treatment disturbing.

In his later films, Anderson continued to use horses as dramatic elements, increasing his popularity with movie audiences who expected ever-greater thrills. His flamboyant theatrics are typified in his 1919 Western *The Son-of-a-Gun*. In one outrageous sequence, he pulls his horse, a rangy sorrel, into a rear before charging into a saloon, guns blazing. Having made his grand entrance, the chunky cowboy dismounts and, with a hearty slap on the rump, sends his trusty steed back out through the barroom doors. Eventually copied to the point of becoming a movie cliché, this wild entrance was new in 1919; such novel theatrics were essential to Broncho Billy's appeal.

After contributing five hundred films to the Western genre, Anderson turned his businesslike eye to comedies, working with Charley Chaplin and Laurel and Hardy in subsequent productions. His on-screen persona of Broncho Billy eventually earned Anderson a special Academy Award for being the first cowboy star. More important, Broncho Billy blazed the trail for future cowboy stars—and their horses.

The first real cowboy to become a stuntman, Jack Montgomery is aboard his Mexican horse Chapo in this photo from 1925, the year Rudolph Valentino rode him in *The Eagle*.

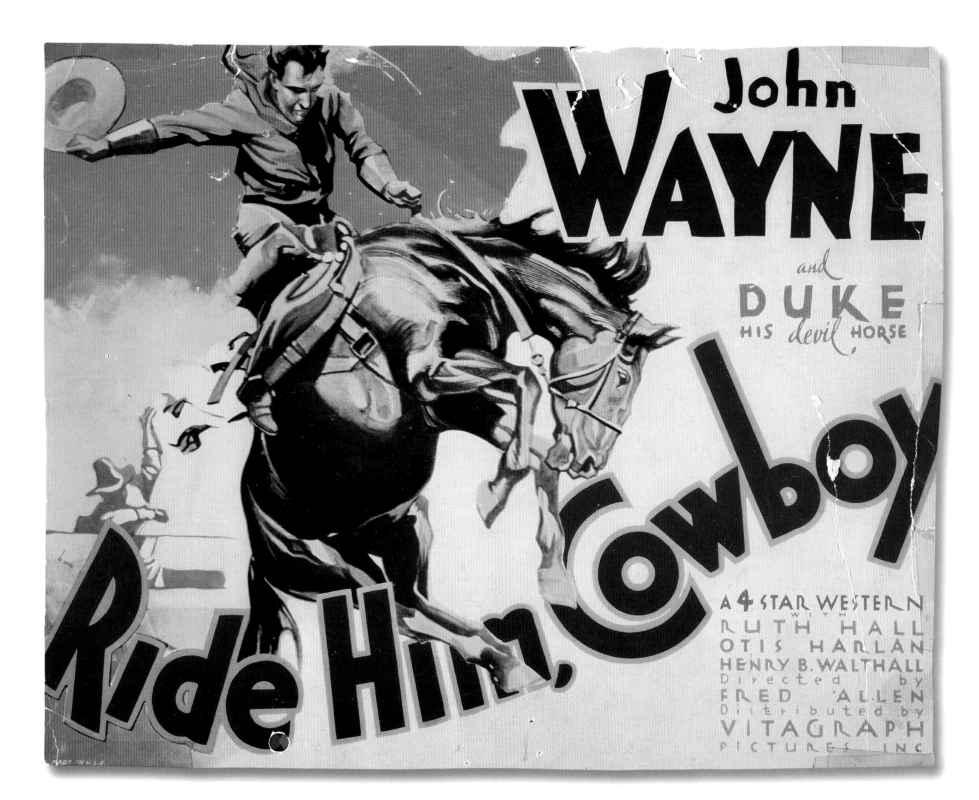

A HORSE AND HIS MAN

"A cowboy is a man with guts and a horse."

—Attributed to Will James

Future superstar
John Wayne was thrust into the public's consciousness aboard his costar Duke.

SINCE HIS AUSPICIOUS debut in the birth of cinema, the movie horse has enjoyed a long canter in the limelight. During the silent film era, 1893–1930, the horse achieved a type of stardom that seems unbelievable today. Even more remarkable, his star power endured for decades. Spurring that rise was the creation of the cowboy-horse partnership. The right man paired with the right horse could make both idols of the silver screen. For some Western fans, the horse was the bigger box office attraction. Roy Rogers, the great cowboy star of the 1940s and 1950s, who became identified with his palomino stallion, once quipped, "I have no illusions about my popularity. Just as many fans are as interested in seeing Trigger as they are in seeing me."

Long before Roy Rogers and Trigger became celebrity icons, however, a dour Western actor and his red-and-white pinto pony, William S. Hart and Fritz, established the cowboy-horse partnership in a series of gritty silent films. Following on their heels was a new breed of Western stars—real cowboys such as Tom Mix and Ken Maynard. One horse, a charismatic stallion named Rex, bucked the formula and fought his way to the top alone.

THE FIRST PARTNERSHIP

Like his predecessor, Broncho Billy, William S. Hart hailed from the East and would establish a screen persona as a "good/bad man." The similarities stop there, however, as Hart had a genuine love of the West and horses. He had spent much of his childhood, in the late 1800s, traveling with his miller father and observing the ways of the disappearing Old West. Living for a time in the Dakotas, he learned good horsemanship and a respect of nature from his Sioux playmates. These childhood experiences would translate into an almost fanatical quest for realism in his films and result in the depiction of interdependent friendship between man and horse.

Before making his first movie, however, Hart spent two decades on the stage, in New York and London, and earned renown as a dramatic actor. His work in two plays about the West, *The Squaw Man* and *The Virginian*, helped create his film persona.

Hart's early movie horse, Midnight—which the star described in *My Life East and West* as "a superb coal-black animal that weighed about 1200 pounds"—was considered hard to handle. Hart got along with the horse and tried to buy him for $150, a large sum in 1914. He belonged to the traveling Miller Brothers 101 Ranch Wild West Show, which during its off-season leased stock to the New York Motion Picture Company's California production arm. When Joe Miller refused to sell the horse, Midnight hit the road with the 101 Show, and Hart began

searching for another mount. Hart soon found himself drawn to a small pinto named Fritz, who was to become the equine half of the first screen cowboy-horse buddy relationship.

ENTER FRITZ

A Sioux chief named Lone Bear reportedly brought Frtiz to California in 1911. Hart first set eyes on the red-and-white gelding at Inceville, producer Thomas Ince's movie ranch. Fritz was practicing his rear with actress Anne Little aboard and almost came down on Hart's head. Despite the close call, Hart was smitten—not with Anne but with Fritz.

Though Fritz was small, weighing only about 1,000 pounds and standing just over fourteen-hands high, Hart saw something special in the little horse. In their first film together, the sturdy pinto impressed the actor with his stamina. The script called for Fritz to carry the six-foot Hart and another actor, who with their guns and the heavy stock saddle must have weighed close to 400 pounds, for hours. The action culminated in Hart's

William S. Hart

discovered his equine partner Fritz at Thomas Ince's movie ranch, Inceville, shown above circa 1916. Opposite page, the inimitable Fritz and Hart are seen in the California Desert.

"falling" Fritz and then using him for a shield in a gunfight. The actor related in his autobiography that the brave but weary little horse gave him a thankful look that "plainly said: 'Say, Mister, I sure was glad when you give me that fall.'"

Fritz apparently didn't mind falling, as Hart regularly threw the pinto from a dead run, using a technique that has been traced back to the armies of Alexander the Great. In an era when tripping devices were commonly used in the movies, Fritz was one of the first trained falling horses.

Because of his markings, Fritz could not be doubled, so he performed every stunt himself—including jumping though windows and fire—except one. In Fritz's last film, *The Singer Jim McKee* (1924), an elaborate replica of the pinto was painstakingly constructed (at the then-huge cost of $2,000) to take his place in a fall from a cliff into a deep gorge—a deadly drop of about 150 feet. Hart galloped Fritz to the edge of the cliff, then pulled him into a fall. Once the pinto was safely removed from the scene, the mechanical horse was brought in and held upright with piano wire for Hart to mount. When the wires were cut, Hart and the dummy tumbled over the precipice. While Hart was badly shaken by the fall, Fritz would not have survived it without serious injuries. The final edited sequence proved so convincing that the board of censors, headed by William Hays, president of the newly established Motion Pictures Producers and Distributors Organization, summoned Hart to New York, certain he had endangered a live horse. Once he explained how the astonishing illusion had been accomplished, the censors were placated, but when the film was released, it still caused a flood of mail from Fritz's concerned fans.

THE GREATEST ALL-AROUND HORSE

Hart adored Fritz, whom he described as "the greatest all-around horse that ever lived." Two of Hart's films, *The Narrow Trail* (1917) and *Pinto Ben* (1924), were made as tributes to the pinto. Hart even ghostwrote a book, *Told Under a White Oak*, published in 1922 and "authored" by Fritz. The charming book tells Fritz's version of all the hard stunts he had performed during his career.

The actor was determined to buy Fritz, but his owner, Thomas Ince, refused to sell, figuring he could keep Hart under contract using the pinto as leverage. Hart outfoxed Ince, however, and made his purchase of Fritz a condition of a contract negotiation, then later withheld him from fifteen films to leverage a higher salary. Since early films were made quickly, Fritz was only out of the public eye for about two years. Fans missed their favorite movie horse, but his absence made his return, in 1919's *Sand*, all the sweeter.

For all his sturdiness and willingness, Fritz had a temperamental streak. One of his quirks was his attachment to Cactus Kate, a feisty mare used in bucking scenes. Hart was obliged to buy the mare to keep his costar happy. On one particular day during the filming of *Travelin' On* (1921), Kate had been left at the studio barn with another stablemate, a giant mule named Lisbeth. Fritz had several difficult scenes with a monkey and refused to work until the mare was brought to the set. With Kate watching from the wings, the shooting proceeded beautifully until a terrible bellowing and thundering of hooves interrupted work. Lisbeth had broken out of her corral and galloped a mile through traffic to join her friends.

Fritz was retired to Hart's ranch in Newhall, California (now a museum), in 1924 and thus did not appear in Hart's last film, *Tumbleweeds* (1925). When the horse died at age thirty-one in 1938, Hart had him buried on the ranch with a huge stone marker that still reads, "Wm. S. Hart's Pinto Pony Fritz—A Loyal Comrade." In a monologue added to the 1939 rerelease of *Tumbleweeds*, the Shakespearean-trained actor gave a heartfelt speech honoring his lost horse.

Audiences had loved Fritz almost as much as Hart had, and savvy filmmakers were on to a winning combina-

tion. By the time Fritz made his last fall, the long parade of cowboy-horse screen partnerships had begun.

RIDE 'EM COWBOYS

With the Old West disappearing and the Western film flourishing, a new breed of actor rode onto the scene—literally. Many expert horsemen looking for ranch work at the turn of the century wound up displaying their skills in the traveling Wild West shows. As the popularity of these shows began to wane in the early 1910s, a number of cowboy performers moved on to the picture business. Rodeo stars were also lured to Hollywood by the promise of greater fame and fortune—or at least a steady paycheck doing stunt work. College athletes traded their track shoes for cowboy boots to cash in on the craze for hard-riding heroes. Thespians who weren't born in the saddle quickly took riding lessons to get in the game, and playing cowboys catapulted a few actors to wider movie stardom. The first big Western star after William S. Hart, Tom Mix, was, however, a genuine cowboy.

TOM MIX AND TONY

Tom Mix would come to be considered—by his cowboy contemporaries as well as by many modern film buffs—the best horseman of all the movie cowboys. Mix, born in Pennsylvania in 1880, learned horsemanship from his father, a stable master. Young Tom became an excellent rider. He also exhibited a theatrical flair and created his own cowboy suit when he was just twelve years old.

At eighteen, Mix joined the army for a three-year stint. He reenlisted but went AWOL a year later when he got married. He worked a variety of jobs, including wrangler, until he joined up with the Miller Brothers 101 Ranch Wild West show in 1906. Mix became one of their

Tom Mix and his
horse .45

top performers. Four years later, he hooked up with the Selig Polyscope Company to make Western movies. A Selig press release for the 1911 film *Saved by the Pony Express* stated: "The mounting and riding at full gallop of Western horses, and of an unbroken bronco by Tom Mix, are some of the most thrilling feats of horsemanship ever exhibited in a motion picture."

Mix rode many horses in the 170 films he made for Selig. His first one, a stout brown gelding, looked like a real ranch horse and obviously derived his unusual name, .45, from the brand on his left hindquarters. Mix's avowed favorite movie mount was his own horse, Old Blue, a tough little roan with two hind socks and a long dished face, typical of Arabian breeding. (It is not known whether this sturdy little gelding actually had Arabian blood.) Old Blue was so loved by Mix that when the horse had to be put down after breaking a leg in his corral at age

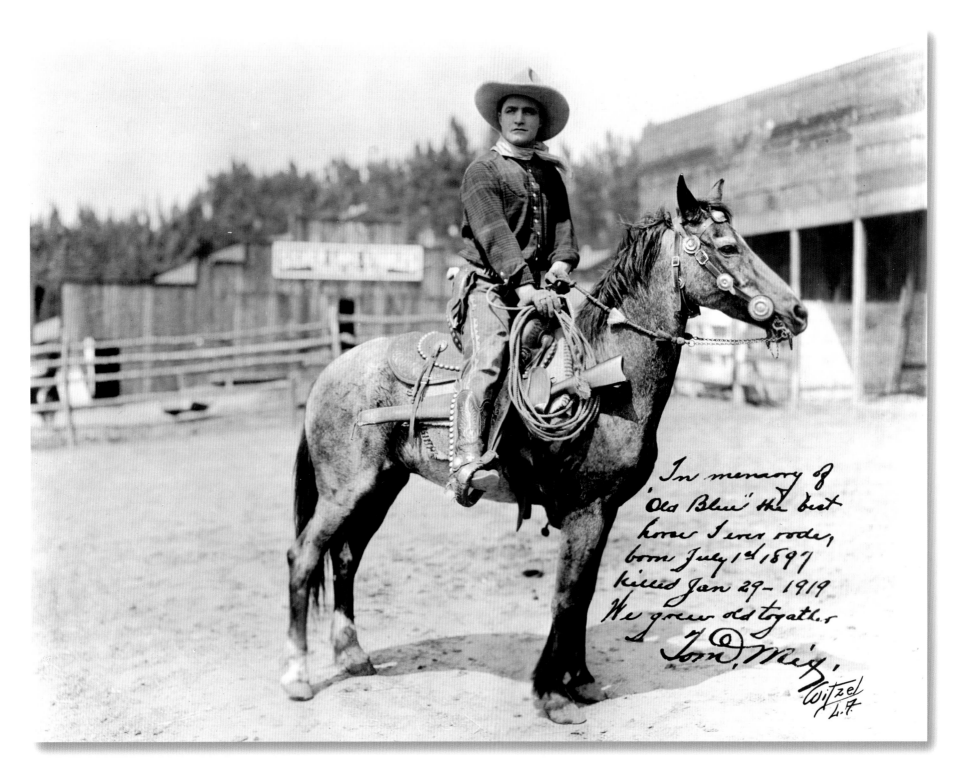

In memory of
"Old Blue" the best
horse I ever rode,
born July 1st 1897
killed Jan 29- 1919
We grew old togather.

Tom, Mix,

Witzel
L.A.

twenty-two, the star was bereft. He had the roan buried at his ranch, Mixville, in Edendale, California, where many of the actor's Westerns were filmed. Ever faithful to "the best horse I ever rode," Mix placed a wreath on Old Blue's grave every Decoration Day.

By 1920, Mix was challenging William S. Hart for the cowboy hat crown. The former's early penchant for clothes had evolved into a flamboyant style, the antithesis of Hart's gritty, authentic look. Mix's movie persona was lighthearted and imbued with clever tongue-in-cheek humor. Audiences responded enthusiastically to Mix, but still something was missing—an equine sidekick as flashy as the man who rode him.

Enter Tony, "the Wonder Horse" Many stories have been circulated about Tony's origins. They usually involve Tony's being noticed as a colt, following his mother as she hauls a vegetable cart. Inevitably, Mix buys Tony for $10 or $12. The foggy details of the colt's metamorphosis into the Wonder Horse imply that Mix himself trained Tony. However, the most convincing version of how Tony arrived in the actor's life comes from Mix's third wife, Olive Stokes. She claimed to have spotted the colt one day in 1914, as he followed a chicken cart being pulled by his dam along Glendale Boulevard near downtown Los Angeles. She contacted Pat Chrisman, Mix's horse trainer, who lived a few blocks away. He liked what he saw and paid the cart driver $14 for the future Wonder Horse. Mix bought Tony from Chrisman in 1917 for a reported $600. Although the actor boasted that Tony did not have to be trained, just shown what to do, Pat Chrisman taught Tony the many tricks that made him famous.

Tony appeared with Mix in a 1917 Selig film, *The Heart of Texas Ryan*, when the horse was three years old; it

was not until Old Blue's demise in 1919, however, that the actor began using Tony as his main movie mount. A sorrel with a long blaze and snip and two hind stockings, Tony appears to have been an American Quarter Horse type. He was highly intelligent and, like his master, had a quirky personality. According to director George Marshall: "Tom was temperamental, but it ran in streaks. Oddly enough, the horse, Tony, was very much like his owner. Pat Chrisman would rehearse him in some tricks for a picture and he would perform beautifully, but when it came time to shoot—nothing! He could be whipped, pulled, jerked, have bits changed, but still no performance. Come out the next morning and he would run through the whole scene with barely a rehearsal. Then he'd look at you as much to say: 'How do you like that? Yesterday I didn't feel like working.'"

On screen, however, Tony was always a loyal comrade. He was probably the first movie horse depicted as possessing a sophisticated knowledge of the English language, not just of simple phrases such "whoa" or "good boy" but also of whole sentences, usually directing him to perform some task. While horses can be trained to respond to certain repetitive phrases, this anthropomorphizing was pure fantasy. Audiences loved it, though, and from then on many actors talked to their horses and the horses were shown responding as if they really understood.

Tony, "the Wonder Horse," was expert at helping Mix out of jams, rescuing damsels, and participating in thrilling stunts. Mix was well known for performing his own stunts. This was partly myth; the actor did have doubles for certain stunts. So did Tony. His doubles, made up to mirror his distinctive markings, performed jumps and falls in his place. A large mare, Black Bess, was used in long shots as her size read better on film. Still Tony often took risks along with his master. On one film,

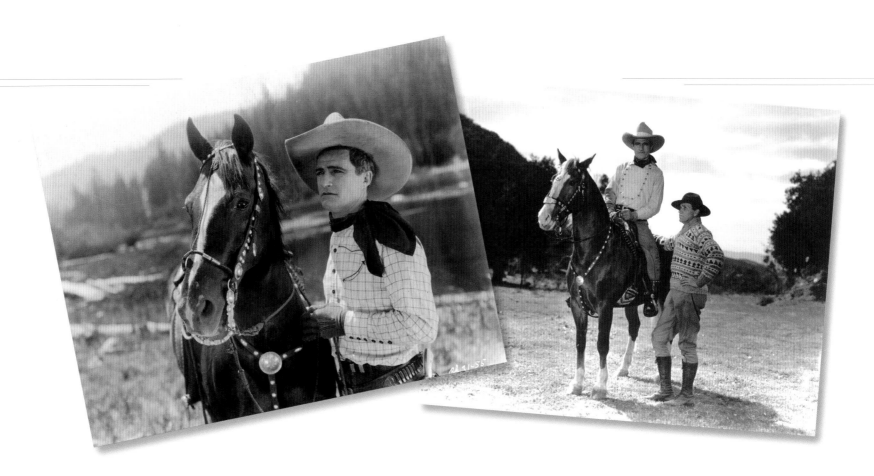

a dynamite blast, ill timed by the special effects man, threw Tom and Tony 50 feet and knocked them unconscious. Tony suffered a large cut; Mix's back reportedly looked as if he'd been hit by shotgun pellets.

For his efforts, Tony, "the Wonder Horse," commanded costar billing and received his own fan mail. One letter addressed simply to "Just Tony, Somewhere in the U.S.A." was duly delivered to the Mix ranch. He was the first horse to have his hoofprints imprinted in the forecourt of Grauman's Chinese Theater in Hollywood, alongside the foot and handprints of Mix and other biped movie stars. Tony's popularity was so great that three Mix films used his name in the titles: *Just Tony* (1922), *Oh! You Tony* (1924), and *Tony Runs Wild* (1926). Tony even "contributed" to a 1934 children's book, *Tony and His Pals*.

Tony was utilized in many publicity campaigns and in one gag shot was shown getting a manicure and per-

manent wave for his appearance at New York's Paramount Theater. He accompanied Tom on a 1925 European publicity tour, during which, according to a letter from Mix to his fans in *Movie Monthly* magazine, "Tony was patted by so many people it's a wonder he has any hair left."

TONY JR. TAKES OVER Although Tony's retirement was officially announced in 1932, his last credited role was in FBO Pictures' *The Big Diamond Robbery* in 1929. When Mix returned to the screen in Universal's 1932 talkie *Destry Rides Again*, he rode a new mount, Tony Jr. (no relation to his namesake). Like his predecessor, Tony Jr. was a sorrel, but he was more striking than Tony, with a wider blaze and four high stockings. He may have been sired by an Arabian and purchased by Mix from a florist in New York in 1930. Tony Jr. made his first known appearance on January 6, 1932, in a

publicity shot with Mix, who was recuperating from illness at home on his fifty-second birthday. Despite the obvious differences in the horses' markings to the trained eye, Universal passed the new horse off as "Tony" and continued to bill him as such through the first half of 1932. Tony Jr. finally received billing as himself in a fall release.

The newcomer achieved his own popularity with audiences and critics. In a 1933 review, a *New York Times* critic wrote, "Tony Jr. was as fine a bit of horse flesh as ever breathed." Unfortunately, Mix was on his way out when Tony Jr. arrived on the scene, and it is unclear what became of him after Mix's death in a solo auto accident in 1940. The original Tony, however, had been provided for in Mix's will and survived his former costar by two years. On October 10, 1942, the failing thirty-two-year-old movie horse was put down in his familiar stall at the old Mix Estate.

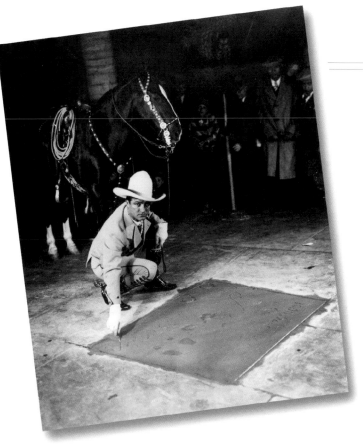

BUCK JONES AND SILVER

Another veteran of the Miller Brothers 101 Ranch Wild West Show who transitioned to the silver screen was a rugged bronc buster and trick rider named Charles Gebhart. For the movies, he was rechristened Buck Jones.

While touring with the Millers' show in 1915, Buck married fifteen-year-old trick rider Dell Osborne in a horseback ceremony. During World War I, Buck broke horses in Chicago for the Allies' cavalry units. After the war, he and Dell performed in several Wild West shows and the Ringling Brothers Circus as trick riders. With a child on the way, they decided to settle in Los Angeles, where Buck found work in the movies as a bit player and stuntman, sometimes doubling his eventual rival and friend Tom Mix.

Buck had his first starring role in Fox Studios' *The Last Straw* (1920), and his career skyrocketed. To compete with the other cowboy stars, however, he needed a special horse. His first horse, a black, unfortunately died in a filming accident. However, in 1922 Buck spotted a beautiful gray on the set of *Roughshod* and knew he'd found his movie mate. He bought the horse for $100 and named him Silver. He was to become almost as famous as Fritz and Tony.

Although Buck preferred action to cute antics, Silver got to perform enough tricks to satisfy audience anticipation while also providing thrilling images as he and Buck streaked across the Western terrain. Silver was so intelligent that he learned to perform stunts, such as leaping through fire, with only one rehearsal. His skill as a one-take actor became legendary.

Buck owned two other horses, Eagle and Sandy, who often doubled Silver. Eagle was usually used in long-shot galloping sequences; he can be easily identified as he swished his tail when he ran. Sandy was always used for

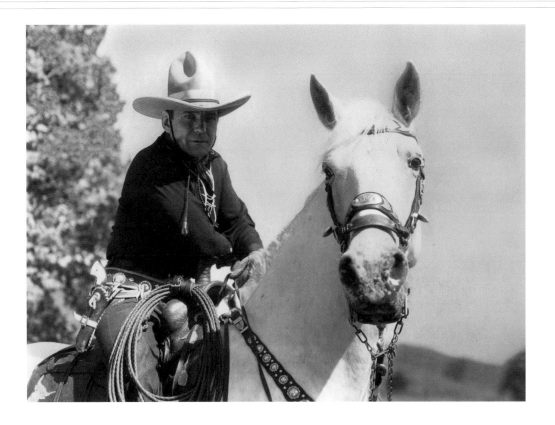

The rugged Buck Jones
with his elegant other half,
Silver.

rearing scenes. Almost indistinguishable from Silver, Sandy had a more photogenic head and was also used for close-ups. Buck loved all his horses and would never subject them to real danger. For hazardous stunts, unlucky rental horses from the studio stables served as doubles.

Buck Jones Productions produced only one film, a non-Western, before folding. The intrepid Jones rallied to put together the traveling Buck Jones Wild West Show. The Great Depression ended that enterprise prematurely, but the actor rebounded and returned to the movies. Though semiretired, Silver was occasionally brought in to do specific stunts. Eagle received billing in some of Jones's later films, and Sandy was billed as Silver in the *Rough Riders* series at the end of Buck's career.

Eagle, always prone to scours, was put down in 1941 after a particularly bad bout left him too weak to recover. When Buck returned from a trip to find Eagle gone, he shut himself in his bedroom and cried. Jones's own life came to a tragic end in 1942, when he perished in a fire at a party being held in his honor in Boston. He died heroically while trying to rescue other guests.

A few months later, Silver began to fail. According to Dell Jones: "It seemed he missed Buck and stopped eating. He would bow his beautiful head and grieve. He was very old for a horse—34 years." Sadly, Dell had the old horse put to sleep. Sandy passed away a few months later.

KEN MAYNARD AND TARZAN

Buck Jones's chief rival was Ken Maynard, a native Texan known throughout the Wild West show circuit as an incredible trick rider and roper. He had made a brief attempt to steal Dell away from Buck, and the men never became friends. Maynard made his name in films aboard a palomino mount called Tarzan.

In 1926, Maynard purchased a ten-year-old gelding at a ranch in Newhall, California. The palomino was what would now be considered a National Show Horse, an Arabian/Saddlebred cross, and was given the name Tarzan at the suggestion of Maynard's acquaintance Edgar Rice Burroughs, author of the novel *Tarzan of the Apes*. The popular film with the same title had come out in 1918, thrusting the name Tarzan into the minds of audiences throughout America.

Former circus trainer Johnny Agee taught the gelding a repertoire of tricks. Tarzan often had the opportunity to display his talents on screen, thanks to Maynard, who wrote such moments into the script. His humanlike qualities allowed the palomino to rescue Maynard from danger on more than one movie occasion. Like Tony, he

was billed as the Wonder Horse, by all accounts an apt, if not unique, nickname.

Tarzan was often doubled by one of eight palominos in Maynard's stable. Though a daredevil rider whose stunts awed audiences, Maynard rarely put the real Tarzan in serious danger. Instead, the actor pampered his star horse and transported him in a custom trailer emblazoned with his name. Maynard and Tarzan successfully transitioned from silent to sound pictures, although the horse's training in verbal cues, rather than visual signals, did create some production challenges.

Tarzan made his last movie in 1940, a film called *Lightning Strikes West*, when he was twenty-four. He was retired to Maynard's ranch soon after and died that same year. Maynard buried him in an undisclosed gravesite, reported to be under an elm or a Calabash tree in either the Hollywood Hills or the San Fernando Valley. The grieving Maynard kept Tarzan's death a secret for years. The actor never again achieved the success he had had when the great palomino carried him to stardom.

FRED THOMSON AND SILVER KING

Fred Thomson was a college athlete who won the national All-Around title at Princeton University in 1913. He eschewed the Olympics to pursue the Presbyterian ministry and became interested in movies while prescreening them for the Boy Scouts. In 1921, after a brief stint in the military, he became an actor. Inspired by Tom Mix, the handsome Thomson became a skilled equestrian, performed his own stunts, and made a star of his horse, a striking gray 17-hand Irish stallion named Silver King. True to his name, the stallion was one of the most spectacular horses to ever grace the silver screen.

The story of how Thomson and Silver King became partners may raise a few eyebrows given today's emphasis on

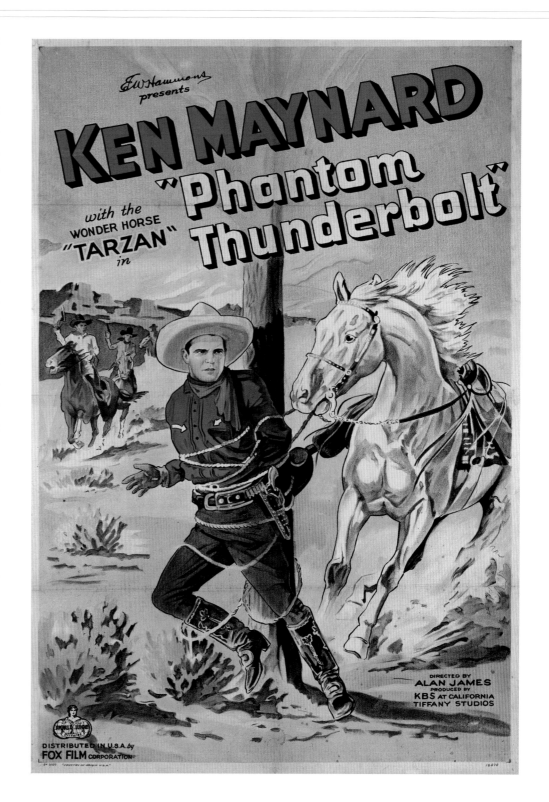

gentle training methods. Thomson was visiting a friend who owned a New York City riding school. Silver King caught the eye of Thomson, who was warned that the stallion was difficult. Undaunted, he took the horse for a ride in Central Park. When Silver King attempted to unload his rider by bucking, whirling, and trying to scrape him off on trees, Thomson responded by throwing the horse to the ground using a cowboy trick of tying his legs with one end of a rope and striking him repeatedly with the other end. Thus Thomson earned the respect of the spirited stallion, and the two became closely bonded. A week after this incident, the actor took Silver King to Hollywood, determined to make him a star. Stabling the stallion at his home, Thomson taught him many tricks, including sitting down, bowing, and performing the strutting Spanish walk. The stallion was a quick study and loved to show off. One of his admirers was the Thomsons' friend Greta Garbo, who loved to sit on the corral fence watching Fred put the stallion through his paces. Once his lessons were learned, Silver King was ready for his close-up.

The stallion loved the camera, and although he seemed bored during rehearsals, he came alive once the director called "Action!" He played significant roles in Thomson's films, and in keeping with the anthropomorphic trend, he appeared to understand and execute abstract demands. A natural box office draw, he received costar billing. The advertisements variously read: "Fred Thomson and His Wonderful Horse—Silver King," or "Fred Thomson and His Famous Horse—Silver King."

In one of Thomson's two surviving films, *Thundering Hoofs* (1924), Silver King shows his stuff by rearing on command, bowing, kneeling at a gravesite, untying ropes, and nudging Thomson toward his love interest. In the film's most frightening sequence, Silver King is condemned to a Mexican bullring as a matador's mount after Thompson's character has been unjustly jailed. The giant bull gores the stallion, who appears doomed. In the nick of time, Thomson's character breaks out of a jail to save his horse by wrestling the bull to the ground. Silver King's bravery in working with the bull can be attributed to the fact that one of his stablemates, and probable costar, was Thomson's pet bull, Muro.

Silver King's antics garnered plenty of attention from the Hollywood press, and the stallion often made headlines with his temperamental behavior. He reportedly threw tantrums if one of his doubles performed a stunt, and while docile as a lamb working with children on camera, he might kick the set to smithereens after "Cut!" was called. When Silver King showed up on a nighttime set wearing sunglasses, the gossip columnists went wild with speculation. Had Silver King gone "Hollywood?" It turned out that the glasses were intended to protect his eyes from the bright Klieg lights used in filming after he had shown signs of temporary blindness. Compresses of cold cabbage leaves and ten days in a dark stall reportedly cured him of "Klieg eyes."

Silver King's brilliant career was cut short when Thomson passed away suddenly in 1928 following a brief illness. Shortly thereafter, the *Los Angeles Times* ran a front-page story about Silver King's mourning his master. The article called him "the most famous horse in the world." Several years later, Thomson's widow, the screenwriter Frances Marion, sold Silver King, and in 1934 he returned to the screen in low-budget films with Wally Wales, a little-known cowboy star. The marvelous Silver King received billing and was featured in publicity materials to attract audiences to the seven films he made with Wales.

OTHER COWBOY DUOS

Many more real cowboys rode the silent celluloid range. Another veteran of Wild West shows to achieve stardom was Jack Hoxie, whose lesser-known actor brother Al sometimes doubled him. A fan of the Appaloosa breed,

The majestic Silver King
and Fred Thomson

Rough Rider "Takes the Trail"

Jack Hoxie became popular along with his most famous mount, Scout, a handsome leopard Appaloosa with black spots.

Trick riders Art Acord and Hoot Gibson performed with Dick Stanley's Congress of Rough Riders as well as the Miller Brothers 101 before they rode into Hollywood from the rodeo circuit.

Art Acord kept rodeoing after he began his film career in 1909 and was crowned World Champion Steer Bulldogger in the 1912 Pendleton, Oregon, Round-Up. During his successful career in silent films, Acord was paired with several different horses. He rode Buddy, Black Beauty, Darkie, and Star, but Raven was his favorite.

Hoot Gibson, an expert at Roman riding (the art of standing upright on the backs of two horses working in tandem, which contrary to popular belief has no link to ancient Rome), won the All-Around Champion title at Pendleton

the same year Art Acord won his award. Gibson began his film career doubling silent star Harry Carey. His daring stunt work eventually landed him his first starring role in a 1919 "two-reeler" series. (The approximately twenty- to thirty-minute "two reelers" consisted of two short reels of film.)

In *King of the Rodeo* (1929), Gibson demonstrates his rodeo expertise. For most of the movie, the affable Hoot rides his palomino, Goldie. Gibson rode several other horses during his career, including Midnight, Starlight, and Mutt, but he was most often associated with Goldie.

African-American rodeo star Bill Pickett was promoted as the World's Colored Champion in the Norman Film Manufacturing Company's 1923 production of *The BullDogger*. Bulldogs were often used by cattle ranchers to help herd unruly steers. In 1903, Pickett had witnessed such a bulldog force a steer into submission by leaping at its head and biting its lip. By imitating the dog's technique, he devel-

oped the rodeo sport of bulldogging: galloping after a steer, leaping onto its neck, wrestling it to the ground, and biting its lip. In 1907, Pickett joined the Miller Brothers 101 Ranch Wild West show and, with his courageous steed Spradley, popularized the daredevil sport. (The lip-biting flourish has since been dropped from the rodeo event.) Pickett's sensational theatrics led to his starring film role, which according to a press release included "fancy and trick riding by black cowboys and cowgirls." Pickett made one more film for Norman, a Western titled *The Crimson Skull*, in 1923. Featuring the heroics of thirty black cowboys, the film celebrated an often-overlooked segment of America's western history.

For a brief time, rodeo champion Yakima Canutt, who won the Pendleton All-Around title in 1917, took a star turn and made a few pictures with a horse called Boy. Canutt eventually gave up acting and concentrated on stunt riding, doubling many Western stars, including John Wayne. In the stunt business, Canutt is revered for pioneering the difficult maneuver of leaping from a galloping horse onto one of the leads of a team of carriage horses and working his way along the rigging of the running team to the vehicle. He perfected this stunt playing an Indian in *Stagecoach* (1939). For the spectacular sequence, he added shimmying along underneath the moving coach, getting shot by Wayne, and falling to his "death." Eventually, Canutt became a stunt coordinator and second unit director, staging some of the greatest horse action of all time, including the thrilling chariot race in the 1959 blockbuster *Ben Hur*.

FUTURE LEGENDS GET A LEG UP

Marion Michael Morrison was no stranger to the saddle. He grew up in the California desert town of Lancaster and rode an old mare named Jenny to school and back, a ten-mile round trip. "Riding a horse always came as nat-

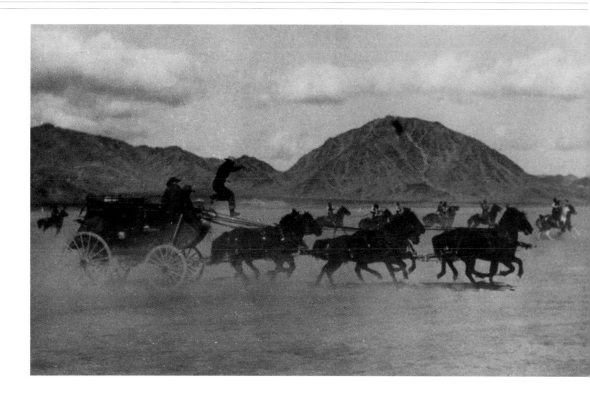

urally to me as breathing," he once said, "and I loved that mare more than anything in the world." Young Morrison, nicknamed Duke, was heartbroken when Jenny had to be put down. He was destined, however, to forge bonds with quite a few more horses in his life as an actor.

Duke Morrison won a football scholarship to USC but, like so many other young men, was drawn to Hollywood. Inspired by his idol, silent Western star Harry Carey, Morrison had a hankering to be a screen cowboy. He worked as a prop man and appeared in a number of films as a bit player until director Raoul Walsh gave him a break in the 1930 Western *The Big Trail*. Walsh reportedly also gave Duke Morrison a new name: John Wayne.

The Big Trail was not a big success, but it started Wayne on his own trail to superstardom. In a series of films for Warner Brothers, he was paired with a white horse named Duke (after Wayne's own nickname). One of these movies, *Ride Him*

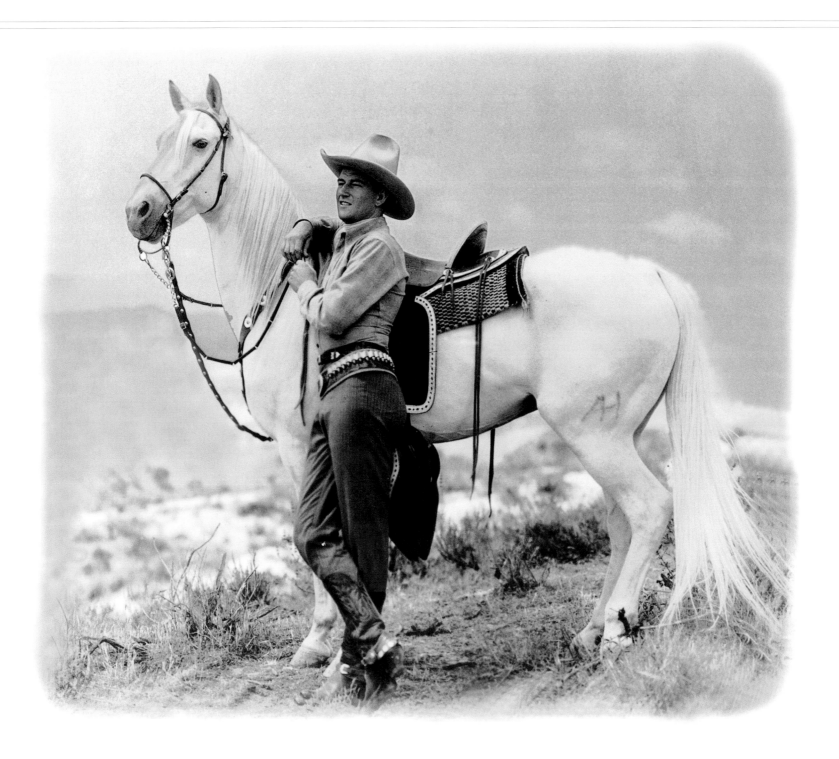

Cowboy (1932), is credited with making Wayne a star. Wayne shared billing with Duke, "his Devil Horse," but the handsome former parade horse, with a long flowing mane and tail, looked anything but devilish.

In later films, Duke (really several different white and light gray or cream horses) became the Wonder Horse. It's amusing now to watch these old films and hear the actor talking to Duke as if to an intellectual equal, something Wayne later admitted he didn't particularly like. In those early days of Westerns, however, there was nothing better for jump-starting an actor's career than the right costar—a good horse.

Another screen legend, Gary Cooper, had his first starring role as "the Cowboy" in the 1927 silent Western *Arizona Bound*. An excellent horseman who spent part of his youth on a Montana ranch, Cooper performed most of his own stunts, including a transfer from a horse onto a fast-moving stagecoach. Later that year, he starred as the title character of *Nevada* aboard a bald-faced sorrel and appeared with a horse named Flash in *The Last Outlaw*. *Variety Weekly* raved about this last film: "Cooper does some good work, rides fast and flashy on his horse 'Flash,' and impresses with his gun totin' generally." Gary Cooper's illustrious career was officially launched—with the help of Flash.

REX, "KING OF THE WILD HORSES"

Most of the early horse actors found fame as partners of cowboy stars. Not Rex, an amazing black stallion, who became a star in his own right. Billed as Rex the Wonder Horse, this beautiful Morgan had incredible screen presence and a genuine wildness that enthralled audiences.

Foaled in Texas in 1915, Rex was registered as Casey Jones. Reportedly abused as a colt, he was eventually sold to the Colorado Detention Home to be used as a breeding stallion. One day a student took Rex out for a ride and never returned. His body was found near a stream, and it appeared that he had

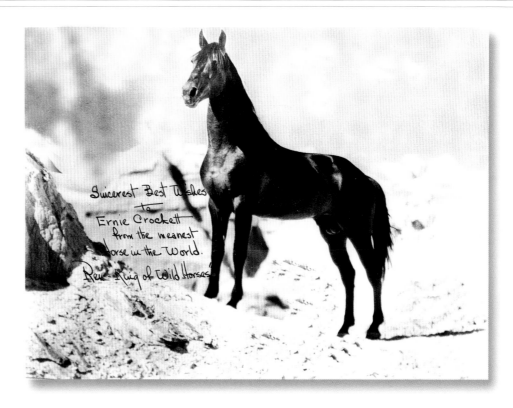

been dragged to death. Perhaps he fell and caught his foot in the stirrup, panicking Rex. Whatever happened, the stallion was branded a killer and sentenced to solitary confinement for two years.

Meanwhile, producer Hal Roach was preparing a new film in 1923, *The King of the Wild Horses*. He was looking for a fresh black stallion to play the lead and recruited Chick Morrison, who looked after Roach's polo ponies, to find the star. Morrison and Jack "Swede" Lindell, considered the most gifted horse trainer in Hollywood at the time, scouted prospects in several western states. The men heard about the "killer stallion" at the Detention Home near Golden, Colorado. They decided to take a chance and went to see Rex. Morrison and Lindell were impressed with the stallion's charisma. They worked with him at the Detention Home for a week and schooled him at liberty, without a bridle or ropes connecting the horse to the trainers. At the end of the week, they staged a demonstration for the astonished wardens.

Above, the black stallion Rex strikes a regal pose in his debut film, *The King of the Wild Horses* (1924). In his best penmanship, Rex has inscribed this photo to early cinematographer and special effects man Ernie Crockett. Opposite page, the Duke relaxes with Duke, his handsome *Ride Him, Cowboy* costar.

Standing at opposite ends of the town's Main Street, Morrison and Lindell called Rex back and forth between them, using only their voices and whip cues. The stallion's talent confirmed, Morrison and Lindell bought Rex for $150 and brought him to Tinseltown, where he was stabled at the barn of Clarence "Fat" Jones, one of the largest suppliers of movie horses.

Despite his ability to work at liberty, Rex never became a docile actor. He was famous for quitting when pressed too hard for obedience and once ran 17 miles from the set on a Nevada location. It was this untamed aura that attracted audiences, making it worthwhile for the studios to work with the difficult horse. Rex made his debut in *King of the Wild Horses*, the film that gave him his nickname, and became an instant hit. Hal Roach Studios quickly capitalized on Rex's appeal with *Black Cyclone* (1925) and *The Devil Horse* (1926). In all these films, he was perfectly type cast as a wild stallion. Hank Potts, a pioneer movie horse handler, once said there was "an unusual and arresting gleam in Rex's eyes, like the untamable stare of an eagle." On one location, Navajo on the film said that Rex had a devil imprisoned in him. Some even wore amulets against his "evil eye."

Oddly, Rex was infuriated by spitting, perhaps as a result of being so taunted at the Detention Home. Whatever the origin of this bizarre quirk, Lindell exploited it to incite the horse's on-screen wrath. Standing just off camera, Lindell only had to spit, and Rex would charge forward, eyes wild and teeth bared.

Since most actors refused to work with Rex, his double, a quiet gelding named Brownie, was used in close-up scenes. Only the fearless former rodeo star, actor, and top-notch stuntman Yakima Canutt would work "up close and personal" with the stallion. Canutt costarred with Rex in *The Devil Horse* and had a close encounter with his wild side. In one scene, Rex had to run to Canutt's character during an Indian battle. He had performed the liberty work beau-tifully for several takes, but Canutt noticed he was getting mad. He warned the director, Fred Jackman, that the horse needed a break. Jackman pressed for one more take—and Rex snapped. He charged Canutt, baring his teeth. "I tried to duck," Canutt remembered in his autobiography, "but his upper teeth hit my left jaw and his lower teeth got my neck. I was knocked to the ground, and he reared above me, striking down with his powerful front hooves." Canutt managed to roll away and kicked Rex on the nose. Still the horse came after him even when Lindell tried to call him off. "I finally rolled over a bank and escaped," wrote Canutt.

Rex's frequent costar was a pinto stallion, Marky. Sometimes he was used as a shill, to incite Rex to fury with an off-screen whinny. Marky had some hair-raising on-screen tussles with Rex, carefully orchestrated by Lindell, who made sure neither stallion was injured no matter how vicious the fight appeared. Their hooves were shod in soft rubber shoes to soften kicks, and their teeth were wrapped in gauze to prevent serious bites. Fake blood added to the realism of the fight scenes, which were acted for keeps by both stallions.

In early 1927, Rex was sold to Universal Pictures. There he continued his career, appearing in several films with Jack Perrin, an appealing cowboy actor. One such film was *Guardians of the Wild*, released in 1928. Perrin plays Jerry, a forest ranger who talks to his gorgeous light gray mare, Starlight, the actor's frequent costar. As bright as she is beautiful, Starlight, of course, understands every word. Playing a sympathetic character for a change, Rex is depicted as smarter than Jerry and expends a considerable amount of energy trying to communicate with him.

Critics loved Rex, as is obvious in this 1928 review of *Guardians of the Wild* from *Photoplay* magazine: "Rex, the 'Wonder Horse,' is the star; but you see little of him. He's

buried under a pile of screaming heroine, half-witted hero, wronged father, and leering villain. Too bad a horse can't choose his own stories!"

In another of Rex's films, *Wild Beauty* (1927), the stallion costars with a French Thoroughbred mare named Valerie. The film features Rex at his wildest, killing a mountain lion, battling cowhands who have roped him, tearing into a rival stallion with a vengeance, and galloping at breakneck speed to accomplish his varied goals in the film. His performance is truly stunning.

Rex never outgrew his wildness. In fact, during the filming of *Smoky* in 1933, he charged an actor and knocked him to the ground, as scripted. What followed was pure improvisation by Rex, who began tearing the man's clothes off with his teeth. The director cut the frightening scene from the film.

Rex is credited in nineteen films, but he played anonymously in countless others as an incorrigible stallion. His career continued into the talkies era, and in 1935 at age twenty, he costarred with the German Shepherd Rin Tin Tin Jr. in a twelve-part Mascot serial, *The Adventures of Rex and Rinty*. Rex made his final film in the late 1930s. He eventually retired to the ranch of Lee Doyle in Flagstaff, Arizona, where he was turned out with a band of mares. Although Rex sired a number of foals, none became a movie star. Truly one of a kind, Rex passed away sometime in the early 1940s.

Behind the back of an oblivious Native American chief, Rex's nemesis, the pinto Marky, menaces his off-screen rival in *The Devil Horse* (1926).

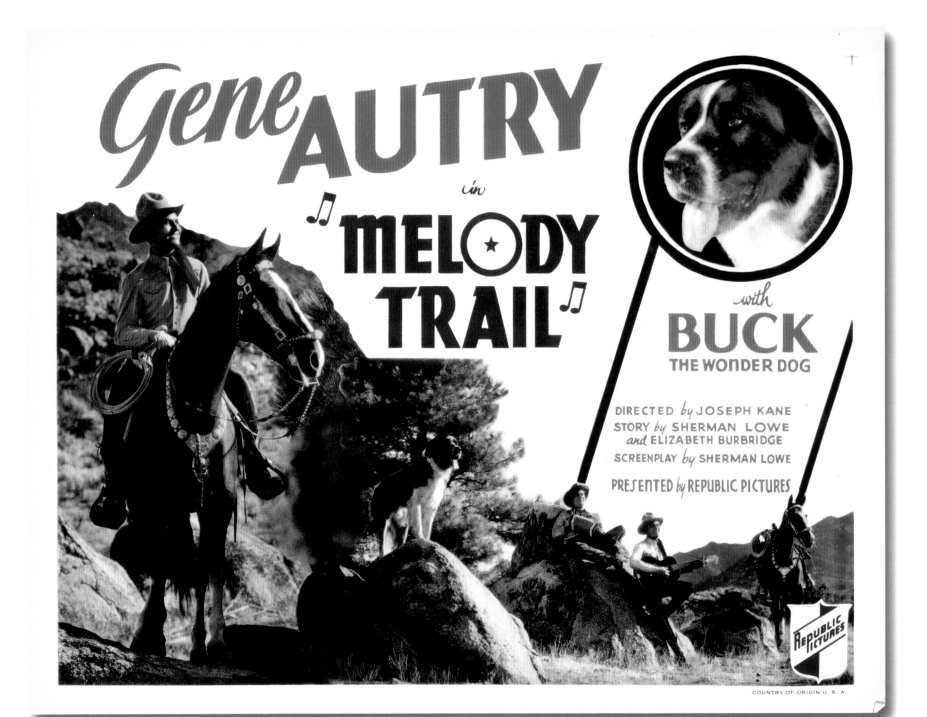

HORSE HEROES AND SINGING COWBOYS

"Back in the saddle again, back where a friend is a friend..."

—Gene Autry and Ray Whitley, "Back in the Saddle Again"

Gene Autry and the original Champion, along with their costar Buck, grace a lobby card for their movie *Melody Trail* (1935).

HE ADVENT OF SOUND opened up whole new vistas on the celluloid range. Actors could be heard delivering their lines at last, and sound effects provided extra realism. For Westerns, this meant that for the first time, smacking fists, gunfire, and thundering hooves rattled speakers in movie houses across America. It also meant the birth of a new kind of Western hero: the singing cowboy. Tough enough to roust out the vilest varmint, the singing cowboy was also clean living and honest to a fault, with a smile and a song always at the ready. More than one of these new heroes sang his way into the hearts of moviegoers. The two most famous were Gene Autry and Roy Rogers. Just as celebrated were their horses, Champion and Trigger.

THE HORSE OPERA

Western music was already extremely popular with radio audiences so it' s no wonder that the first sound Western, *In Old Arizona* (1929), was also a musical. Warner Baxter won an Academy Award for his performance as the Cisco Kid. Both he and his costar, Dorothy Burgess, sang as did members of the cavalry. A microphone strategically hidden in some sagebrush captured the exciting sounds of galloping horses for the first time in movie history. The immense success of this Best Picture–nominated venture convinced filmmakers that cowboys and music were a marriage made for box office heaven, and the horse opera was born.

The singing cowboy's boots are planted in practical tradition. Cowboys driving cattle from Texas to northern stockyards learned that nervous steers could be comforted by song. Yearning for amusement after dusty days on the trail, cowboys also sang to entertain one another. While no record of these early singing cowboys' efforts exists, they sparked an enduring tradition. Even now, many country music stars dress as cowboys and cowgirls, embracing the imagery of the Old West that has come to symbolize all-American qualities of integrity and freedom.

Tom Mix hired live cowboy singers to entertain audiences between showings of his silent films but never attempted to warble himself. Western star Ken Maynard, however, had "long had a hankerin' " to sing, and in his first all-sound feature, *Kettle Creek* (1930), he not only performed some of his most spectacular stunts with Tarzan but also worked in some songs. He repeated the formula in a few more films for Universal. Although Maynard enjoyed a brief recording career with Columbia Gramophone, the cowboy star had a raspy, nasal singing voice that limited his appeal. Undaunted, he bought the films rights to a popular ballad about an incorrigible horse, *The Strawberry Roan*, and sang the title song in the 1933 movie of the same name. Maynard believed the singing cowboy was the next big thing, and Mascot Pictures chief Nat Levine agreed. In 1934, Levine produced *In Old Santa Fe*, which blended Wild West action and cowboy music on a modern dude ranch. Ken Maynard and Tarzan received top billing, but a young WLS radio star named Gene Autry, the "Cowboy Idol of the Air," stole the singing thunder of his own long-time idol Maynard, whose poor singing had to be dubbed in the movie. Maynard and Tarzan were already fading into the sunset as Autry began his meteoric rise.

AMERICA'S COWBOY AND THE WORLD'S WONDER HORSE

"Back in the Saddle Again," a catchy song about the pleasures of riding the range, became the first famous singing cowboy's theme song. In Gene Autry's case, the

saddle was usually aboard one of a series of blaze-faced sorrel horses, all named Champion, who costarred with Autry in more than eighty films.

THE YODELING COWBOY

Born in 1907, a few miles outside the small town of Tioga, Texas, Gene Autry grew up around horses since his father, Delbert Autry, was a horse trader and livestock dealer. Blessed with a beautiful singing voice, Gene was recruited for the choir in his Baptist minister grandfather's church when he was just five years old. A little later, his mother taught him to play the guitar on a mail-order instrument. Young Gene was too practical, however, to consider music more than a hobby. Determined to avoid the financial insecurity that plagued his father's life, he pursued more sensible ways to support himself. In 1924, the teenaged Autry was working as a telegrapher. On slow days, he would amuse himself by playing the guitar and singing. On one such day, legendary western entertainer Will Rogers came in to send a telegram. After hearing the young man sing, Rogers encouraged him to try his luck in show business. Despite his previous concerns, Autry decided to take the advice and eventually landed a job singing on Tulsa station KVOO and became Oklahoma's Yodeling Cowboy.

Autry initially found success as a radio personality, songwriter, and recording artist. By the end of 1931, he was a star on the network National Barn Dance and had his own radio program, *Conqueror Record Time*. His first hit, "That Silver Haired Daddy of Mine," became the first million-selling gold record. Deservedly known for his business acumen, Autry realized the wide commercial appeal of a clean-living cowboy and honed his image accordingly. He came to the attention of Mascot's Nat Levine, who cast him in *In Old Santa Fe*. Billed as the World's Greatest Singing

Cowboy, Autry sang two songs in the film and had a few spoken lines. Despite his greenhorn status as an actor, moviegoers responded positively to Autry and his smooth, melodious voice.

THE PHANTOM EMPIRE

Mascot subsequently signed Autry to star in a twelve-chapter serial, *Phantom Empire*, a kitschy combination of science fiction and Western genres that showcased the actor's singing. To bring Autry's riding ability up to snuff, the studio paid for lessons with former rodeo champion and stuntman Yakima Canutt.

In the *Phantom Empire* series, Gene Autry played himself as the cowboy star of the Radio Ranch radio program who gets involved with a subterranean colony of technologically advanced aliens, the Muranians. The series also featured a terrific young trick rider, Betsy King Ross. In the series, the Muranians have a mounted army that surfaces to pursue their foes. Dubbed the Thunder Riders by Betsy and her serial brother, Frankie Darro, the alien cavalry prompts the kids to start

Gene Autry sings from atop the original Champion, who is easily distinguishable from his successors by his three white stockings.

their own club of junior Thunder Riders. It's quite something to see the caped and silver-helmeted Muranians galloping along the prairie, with a gaggle of kid mock aliens wearing customized silver buckets on their heads tearing along on their own horses. Gene's mount in the series varied, but sometimes his horse is a blaze-faced sorrel with three stockings, sometimes one with four. Whether any of these horses went on to become the original Champion is not certain, but clearly Autry's preference for the color combination was evolving.

ORIGINAL CHAMPION—WONDER HORSE OF THE WEST

The success of *Phantom Empire* led to Gene Autry's first feature-length star vehicle, *Tumbling Tumbleweeds* (1935), which also introduced Champion. Although uncredited, the original Champion is easy to spot because of his three white stockings and distinctive T-shaped blaze. A 1939 promotional spot showing Gene putting Champion through his paces revealed that the gelding also had a large patch of white on his belly, visible only when he rolled on his back.

There has been much confusion about the number of Champions, their markings, and their origins. Autry, probably hoping to perpetuate the myth of a single Champion among his fans, was not particularly helpful when questioned on the subject. In one interview, he stated that the original Champion had come from Oklahoma and in another that he had acquired Champion from the Hudkins Brothers Stables, a company that provided horses for Autry's films. It has been widely accepted that the Hudkins brothers owned the original Champion and perhaps he originally came from Oklahoma. Regardless, the dark sorrel gelding was chosen because he photographed well. With three white stockings and one dark right foreleg, he can be easily distinguished from subsequent Champions, who all had four white stockings of varying height. The T-shaped blaze

starting high on his forehead and extending over his muzzle further distinguishes the original Champion.

Autry and producer Armand Schaffer reportedly chose the name Champion, deciding that "Champion" reflected "the best of everything." It was a fitting name for the clean living hero who championed a strict code of ethics known as the Cowboy Code. Champion first received billing in 1935's *Melody Trail*. As his partnership with Autry solidified, the gelding began to be billed as the Wonder Horse of the West. Trained by Tracy Layne, he could untie knots, roll over and play dead, bow, nod his head for yes and shake it for no, and come to Gene's whistle. Wearing his signature bridle featuring bit shanks in the shape of pistols, he carried Gene safely through many adventures. Sometimes he merely had to stroll along the prairie looking sharp while Gene sold a song from his saddle. That might sound like easy work, but it takes a special horse to mosey along carrying a singing cowboy while being photographed by a motion picture crew and its attendant paraphernalia. Sometimes such scenes were photographed on a soundstage with the horse on a treadmill and the scenery projected in the background. On other occasions, Gene and Champion are clearly riding through the sagebrush outdoors.

The original Champion starred with Autry in all his Mascot and Republic Studios pictures until the actor's screen hiatus during World War II. His last picture was *The Bells of Capistrano* (1942). It has been written that in 1943 Champion, approximately seventeen years old, died of an apparent heart attack on Gene's Melody Ranch, while his master was in the army. Johnny Agee, who was employed by Autry to train and care for his horses, reportedly buried Champion. An obituary notice in the January 26, 1947, edition of the *New York Times* tells a different story, reporting that the original Champion was retired in 1943 and died on January 25, 1947, at age seventeen.

Perhaps the former story was concocted to romanticize Gene's loss of his original horse, who may well have been retired due to lameness—a not uncommon side effect of toiling in Westerns. Even though he had multiple stunt doubles, Champion did do quite a bit of galloping over hard ground in his early movies, which over time damages the tissues and bones of a horse's legs.

CHAMPION JR. AND LITTLE CHAMP

Returning to films in 1946's *Sioux City Sue,* Autry rode a new horse, who would be billed as Champion in Autry's first three postwar films. In 1947's *Saddle Pals* and *Robin Hood of Texas,* the same horse is billed as Champion Jr., but when *The Last Round Up* was released later that same year, the "Jr." had been dropped and the mythical "Champion" returned.

Champion Jr., the second screen Champion, was a high-spirited sorrel stallion—who was eventually gelded—with a flaxen mane and tail and four high white stockings. He had a narrower blaze than his predecessor, and it ended in a snip on his nose. Remarkably, he also had a white patch on his belly. He was a show horse originally called Boots and owned by Charles Auten of Ada, Oklahoma. Having heard that Autry was looking for a new Champion, Auten supposedly hauled the four-year-old Boots to Fort Worth, Texas, when Autry was appearing at a rodeo there. The actor reportedly bought the horse for $2,500, even though he later claimed he had never paid more than $1,500 for a horse. The name Boots certainly seems an apt one for Champion Jr., as his flashy stockings extended well up to his knees.

Champion Jr. became known only as Champion, and his status was elevated from Wonder Horse of the West to World's Wonder Horse when Gene moved from Republic Pictures to Columbia Studios. More highly trained than the original Champion, he could dance as

well as perform an impressive array of tricks. He made some personal appearances with Gene and appeared with him at Madison Square Garden in 1946.

Starring as a wild stallion, Champion (Jr.) showed off his talent in a remake of the Ken Maynard vehicle *The Strawberry Roan* (1948), Autry's first color film. The film also marked the debut of Little Champ, a foal supposed to be Champion's son. Little Champ grew up to become a well-trained trick pony, featured in two more films, *Beyond the Purple Hills* (1950) and *The Old West* (1952). He also appeared at Gene Autry's Madison Square Garden rodeo in 1948 and traveled with the 1949 national tour of "The Gene Autry Show." A junior version of the Champions, he, too, was a blaze-faced sorrel with four stockings. There's no record of how long this little crowd pleaser lived, but based on the great care Autry took of all his horses, Little Champ doubtlessly had a good life.

As for Champion Jr., he and another Champion named Wag were put to sleep at Melody Ranch on December 29, 1969, "due to old age," according to a handwritten note found in Autry's personal archives.

The four high white stockings of Champion Jr. earned him the nickname Boots.

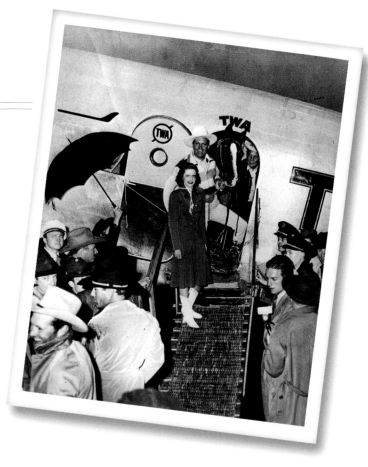

Autry made quite a few appearances with at least three more Champions. The touring Champions were also sorrel geldings with white blazes and four stockings, instead of three. All were highly trained trick horses.

One of these was known as the Lindy Champion because he was born in 1927 on the day of Charles Lindberg's first flight over the Atlantic. Originally from Nashville, Lindy was a registered Tennessee Walking Horse trained by Johnny Agee. He had also been used by Tom Mix in live appearances. Distinguished by an oval-topped blaze and a black dot on his nose (sometimes powdered or bleached), he made aviation history of his own when he became the first horse to take a transcontinental flight. In September 1940, he flew in a customized stall aboard a TWA plane from Burbank, California, to New York City for the opening of the Gene Autry Rodeo at Madison Square Garden. It is not known how long the Lindy Champion lived, but since he was born in 1927 and was still working at thirteen, he undoubtedly had a long life.

The horse most commonly known to insiders as the Touring Champion appeared with Gene in the late 1940s and the 1950s at rodeos and stage shows, including Madison Square Garden in 1947. He joined Autry on a publicity tour of England in 1953 and accompanied him into the Savoy Hotel. Widely photographed, this Champion is also the horse immortalized by his hoofprints next to Gene Autry's handprints at the Chinese Theater in Hollywood. He can be identified by his medium-wide blaze, which veers to the right side of his forehead. It's possible that the "Touring Champion" was the one called Wag who, like Boots, was euthanized in 1969. The final touring Champion, and Gene's last horse to be honored by the name, had a crooked blaze that feathered into his roan color on the left side of his face. Yet another sorrel with four white stockings, he was a stockier gelding than his predecessors. He never worked in films but accompanied Gene on personal appearances from the late 1950s until 1960. He also joined the star on the *Merv Griffin* and *Ed Sullivan* television shows. This final Champion, called Champion III by Autry insiders, died at Melody Ranch in 1990. He was forty-one.

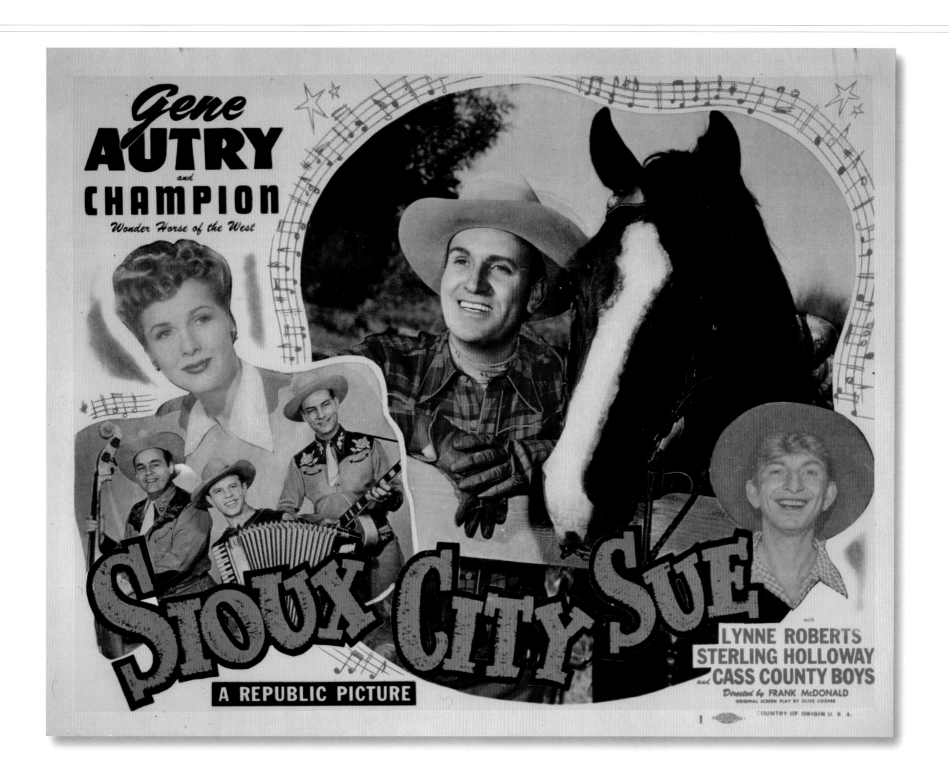

Gene Autry, of course, fulfilled his youthful dream of financial stability and implemented his business skills to build a media empire. Returning to his roots in broadcasting, Autry launched a solo career for his mythical horse with *The Adventures of Champion* radio serial. Lasting one season, from 1949 to 1950, the show aired on the Mutual Broadcasting system and featured celebrity guest stars.

Among the first entertainers to understand the power of television, Autry starred in his own production, *The Gene Autry Show*. Yet another Champion starred with Gene in ninety-one episodes from 1950 to 1955. Trained by Glenn Randall, this horse was a light sorrel gelding with a wide blaze extending over his nose and lower lip. A lack of pigmentation around his eyes was usually covered with make-up. In 1949, at the outset of the horse's career, as a publicity stunt, Autry took out a $25,000 insurance policy naming this Champion as beneficiary. The same Champion inspired a comic book series, *Gene Autry's Champion*. When *The Gene Autry Show* left the air, Champion remained on TV without Gene in a spin-off of the comic book series. Named after the radio program, *The Adventures of Champion*

aired on CBS from September 1955 to March 1956, for twenty-six episodes. This Champion had replaced Champion Jr. as Gene's movie horse in the 1950s, so he appeared in Gene's final films as well. Gene Autry passed away on October 2, 1998, just a few days after his ninety-first birthday. The great singing cowboy and his iconic horse Champion have been immortalized by a gorgeous life-size bronze sculpture aptly titled "Back in the Saddle," which graces the plaza of the Autry National Center in Griffith Park in Los Angeles. Autry's last Champion, Champion III, was the life model for the sculpture by De L'Esprie.

THE KING OF THE COWBOYS AND THE SMARTEST HORSE IN MOVIES

Gene Autry and Champion blazed the trail for their chief rivals, Roy Rogers and Trigger. The cowboy with twinkling eyes and his beautiful golden palomino stallion still hold a special place in the hearts of many movie fans. Some are lucky enough to have seen the spectacular duo in one of their many personal appearances, as Rogers, bedecked in rhinestone-fringed splendor, galloped into a stadium on his shimmering stallion. The dazzling sight was pure magic.

LEONARD SLYE AND THE SONS OF THE PIONEERS

Born Leonard Frank Slye in a Cincinnati tenement on November 5, 1911, Rogers overcame his humble beginnings to pursue his dream of a career in show business. Developing his natural musical talents, he eventually headed for Hollywood, where he formed the Pioneer Trio, which landed a KFWB radio spot in 1933. The Pioneer Trio evolved into the Sons of the Pioneers, one of the most successful cowboy groups in history.

The cowboy with twinkling eyes and his beautiful golden palomino stallion still hold a special place in the hearts of many movie fans. Some are lucky enough to have seen the spectacular duo in one of their many personal appearances, as Rogers, bedecked in rhinestone-fringed splendor, galloped into a stadium on his shimmering stallion. The dazzling sight was pure magic.

The Sons of the Pioneers appeared in several films, including Gene Autry's *Tumbling Tumbleweeds*. But Leonard Slye had his sights set on solo stardom. In 1937, Republic Pictures was holding auditions for singing cowboys. Without an appointment, Slye pulled on his white Stetson and sallied past the Republic gate guard with a group of studio employees. A fan of the Sons of the Pioneers, producer Sol Siegel invited the singer to audition, and on October 13, 1937, Slye signed a seven-year contract with Republic at $75 a week. His name was promptly changed to Dick Weston.

Dick Weston languished in bit parts until Autry went on strike in 1938 just before the start of his new picture, *Under Western Stars*. Slye/Weston was tapped to replace the star. After the producers decided he needed a catchier name, Slye picked the surname Rogers in tribute to his hero, Will Rogers—ironically the man who had kick-started Autry's career. Even though the actor didn't particularly like the name, Roy was chosen because of its pleasing alliteration with Rogers.

QUICK ON THE TRIGGER

Roy Rogers shrewdly figured that if he partnered with a unique horse, he would be harder to replace should he fall out of favor with Republic. He tried out several horses owned by the Hudkins Brothers Stable and struck gold with Golden Cloud, a registered palomino, half-Thoroughbred stallion with a wide blaze and one left hind sock. His golden color was highlighted by an exceptionally long snowy mane and forelock. The Hudkins Brothers had acquired the horse from the ranch of Ray "Crash" Corrigan, another cowboy star. Golden Cloud's sire was a Mexican racehorse, and his dam was what Rogers called a "cold-blooded" palomino, most likely a Quarter Horse mix. At only three years old, he had already debuted as

Olivia de Havilland's mount in *The Adventures of Robin Hood* (1938). The stallion's matinee idol's looks and his amazingly tractable temperament marked him for stardom.

Roy Rogers once said, "I got on [the horse that was to become] Trigger and rode him down the street and back. I never looked at the rest of them. I said, 'This is it. This is the color I want. He feels like the horse I want, and he's got a good rein on him.' So I took Trigger and started my first picture."

According to Cheryl Rogers-Barnett, Roy's eldest daughter, "Dad always told me there was a genuine connection between the two of them, right from the first time he sat in the saddle. Dad had a gift for handling most animals, but he said there was some sort of instant communication between him and Trigger. In Dad's case, it was love at first sight."

Golden Cloud became Trigger when Rogers and his comic costar, Smiley Burnette, were brainstorming to find a more fitting name for a cowboy's horse. "The name came up when we were getting ready to do the first picture," Roy once explained. "I believe it was actually Smiley who said, 'As fast and as quick as the horse is, you ought to call him Trigger. You know, quick-on-the-trigger.' I said, 'That's a good name.' And I just named him Trigger." The naming scene is recreated in *My Pal Trigger* (1946), which depicts the fictionalized birth of the stallion.

Costarring with Rogers in *Under the Western Stars* (1938), Trigger, who had just turned four, was indelibly linked to the actor's success. Realizing Trigger's long-term value, Rogers arranged in 1938 to purchase the palomino from the Hudkins brothers for $2,500. It was a huge sum for Rogers on his meager salary, but Ace Hudkins agreed to let him make payments. It took several years before Roy owned Trigger completely, but he never doubted his investment.

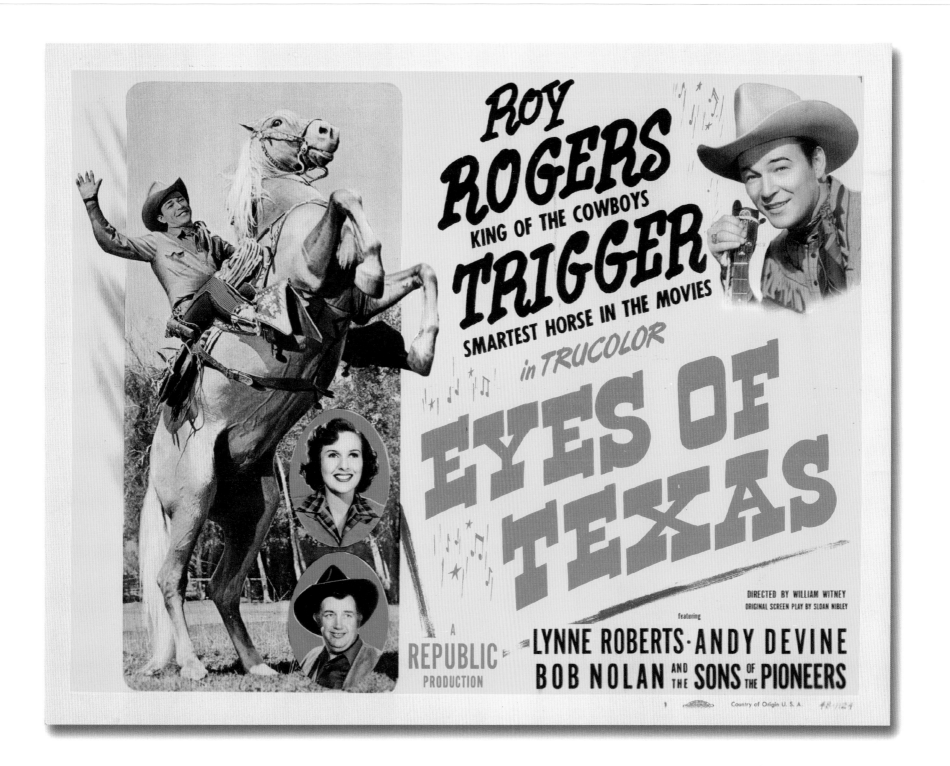

Trigger and Roy inspired scores of toys, such as this one. Opposite page left, Little Trigger and Glenn Randall play jump rope with Roy. Opposite page right, Trainer Corky Randall and Trigger Jr.—as Golden Zephyr—demonstrate the elegant Spanish walk at a horse show.

Rogers put Trigger in training with Glenn Randall, who schooled him at liberty and taught him some basic tricks, including how to rear. The stallion had tremendous strength and could hold a spectacular rear far longer than most horses. He also had great stamina and carried Roy through many chase scenes. In one movie, Roy and Trigger jumped a series of 50-gallon drums that rolled off the back of a truck they were chasing. Although unrehearsed, Trigger negotiated the jumps in one take. Billed as the Smartest Horse in Movies, he was easily the handsomest. Whether galloping pell-mell with his beautiful long mane flying in the wind or just standing by waiting for action, he was always a magnificent sight.

Billed as the King of the Cowboys, Rogers was an excellent horseman. He did running mounts and dismounts on Trigger, who took it all in stride. Like most star horses, Trigger had doubles for dangerous stunts and rough-riding long shots.

Contrary to rumors that Roy owned many Trigger doubles, these horses were rentals from Hudkins or Glenn Randall. The good care Trigger received and his overall hardiness meant a horse that was never lame.

Roy never gelded Trigger for fear of dulling his famous spark; yet never bred him either. According to Roy's son Dusty Rogers, "Dad was afraid to breed because he was worried that Trigger might decide he liked breeding better than making movies."

Like his famous predecessors, Fritz, Tony, and Champion, Trigger inspired movies that revolved around him. One of the most beloved was *The Golden Stallion* (1949). Trigger costarred with Roy Rogers in eighty-two movies between 1938 and 1953. Together they made the transition from film to television in December 1951 with the debut of *The Roy Rogers Show*. Trigger costarred in all one hundred episodes.

Rogers made the most of their fame. Roy Rogers's and Trigger's names and likenesses appeared on sixty-five products marketed in 1949. *Roy Rogers' Trigger*, a Dell comic book series based on the palomino's escapades, sold millions of copies.

Trigger worked well into his twenties and was eventually retired in 1957 at the Rogers' ranch. After he died on July 3, 1964, at the age of thirty-three, Roy had him mounted so the public could view Trigger at the Roy Rogers–Dale Evans Museum.

LITTLE TRIGGER AND TRIGGER JR.

A couple of years after he acquired Trigger, Roy purchased another blaze-faced palomino stallion, known by insiders as Little Trigger (aka the Little Horse). A Morgan, this horse was smaller than Trigger (who then became known to the Rogers and Randall families as Old Trigger) and lighter in color. He had four white stockings. Seen on his own, however, Little Trigger looked enough like Old Trigger, with his handsome body and long flowing white locks, that he could pass for the original. He

was presented to the public as simply Trigger. Just as Gene Autry always had one "Champion," Roy Rogers perpetuated the myth of one Trigger and never mentioned Little Trigger in an interview.

Little Trigger was, according to both Rogers and Glenn Randall, truly the smartest horse in movies—or anywhere else for that matter. Highly intelligent, he learned quickly and retained more than a hundred cues for tricks and dances. Most astonishing of all, he was housebroken, a quality that allowed him to accompany Roy on his many appearances in hospitals to visit sick children and into fancy hotels without worrying about an embarrassing mishap. He is the only celebrity horse of record who could accomplish this feat.

Little Trigger was also notoriously ornery and quick to show his displeasure by biting. According to Cheryl Rogers-Burnett, he didn't like kids or women, which is ironic consider-ing they composed much of his fan base. He did love the spotlight, however, and he knew that as long as he was performing in front of a crowd, Roy wouldn't discipline him. On one occasion, Little Trigger ruined a dramatic routine during which he and Roy played dead. The stallion tried to sneak out of the stadium as the houselights were dimmed, leaving Roy lying alone in the middle of the arena. The actor grabbed for Little Trigger's reins and found his saddle horn. When the houselights came on, Little Trigger was gleefully galloping around the arena with Roy hanging off the saddle. Furious, the actor intended to reprimand Little Trigger backstage and backed him into a corner. However, when Roy approached the horse, the wily stallion started desperately going through his tricks, finally sitting down and bowing his head in prayer. Instead of punishing Little Trigger, Roy cracked up laughing, along with the cowboys who had witnessed the amazing display.

Little Trigger doubled Trigger in dancing sequences in *Don't Fence Me In* (1945). He also masqueraded as Trigger in the 1952 musical comedy *Son of Paleface*, starring Rogers, Bob Hope, and Jane Russell. He danced and performed many tricks, including untying ropes, running up a staircase, and sharing a bed with Hope, fighting over the covers. "Trigger" stole the show and won a PATSY, the American Humane Association's version of the Academy Award, for his work.

Rogers and Little Trigger toured the country regularly, but their most famous appearance—and most notorious publicity stunt—took place in New York City during a 1944 Madison Square Garden engagement. Roy led the stallion into the lobby of the Hotel Astor and offered him a pencil. Holding the pencil in his teeth, Little Trigger marked *X* on the guest register. Later, he attended a cocktail party honoring him in the hotel's Grand Ballroom.

According to trainer Buford "Corky" Randall, son of Glenn Randall, Little Trigger lived well into his twenties and was humanely put down due to complications of old age. Rogers purchased a third palomino to understudy Little Trigger. Named Trigger Jr., he took over as Roy's personal appearance horse when Little Trigger was retired in the early 1950s. A flashy dark palomino with a blaze and four white stockings, Trigger Jr. was also trained by Glenn Randall. The new horse specialized in crowd-pleasing dance routines. Corky Randall showed Trigger Jr., a Tennessee walking horse, under his registered name of Golden Zephyr. Trigger Jr. appeared in a namesake film, *Trigger Jr.* (1950), alongside Trigger, who was six years his senior. Trigger Jr. was nine years old when Rogers purchased him. He died at twenty-eight and was also mounted and put on display at the Roy Rogers Museum.

The Queen of the West and Buttermilk

In 1944, Rogers made his first picture with a dynamic singer and dancer named Dale Evans. *The Cowboy and the Senorita* proved to be a hit, and Roy and Dale went on to make twenty-eight more features and one hundred television shows together. Along the way, they fell in love. Roy proposed to Dale as they were about to ride into Madison Square Garden for a public appearance by asking, "What are you doing New Year's Eve?" They married on December 31, 1947. The wife of the King of the Cowboys became known as the Queen of the West.

In her early Rogers films, such as 1945's *Bells of San Angelo*, Dale rides a pinto. Roy decided the Paint was too flashy, and Glenn Randall found a gentle palomino gelding called Pal for Dale. Roy worried, though, that the horse's color would draw attention away from Trigger. The quest began for a horse of just the right color.

Glenn Randall spotted an athletic little buckskin Quarter Horse named Soda on a Wyoming ranch. Soda had an extremely shaggy winter coat, but Randall could see his potential through the hair. He purchased the buckskin and hauled him back to California. When Soda shed his winter coat, his pretty conformation was revealed. Randall brought him to the location of one of Roy and Dale's movies and tied him next to Trigger. The two looked great together, with the buckskin's black mane and tail contrasting nicely with Trigger's opposite markings. Roy approved, and Dale gave Soda a try. Quick and athletic, he was challenging to ride, but the Queen of the West was up to the task. She purchased Soda from Glenn Randall, who retrained him for the movies.

Soda needed a more theatrical name. On location in Lone Pine, California, the site of hundreds of

Westerns, Dale and wrangler Buddy Sherwood were admiring the sunset. Sherwood remarked that the mottled milky clouds looked like "clabber." Dale reportedly replied, "You mean buttermilk?" Thus she was inspired to rename the buckskin Buttermilk Sky.

Buttermilk Sky became known simply as Buttermilk, and Dale rode him in the remainder of Roy's films and the television series. He was not only smart and fast but also exceptionally quick off the mark. As soon as he heard "Action!" Buttermilk would spring forward, and Dale had to rein him back to let Trigger get ahead in films.

Left, trainer Glenn Randall in a rare portrait aboard Soda before he became Buttermilk Sky. Opposite page, the Queen of the West, Dale Evans, and Buttermilk Sky display the charm that made them a perfect complement to Roy and Trigger.

Buttermilk had a long, successful career supporting the superstar Trigger. Buttermilk also stands mounted at the Roy Rogers–Dale Evans Museum, alongside Trigger, Trigger Jr., and Roy and Dale's German Shepherd, Bullet. Originally in Apple Valley, California, the museum is now in Branson, Missouri.

THE SECOND STRING

The immense success of Gene Autry and Champion and of Roy Rogers and Trigger pushed many more singers into the saddle. Some of these "singing cowboys" were good horsemen but couldn't sing—like John Wayne, whose voice was dubbed in his brief career as Singin' Sandy Sanders. Others were decent crooners, but their cowboy personas were strictly Hollywood fantasy.

Popular star Eddie Dean could sing all right but he did not have a particular equine partner. Even though his various mounts were virtual unknowns, the studio still gave them cobilling: the mere fact that they were *horses* helped sell Dean's films.

Broadway star Tex Ritter was tapped for the movies by Grand National pictures in 1936 and quickly brushed up his horsemanship for his new career as a singing cowboy. Following the formula, Ritter was paired with White Flash, a studio invention played by different rental horses. It wasn't until 1941 that Ritter purchased a permanent White Flash. Like his role models, the white horse with brown eyes went into training with Glenn Randall. Consequently, scenes were written for White Flash that enabled him to show off his tricks.

Crooner Monte Hale made a number of films for Republic during the 1940s. His equine partner was, appropriately, named Pardner. Despite an appealing singing voice and an affable persona as a gentleman cowboy, Hale never hit the big time. He maintained a sense of

humor, however, and well into his eighties in 2005 when he received a star on Hollywood Boulevard's Walk of Fame, was still passing out stickers commemorating the most ridiculous line of dialogue he ever had to utter, "Shoot low! They may be crawlin'."

HERB JEFFRIES AND STARDUSK

One of the most unusual singing cowboys was jazz musician Herb Jeffries. Born in 1911 in Detroit, Jeffries inherited his light brown skin from his father's Ethiopian ancestors. He learned to horseback ride on his grandfather's farm and enjoyed watching Tom Mix and Buck Jones Westerns.

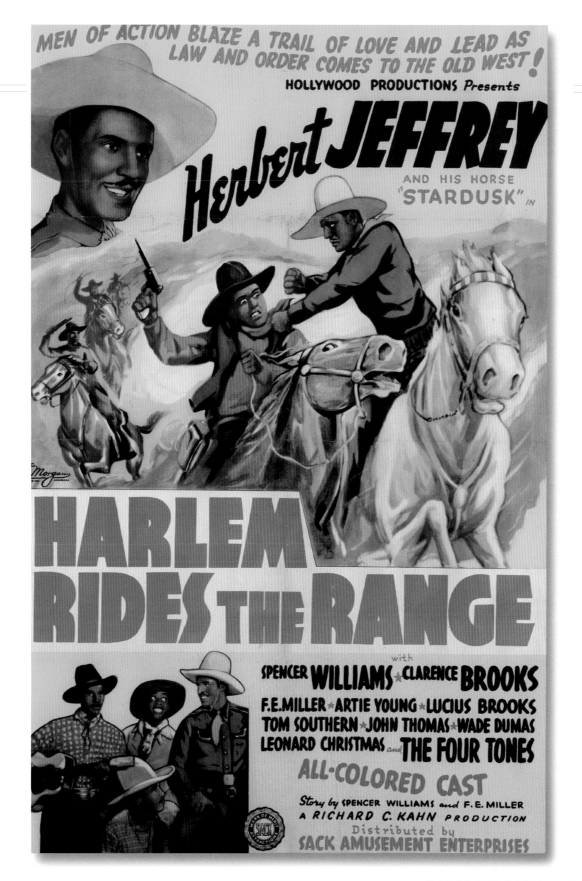

Jeffries began singing professionally as a teenager and toured with some of biggest names in jazz. While traveling through the South in 1934, Jeffries noticed that blacks-only movie theaters played all-white Westerns. Unfortunately, the trend started by the Norman Company and rodeo star Bill Pickett in the 1920s had not resulted in more Westerns about African-American cowboys.

One afternoon, in an alley behind a jazz club, Jeffries spotted some children playing cowboys and Indians. He noticed a little boy crying because his friends wouldn't let him play. The child told Jeffries that he wanted to be Tom Mix, but his friends wouldn't let him "because Tom Mix isn't black." Deeply touched, Jeffries determined that black children ought to have a cowboy hero who looked like them. He approached independent producer Judd Buell with an idea for a musical Western with a black hero. Buell agreed to finance such a film.

The challenge was finding a black actor who could sing and ride a horse. Jeffries wound up with the lead role by default. Because his skin was light brown, he applied dark makeup so black audiences would better relate to him. With the release of *Harlem on the Prairie* (1936), Jeffries—billed as Herbert Jeffrey—became the first black singing cowboy hero in a feature film. Of course, the hero had a four-legged friend. Jeffries chose a white horse named Stardusk. A hit with the kids, this pair made movie history.

Part Arabian, Stardusk had been bred on a ranch in Santa Ynez, California. When preparing for their first film together, Jeffries and Stardusk spent two weeks getting acquainted. By that time, Jeffries said, "We were pretty much in love with each other."

After shooting wrapped on *Harlem on the Prairie*, Stardusk was returned to his owners in Santa Ynez.

Jeffries, who was living in a Los Angeles boarding house, would visit regularly. As soon Jeffries arrived at the ranch, Stardusk would start whinnying for him. When producer Richard C. Kahn approached Jeffries with a deal for three more movies, the star made the purchase of Stardusk a condition of his contract. Together they made *The Bronze Buckaroo* in 1938 and two films in 1939, *Harlem Rides the Range* and *Two Gun Man From Harlem*. Jeffries later moved to France and gave Stardusk back to his original owners, and the former thespian equine enjoyed the rest of his life in Santa Ynez.

REX ALLEN AND KOKO

An Arizona rancher's son named Rex Allen would be the last of the singing cowboys. Like Autry and Rogers, the handsome blond Allen was signed by Republic Pictures after a career in radio. And like his predecessors, Allen knew he needed an extraordinary horse. Glenn Randall, meanwhile, had recently acquired KoKo, a stunning dark sorrel stallion with a flaxen mane and tail, from a female trick rider in Missouri. A Quarter/Morgan cross, KoKo had originally been purchased for Dale Evans but had proved too much horse for her.

The minute he laid eyes on KoKo, Allen fell in love with him. An accomplished rider, Allen found that the horse just needed a firm hand and some fine-tuning to get him ready for the movies. He bought KoKo from Glenn Randall in 1950 for $2,500. Randall continued to work with KoKo and Rex Allen during their short but successful career.

Allen's first film, *The Arizona Cowboy* (1950), featured KoKo in an uncredited role, but in their next film, *Hills of Oklahoma* (1950), KoKo received billing. Dubbed the Miracle Horse of the Movies, he costarred with Allen in nineteen films for Republic, including *Silver City*

Bonanza (1951), *Rodeo King and the Senorita* (1951), and their swan song, *The Phantom Stallion* (1954).

His unusual coloring destined KoKo to do nearly all of his own stunts. Although doubles were used for galloping long shots, they required considerable work to look anything like the stallion, even from far away. White horses were dyed a rich chocolate with vegetable coloring, with only a blaze, mane, tail, and stockings left white. Consequently, KoKo was worked hard, according to Allen, who once lamented, "I just had to run KoKo to death on nearly every film because we just couldn't double him that close."

KoKo only worked in movies for five years, from 1950 through 1954, during and after which time he also went on personal appearances with Allen. KoKo was retired in 1963 after foundering (the result of getting into a grain bin and gorging himself) and lived out the rest of his life at the Diamond X Ranch, Allen's California spread. He died in 1968 at age twenty-eight. His remains are buried at the Cochise Visitor Center and Museum of the Southeast, in Wilcox, Arizona. His grave is marked with a plaque that reads: "KoKo, Rex Allen's stallion costar in 30 motion pictures. Traveled over half million miles with Rex in U.S. and Canada. Billed as 'The Most Beautiful Horse in the World.' At rest here, 'Belly High' in the green grass of Horse Heaven."

SPOTLIGHT ON SIDEKICKS

It gets lonely on the celluloid range, and a cowboy has only so many songs for his horse. He needs a human companion to help move the plot along, too, and in Westerns the bill was often filled by a sidekick. Offering comic relief, a helping hand, and a ready ear, the sidekick became a horse opera staple. Two standout sidekicks,

Rex Allen, the last of the singing cowboys, and KoKo

Smiley Burnette and Slim Pickens, rode alongside three of the most famous singing cowboys, on their colorful mounts Ring-Eyed Nellie and Dear John.

SMILEY BURNETTE AND RING-EYED NELLIE

Lester "Smiley" Burnette had the distinction of working as a comic sidekick of Gene Autry and Roy Rogers. A musical prodigy, the twenty-two-year-old Burnette started his career with Autry as an accordion player on Gene Autry's WLS radio show in 1933. Smiley accompanied Autry to Hollywood and appeared in his first feature film, *In Old Santa Fe*. Honing his screen persona as "Frog Millhouse," the gangly, pudgy, sweet-faced Smiley used his voice's deep bass register to add comic punctuation to musical numbers. He appeared in fifty-four prewar Westerns with Autry, wearing a checkered shirt and trademark black Stetson with a pinned up brim. He rode a white horse with a black ring drawn around its left eye—so Smiley would remember to mount from the left. First known as Black-Eyed Nellie, the horse later became know as Ring-Eyed Nellie and finally just Ring Eye. The horses were studio rentals, but according to Smiley's son, Stephen Burnette, his dad did have a favorite, one who would allow Smiley to lounge on his back reading the newspaper between takes.

When Gene Autry went into the service, Republic Pictures recruited Smiley and Ring Eye for several Roy Rogers films, beginning with *Hearts of the Golden West* (1942). When Gene returned to Hollywood, Smiley and Ring Eye resumed their partnership with Autry in 1951's *Whirlwind* for Columbia Pictures. They worked in six more Columbia films during the 1950s. The name of Frog Millhouse belonged to Republic, however, so Smiley became Smiley once more. Ring Eye didn't have to change his (or her) name.

Smiley Burnette had his own sidekick, played by Joseph Strauch Jr., who appeared with Burnette in five Autry films, beginning with *Under Fiesta Stars* (1941). Dressed in the same clownish outfit as Burnette, Strauch got laughs portraying Frog Millhouse's younger brother, Tadpole. He was mounted on a Little Ring Eye, a white pony with a black circle painted around its eye.

SLIM PICKENS AND DEAR JOHN

Rex Allen's sidekick was Slim Pickens, a former rodeo clown known for his goofy charm and rubber-faced reactions. Born in Kingsburg, California, in 1919, Louis Bert Lindley Jr. acquired his nickname as a fifteen-year-old rodeo contestant. He was told his chances for winning were going to be "slim pickin's." As Slim Pickens, however, Lindley went on to reap many riches, along with a blue roan Appaloosa named Dear John.

Slim first spotted Dear John in 1954, in a Montana pasture. Although the young gelding had bucked off everyone who had tried to ride him, Slim saw something special in the Appaloosa. He purchased John for $150 and took him to California to work in Rex Allen movies. Their first picture went smoothly, but on the second one, Dear John tested his new master, coming unglued. "After that," Slim said in a 1973 interview, "it took more'n six months of us punishin' each other before we came to an understandin'. After that there wasn't anything that horse wouldn't do that was in reason."

Slim worked with Glenn Randall to teach John a variety of tricks, including bucking on cue. Look closely at most bucking horses in a movie or at a rodeo, and you can see a "bucking strap" circling their bellies well behind the saddle. This piece of leather is so annoying to a horse that it drives him into a mad fit of bucking. Dear John was unusual in that he did not need a strap

You can almost hear Slim Pickens whoop for joy as Dear John puts some sky between them and the wagon in this publicity shot.

and was trained to buck with a combined rein and leg cue. Using this shtick to great comic effect, Slim would go galloping and bucking after Rex Allen and KoKo, bellowing, "Whoa John!"

Dear John was also taught to sit on his haunches like a dog, a trick he would perform on his own, long after he was retired to pasture. A powerful jumper, John could clear teams of horses, wagons, and huge stone walls that scared Slim to confront. But he knew that if John went at an obstacle, he could clear it. If the horse refused, it was because he knew he couldn't make it, and Slim trusted Dear John's decision. The two developed more than an understanding; they had an uncanny rapport and seemed to communicate telepathically.

By the end of his stint in Rex Allen films, Dear John had become so famous in Hollywood that Slim began getting calls for the horse. The actor refused to let anyone else ride John and insisted on being hired to handle him as well.

Slim retired Dear John to a pasture owned by veterinarian Joe Hird, in Bishop, California, in 1964. He visited the horse frequently but had difficulty catching him as John was afraid he would have to go back to work. One day, however, when Slim and Rex Allen went to see Dear John, Slim was able to hop on his old pal bareback and cued him to buck. John sent him flying, but Slim landed happy. Instead of running away as was his custom, Dear John rested his head on Slim's shoulder affectionately. Several years later, Slim awoke in the middle of the night knowing his horse had gone. According to his wife, Maggie, he sat bolt upright in bed and said, "John's dead." A few days later, he got the confirmation call from Joe Hird, who had been unable to break the news at first. Dear John had passed away the night Slim received his last message. He was thirty years old.

Above, brave buckeroo
Slim hangs on as Dear John does what he does best. Opposite page, Autry and the original Champion with their sidekicks, Smiley Burnette and Ring Eye and *their* sidekicks, Joseph Strauch Jr. and Little Ring Eye, as they appeared in *Under Fiesta Stars.*

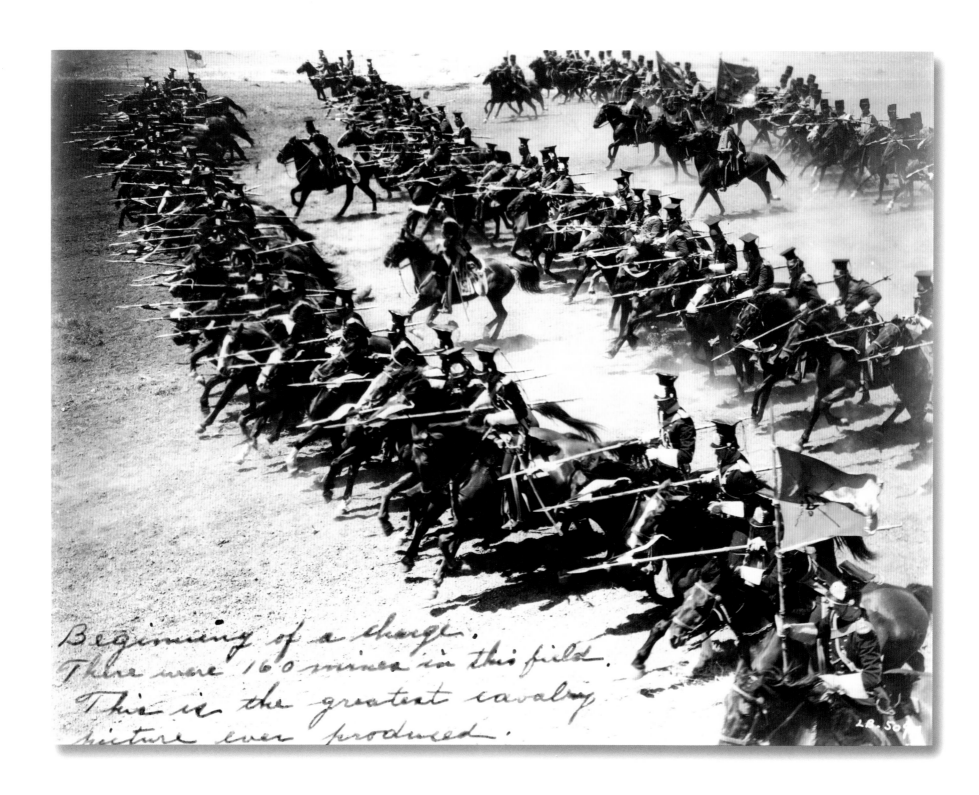

Beginning of a charge.
There were 1600 mines in this field.
This is the greatest cavalry
picture ever produced.

LB-50

UNSUNG HORSE HEROES AND HUMANE ADVANCES

"If a dancer was forced to dance by whip and spikes, he would be no more beautiful than a horse trained under similar conditions."

—Xenophon, 400 B.C.

Unaware of the perils ahead, hundreds of horses eagerly gallop in formation for the infamous "charge of the 600" in *The Charge of the Light Brigade* (1936).

STAR PERFORMERS SUCH AS Tony, Trigger, and Champion were rightfully treated like gold. While every precaution was taken to ensure the well-being of these valuable horses, their lesser-known peers were often forced to perform dangerous stunts that could leave them dazed, injured, or dead. These willing, unsuspecting, unsung heroes gave their all in the name of exciting action. Social attitudes towards animals were quite different decades ago, and filmmakers' ethics—and economics— did not always accommodate humane treatment. Audiences were bliss-fully unaware of the sorry state of affairs until Errol Flynn, one of the most popular stars of the 1930s and 1940s, spoke out against cruelty to horses. Soon others rallied to the cause of protecting performing animals.

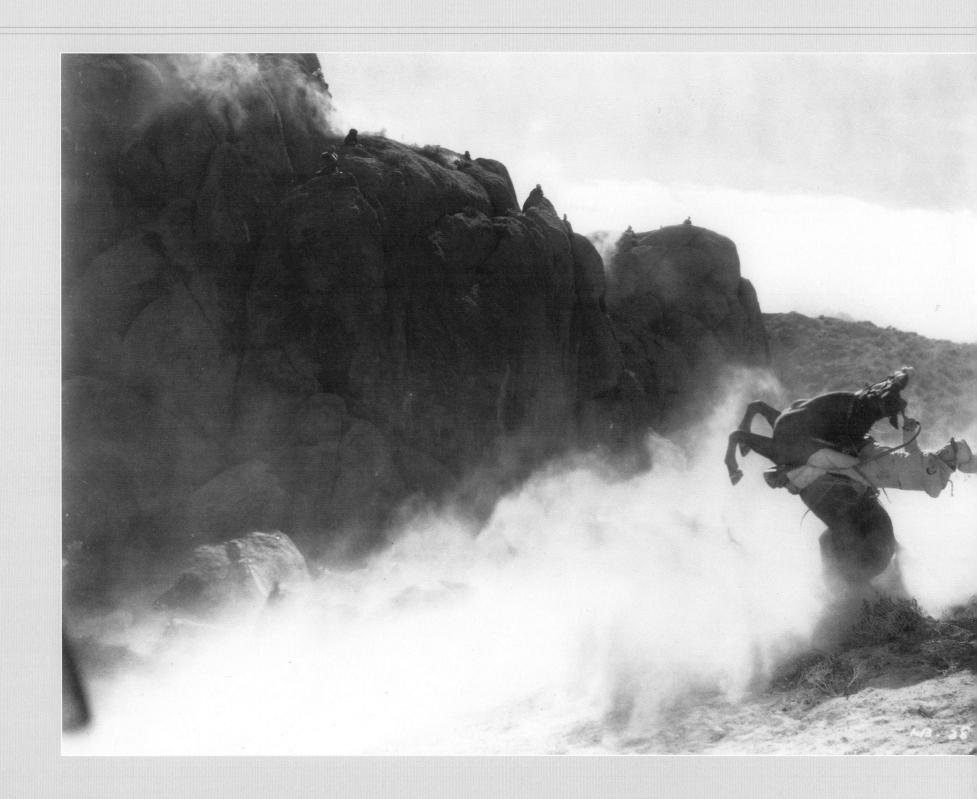

Today the American Humane Association's Film and Television Unit works hard to monitor all animal action, but it wasn't always so. A nonprofit organization founded in 1877 to protect the welfare of children and animals, the American Humane Association first became involved with Hollywood in 1940 after a series of publicized equine fatalities. The association outlawed inhumane practices and encouraged filmmakers to use trained stunt horses. It even celebrated such performers with their own awards. In the mid-1960s, a power shift in the film industry undermined American Humane's authority, and the result was more injuries and fatalities to horses. After almost two decades of frustration, American Humane established a new alliance with Hollywood in the 1980s. In 1988, American Humane published its *Guidelines for Safe Use of Animals in Filmed Media* for the protection of all animal actors, still considered the industry standard. Today, computer effects and advanced editing techniques offer further protection to performing animals, but the need for vigilance remains.

HARROWING TIMES FOR OUR HEROES

Over the decades, countless battle and chase sequences have depicted horse after horse biting the dust. With rare exceptions, most early equine actors were tricked into the stunts. Pits were dug and disguised so that galloping horses would simply tumble into them. The controversial Running W created spectacular somersault falls. Wires attached to a horse's forelegs were threaded through a ring on the cinch and secured to buried dead weights. When the horse ran to the end of the wires, his forelegs were yanked out from under him.

Master stuntman Yakima Canutt was determined to make a safer Running W. Canutt engineered a new Running W so the wires, threaded through his invention, the "W Ring," which attached to a special cinch, would break before the horse hit the ground. Not only did this innovation reduce the force of the pull by half, but it also freed the horse quickly. On location of the

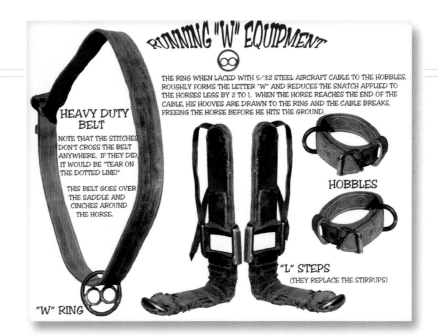

1940 film *Virginia City*, directed by Michael Curtiz, in which Canutt doubled Errol Flynn, he staged a demonstration of his improved Running W for the two officers of the American Humane Association assigned to monitor the picture's action. After preparing the ground so it would be soft for the landing and making sure any rocks in the shot were rubber props, Canutt safely performed the stunt, and filming proceeded without incident. In his autobiography, the late Mr. Canutt proudly claimed, "I have done some three hundred Running Ws and never crippled a horse." He admitted, however, that once a horse got wise to the stunt, he soured on performing. Doubling his friend John Wayne in *Dark Command* (1940), Canutt attempted a Running W with an experienced horse. When the horse got within several feet of the prepared falling site, he stopped and lay down.

Not all early filmmakers had the knowledge or desire to protect horses from the hazards of the original Running W, however. In fact, director Michael Curtiz was oblivious to the dangers in staging the action in an earlier Errol Flynn movie, *The Charge of the Light Brigade* (1936). The second unit director, B. Reeves "Breezy" Eason, was largely responsible for the infamous charge sequence, for which adequate safety precautions were simply not taken. Though at least one trained falling horse,

Above, Yakima
Canutt's designed Running W equipment was more humane and safer than the original equipment used by filmmakers to create spectacular falls among movie horses. Opposite page, stuntman George Williams's Goldie, however, was trained to take this fall in *The Charge of the Light Brigade*.

Goldie, ridden by his stuntman owner, George Williams, worked in the sequence, there were just not enough trained horses available. Some 125 horses were rigged with old-style Running Ws for the climactic scene. One of the stunt riders was Jack Montgomery, who first got a taste of trip-wired falls working for Broncho Billy Anderson. Sickened by the resultant carnage of the charge, Montgomery estimated that twenty-five horses were either killed in action or destroyed after filming because of broken legs. Scores more horses and riders received serious injuries. Errol Flynn was furious and went public with his outrage. It took a star of Flynn's magnitude to focus producers' attention on the treatment of performing animals, but it would still be several years before the public joined his cry and Running Ws were banned.

Another potentially fatal device was the tilt chute. A curtain often disguised the entrance to the chute, or a horse was blindfolded or blinkered to coerce him to enter. The floor of the chute was a greased and slanted metal ramp that sent the horse flying, usually off a cliff into water. A version of the tilt chute, more like a teeter-totter, produced the same result. Occasionally, the outcome was a broken neck, but a quick cut to the hero swimming out of the river on a fresh horse with similar markings left the audience none the wiser.

Different from traditional blinkers, movie blinkers featured patches of padded leather with eyes painted on them. They were hinged in the middle, held together by a small pin, and attached to the bridle. A piece of filament ran from the pin to the reins and was tied high up on the horse's neck. The blinkers were used to keep a horse from shying during a variety of stunts, such as when a cowboy jumped from a height onto the back of the horse. When the stuntman hit the saddle and grabbed the reins, the pin would release the blinkers so the horse could see. Blinkers were also used in dangerous dives to keep a horse literally in the dark until it was too late for him to turn back.

In the 1939 Tyrone Power film *Jesse James*, two horses, ridden by stuntman Cliff Lyons, were killed in spectacular 75-foot jumps into treacherous white water. It has often been reported that the horses were forced into chutes to make them jump, but the late Cliff Lyons told his colleague Tap Canutt, the stuntman son of Yakima Canutt, that the horses were simply blinkered and ridden over the cliff. The result is a few shocking seconds of film, clearly depicting a hideously contorted horse tumbling through the air. Mr. Lyons was paid a then record $2,350 fee for the jumps. The horses paid with their lives.

A particularly brutal Running W stunt in Cecil B. DeMille's *Northwest Mounted Police* claimed two more horses the same year. This time the public became aware of the fatalities in both films and protested loudly.

AMERICAN HUMANE TO THE RESCUE

As a result of the public outcry, the American Humane Association's head, Richard C. Craven, worked with the Motion Picture Producer's Association's Hays Office (created in 1927 to establish moral codes for the film industry) to set guidelines for protecting performing animals. In 1940, the first American Humane monitors, now called certified safety representatives, stepped onto a film set. This period of safety continued until 1966, when more permissive social mores led to the abolishment of the Hays Office. Unfortunately, while the move resulted in greater freedom for filmmakers, it placed the protection of performing animals in jeopardy. Although American Humane continued to push for humane treatment of animal actors, industry compliance was voluntary and inconsistent. As filming trends demanded more realism, action often became more dangerous. The years between 1966 and 1980 were sometimes harrowing for animal actors, especially horses, the ones most often placed at risk.

Director Sam Peckinpah's 1969 Western *The Wild Bunch* contains a scene that would be filmed quite differently in today's

NOBODY'S GOING TO PULL A STUNT LIKE THIS AGAIN.

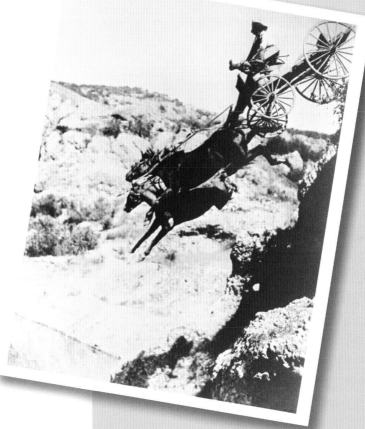

This clip is from the 1939 Western, "Jesse James."

The cliff was 70 feet high. The rider was a professional stunt man who knew what he was doing. And the horse? It was a poor beast that didn't have a clue.

You see, it was blindfolded, then forced to run full gallop into a tripwire stretched across the top of the cliff.

The tripwire, as it was intended, flipped the horse over the edge upside down.

It made for a very dramatic scene. Riveting, in fact. The stuff of which box office smashes are made of.

Unfortunately, it also made for a very dead animal, the horse having smashed its back in the rapids below.

Yes, the stunt man gets wet, the horse gets killed—sacrificed so cinematic realism could be preserved. (Are you gagging on your popcorn yet?)

Well, if we have anything to say about it, nobody's going to pull a stunt like this again.

And who are we? We're the American Humane Association, a national organization committed to protecting children and animals.

And one of the many, many things we do is protect animals in the entertainment industry.

In fact, our Los Angeles Regional Office, established as a result of this horrific stunt, has sole responsibility for monitoring the safety and protection of animals in film.

It reviews all scripts in which animals are involved, looking for potential problems of abuse.

It supervises as many animal stunts as it possibly can.

It is, bluntly put, oftentimes the only thing that keeps animals from literally dying to be in the movies.

For more information on how you can help us make sure nobody pulls more stunts like this, or to make a contribution, call 1-800-227-4645.

Or write: The American Humane Association, 63 Inverness Drive East, Englewood, CO 80112-5117.

1877 AHA established the first national organization to protect animals.
1885 AHA also dedicated its effort to child welfare.
1914 Originated "Be Kind To Animals Week."
1916 Emergency Animal Relief Fund established, the only one of its kind.
1939 The first to protect animals in the entertainment industry.
1982 First with National Horse Abuse Investigators Training School.
1990 First with National Cruelty Investigations School.

AMERICAN ✝ HUMANE ASSOCIATION

age of computer effects: a group of five stuntmen on horseback are standing on a wooden bridge spanning a river when the bridge explodes, sending the whole kit and caboodle into the drink. Fortunately, there were some expert stuntmen on the show. Tap Canutt and his brother Joe, along with Bill Hart, Bill Shannon, and Jimmy Shepard, worked in the risky scene. They prepped the horses to get them used to explosives and made sure that safety precautions were taken—including convincing the director not to use a second charge of dynamite in the water. Tap Canutt put it to Peckinpah this way: "Sam, if that dynamite goes off one second late we'll all be under water, which will kill five stuntmen and five horses. Now, that probably won't bother you near as much as your shot being completely hidden by a wall of water." Apparently that got the director's attention, and the underwater dynamite was removed.

The horses in the stunt were Mexican animals, acquired on location. The cowboy stuntmen preferred to use local horses because they were accustomed to the terrain and knew how to avoid the plentiful piercing cholla cactus. In addition to conditioning the horses to loud noises, extra precautions were taken before the bridge stunt. Rubber foam pads were used instead of saddle blankets, which would have become waterlogged. Open "L step" stirrups replaced regular ones to prevent the men from getting their feet caught under water.

The stuntmen were mounted and in position a good half-hour before the explosives detonated. According to Tap Canutt, "Waiting is the worst part of any stunt involving livestock, for when a man gets even a little nervous, the animal senses it and may rear and start jumping around." However, the horse Tap was astride actually fell asleep. "Once in position on the bridge," he recalled, "I relaxed my legs and arms and sat perfectly still with the reins loose, watching his head. Pretty soon the little guy's head started drooping lower and lower until he went to sleep. When the first charges went off, they were to our left and

he immediately straightened up and looked in that direction. The next blast was directly below us and he looked down. When the bridge blew, we were in a perfect diving position." Miraculously, the scene was filmed without any injuries to the men or horses, although Tap admits, "it did get a little dicey with that many men and horses upside down and under water."

Not all horses in this time period were so lucky. After several well-publicized tragedies, culminating in the deaths of several animals in 1980's *Heaven's Gate*, including that of a horse who died after his rider was directed to ride over an explosive charge, the Screen Actor's Guild and the Alliance of Motion Picture and Television Producers granted American Humane oversight authority for animals in film. The guidelines American Humane published in 1988 address such concerns as training methods, hours worked, and health care as well as risks posed by specific action. They are amended as needed to ensure the comfort and safety of animal actors within the changing film industry.

FALLING FOR A LIVING

In the early 1940s, American Humane's certified safety representatives were often a nuisance to directors eager for dramatic action, but with vigilance came a new breed of performer, the specially trained stunt horse. Blessed with marvelous reflexes, the trained falling horse is the most prized of the specialty performers. Famous falling horses such as Cocaine, Coco, Hot Rod, Gypsy, Tadpole, and the Jerry Brown Falling Horse commanded top salaries befitting star athletes. In careers that spanned decades, these horses appeared in picture after picture, often falling multiple times in the same battle sequence, "costumed" as different horses with a paintbrush.

HOW TO TAKE A FALL

Falling horses are trained today as they were in past decades, utilizing the same basic techniques devised by ancient armies who downed their horses to create shields. Like all training,

teaching a horse to fall requires great patience. Preparation and the right equipment, such as a snaffle bit and western saddle, are key. Before beginning, the trainer softens a landing spot, usually with a mixture of dirt or sand and sawdust.

The horse is first taught to lie down from a halt. After tying up the animal's left foreleg, the trainer stands on the left side of the horse and gently pulls him off balance by pulling the right rein over the saddle. It might take thirty minutes to get the horse down the first time, and once he lies down, it is important that he receive a great deal of reassurance and praise so his fear of falling is replaced by confidence. The trainer repeats the process daily until the horse learns the rein cue and no longer needs to have his leg tied. Once he masters step one, he is ready for mounted falls. The trainer repeats the process, first at a halt, then a walk, trot, and canter and finally a gallop—always with the ground properly prepared for soft landings. Of course, the trainer must be an expert at going down with his horse and getting clear of the fall.

Special tack is used. Leather-covered soft rubber stirrups are worn on the falling side and on the other side, a regular western or cavalry style stirrup shielded at the toe with leather to prevent the stuntman's foot from going through and getting caught.

Horses have different falling styles. According to stuntman and former USC athlete Jack Williams, who learned his craft from his father, George Williams, "It's a judo throw. But it has to be done in such a way that the horse is not anticipating it, that you catch the horse in the right kind of a stride so that as you pull the horse to the right, he follows his head." Normally, a horse thrown in this way will land on his side. However, Jack added, "if he's got a rear in him, he will go up in a pirouette. That was the exciting thing to me, to put something on the screen that looked like the horse exploded: go up on a pirouette, come down and, ideally, go over the top of you. But things don't always happen that way, so you're gonna get nailed." Sometimes a horse will roll over after hit-

Above, Cocaine was dyed black to take this fall for Robert Mitchum's mount in *The Wonderful Country* (1959), while Chuck Roberson donned a sombrero to double the star. Opposite page, Cocaine's blaze was widened to match Dollor's for this spectacular leap through a prop window. Chuck Roberson, ducking to avoid flying shards of candy glass, doubled John Wayne.

ting the ground. In the movie *How the West Was Won* (1963), there is a breathtaking moment when Williams, portraying an Indian, and his mare Coco are shot down by Gregory Peck's character. Coco rolls on her back and teeters there for several seconds, finally rolling over the stuntman, who was miraculously unhurt. Contemporary stuntwoman Shelley Boyle, who has done many horse falls, including some in *The Horse Whisperer* (1998), explains it this way: "Basically, you stay in close to the horse, and they roll over you. It sounds worse than it really is. You want to stay close to the horse because it's easier to get rolled over than to get stood up on. There's less damage."

STUNT HORSES OF YESTERYEAR

In addition to athletic ability, a falling horse must have other attributes to make it in the movies. As Jack Williams has explained, "You have to have a horse with a good disposition, with a little life to him. And you've got to have a horse that looks good. You know, like they say with actors, 'The camera loves 'em.' The camera has to love the horse."

One horse the camera surely loved was a handsome gelding named Cocaine, owned by the late stuntman and double for John Wayne "Bad Chuck" Roberson. In his autobiography, Roberson devoted an entire chapter to Cocaine, a seven-eighths Thoroughbred out of a Quarter Horse mare. "I liked him the first time I saw him," wrote Roberson. "He was a big sorrel gelding, not that color meant anything. In his working life, he was destined to be painted thousands of times. He and I single-handedly doubled entire tribes of Comanche Indians getting shot to pieces. We'd ride out in front of the camera, get shot down, come back; I'd change my headdress, and they'd paint another spot on Cocaine, and we'd ride out and bite the dust again."

At 6 feet 4 inches Roberson was looking for a big horse for the upcoming production of the Ronald Reagan film *The Last Outpost* (1951) when he found Cocaine at the stable of trainer Frosty Royce. Although only four years old, the blaze-faced sorrel had size and presence. He was totally green, but Roberson was undaunted and leased Cocaine for the picture without even trying him. As soon as the stuntman climbed aboard the sorrel, he knew he'd picked a winner. "With a man on his back," Roberson wrote about Cocaine, "all he wanted to do was move out, race the wind, and win. He had heart and style, and I knew I could make a falling horse out of him." Roberson had only three weeks to prepare Cocaine for the shoot.

Cocaine learned his lessons with amazing speed and in three weeks was ready for his debut in *The Last Outpost*. Jack Williams also worked the sorrel mare Coco for the first time on this movie. Although Roberson owned her, Coco, at just under 15 hands, was too small for him. She suited the trim 5-foot 10-inch Williams just fine. Coco was trick trained and could bow, sit, and lie down. Williams, who had figured she could play dead in the battle scenes, soon discovered Coco's talent for falling. Like a ballerina, she was capable of spectacular airborne pirouettes.

Guided by Roberson and Williams, Cocaine and Coco did a record eighty-seven horse falls in three days on *The Last Outpost*. "Every passing day, I became more impressed with the intelligence of this animal," Roberson wrote about Cocaine. "More than that, he had a desire to please; he seemed to enjoy doing things right for me. A word of praise seemed to light up those big, brown eyes of his and I got as attached to him as to any horse I had ever ridden." When the picture finished, Roberson knew he could not part with the big red horse so he purchased Cocaine from Frosty Royce.

Jack Williams, similarly smitten by Coco and her outrageous style, bought the little mare from his buddy for $400 and a television set. The pair would go on to enliven many a movie. Williams remembered Coco fondly in 2001: "Coco, my famous mare, was unique. She seemed to understand that you're making a movie." When he started working with Coco in 1950, she was about five or six; they made *Rio Lobo* (1970), their last picture together, almost twenty years later. "She died on my ranch in 1976. She was thirty something." That might seem extraordinary for a horse that had performed such rough work, but as

William explained, "You've got riding academy horses that are used up when they're seven years old. They get arthritic if they're used on hard ground a lot, so for longevity, probably the best thing a horse can possibly do for a career is to be a good falling horse."

Cocaine and Roberson also made movie history for two decades. Whether splashed with white to play an Indian pony in movies such as *The Last Outpost* or painted black to double Robert Mitchum's mount in *The Wonderful Country* (1959) or jumping through a candy glass window (which looks real on film but is perfectly safe) with Roberson aboard doubling John Wayne in *Chisum* (1970), Cocaine always made a strong impression. Unusually versatile, he was trained to jump and do drags, transfers, and bulldogs, in addition to falling. His great contribution to movies was acknowledged mid-career with the American Humane's Craven Award for Best Performance by a Stunt Horse for his work in the John Wayne film *Hondo* (1953). He won his second award at the end of his career, in 1972, another Wayne picture, *The Train Robbers*.

A fiery gelding named Hot Rod was, according to Tap Canutt, one of the most spectacular falling horses of the 1950s and 1960s. One of the first Thoroughbreds trained in that capacity, he raced under his registered name of Salvage Goods. He left the racetrack as a four-year-old with two bowed tendons. A proud-cut gelding, he still had enough testosterone to make him a handful. Stuntman Danny Fisher purchased Salvage Goods and turned him into the top falling horse Hot Rod. It was Fisher who taught Tap Canutt how to fall a horse, and Canutt got to throw the Rod, as he was known, many times. Their first film together was a Randolph Scott vehicle, *Hangman's Knot* (1952). Hot Rod was eventually sold to stuntman Red Morgan, who continued to use him for many years.

Danny Fisher later gave Tap Canutt another Thoroughbred, a tall sorrel mare, to train as a falling horse. Canutt changed her name, L'Elegante, to Gypsy. Gypsy worked with him on many films, including *The Last Command* (1955), *Friendly Persuasion* (1956), and *Spartacus* (1960). When he served in the Korean War, Canutt lent the mare to a friend, stuntman Joe Yrigoyen, who later purchased her with the condition that Canutt could use her anytime she was available.

Gypsy also had a long career but sadly had to be euthanized after suffering an injury in the line of duty. Sometimes accidents can foil even the most careful planning, and Gypsy took an unscheduled spill while performing a stirrup drag—a dangerous "gag" in which a stuntman is literally dragged behind the horse with one foot caught in a stirrup. Gypsy had been chosen for the stunt because she had a kind disposition and wouldn't kick while dragging a stuntman at a full run. Ironically, the valiant mare who had fallen so many times without mishap fractured a leg in the accidental fall. Joe Yrigoyen was with the much-beloved Gypsy at the end.

Chuck Roberson provided another horse to Tap Canutt when the latter was working as Lee Marvin's double on *Cat Ballou* (1965). Canutt had hoped to use Cocaine for a falling sequence,

but the big red horse was busy elsewhere. Roberson suggested Tap try Tadpole, whom Roberson was boarding for their mutual friend stuntman Bill Hart. Chuck promised Tap he'd love the horse. Wrangler Dick Webb hauled Tadpole to the *Cat Ballou* location. En route, he tore up the inside of the van and almost crippled three other horse passengers. Webb unloaded the monster and snubbed him to a tree out of harm's way. He warily informed Tap his falling horse had arrived.

"Skipping what I thought was a well-deserved lunch," Tap recalled, "I carried my saddle and falling horse bridle down to where they'd tied the beast from hell. Expecting to see a red-eyed creature with flames coming out of his mouth, I was a little surprised to find what appeared to be a reasonably sound bay horse.

" 'Don't let him fool ya!' I heard Dick yell as he came riding up. I smiled and kept my eyes open as I saddled and bridled him. After walking him around for a few minutes, I climbed in the saddle and rode down into a wash where there was soft white sand. A perfect spot. I galloped him though the sand a couple of times, then on the third pass, I snatched him. Lifting in the front and lunging forward and high, he twisted to the left and came down on his hip and turned completely over. Chuck was right: I fell in love with this horse before he hit the ground."

Tap worked with Tadpole in many films. Notably, the two appeared together in *The Wild Bunch*, jumping through candy glass and tumbling down a sand dune in a group fall. A fantastic performer, Tadpole was treated like a star for the rest of his career.

These stunt horses lived pampered, and generally long, lives. Cocaine lived to be almost thirty-two. Roberson's father put the old horse down in 1975 when blindness and arthritis compromised the quality of his life. Unable to face his partner's demise, Bad Chuck took off for a drive to San Francisco and thought about all the good times he and Cocaine had had. "Then I hung my head," Roberson wrote, "and I'll be damned if I didn't cry some."

Like Cocaine and Coco, Hot Rod and Tadpole also had long lives. Another versatile performer, the Jerry Brown Falling Horse, an expert at jumping an obstacle and then falling over, lived to be thirty-four. Acquired at the end of World War II from the cavalry post at Fort Reno, Oklahoma, the gelding was owned by the Hudkins Brothers but trained by stuntman Jerry Brown (hence his name). He performed his special stunt in *Northwest Outpost* (1947) and the John Wayne vehicle *The Fighting Kentuckian* (1949). The stunt was eventually banned because of injuries to other horses that attempted it. The Jerry Brown Falling Horse, however, was a superb athlete and worked for many years. He was awarded the Humane Association's Craven award for excellence in 1951.

AND THE WINNER IS ...

The Craven Award, named after American Humane's Hollywood office head, was inaugurated in 1951 to honor stunt animals. The PATSY Award, given to the Picture Animal Top Star of the Year, was also begun by American Humane in 1951 to honor animals in starring roles. These awards were given until the mid-1980s. If such awards existed today, the most likely equine recipient of a lifetime achievement award would be a handsome sorrel American Quarter Horse named Hightower.

Hightower was trained by his owner, Rex Peterson. A protégé of the late Glenn Randall, Rex bought Hightower as a ranch horse but quickly realized the gelding's potential as a movie horse. Docile yet athletic, highly intelligent and eager to please, Hightower had everything it takes to be a star, including good looks. Rex began by "whip training" Hightower to work at liberty when he was just a two-year-old. Using the whips like a conductor's baton, the trainer taught Hightower to come to him, back up, lie down, and rear, all with a different flick or position of handheld whips. The whips are never used to hurt the horse. According to Rex, "If I was to hurt him, when I get out in ten thousand acres and there's not a fence in sight [as sometimes happens on movie locations], he's not going to be with me. The only thing that keeps him around is his confidence in me." Time and time again, movie trainers stress that the single most important ingredient in training a horse for any kind of work is trust.

Hightower made his film debut in 1988's *Winter People*, in which he was required to simulate dragging a man to death, first through water and then across snow. Horses are easily spooked by dragging inanimate objects and must be slowly trained to accept pulling dead weight. Hightower learned quickly, and although he had to perform out of sight of Rex, he followed his trainer's direction and accomplished the complicated stirrup drag without injury to the stuntman. Rex knew he had a keeper.

In 1994, Hightower played the mare "Ginger" in *Black Beauty*. Shot to disguise his gender, he played costar to his stablemate, the black American Quarter Horse stallion Doc's Keepin' Time, who played "Beauty." Director Caroline Thompson fondly recalls: "Hightower has an attitude of gratitude. He really is your perfect horse. He has kindness, and he will try, try, try, try, try. He has more heart than I have seen in any horse, and most other creatures I can think of!"

Another fan of Hightower is actress Julia Roberts, who can been seen galloping away from her character's jilted bridegroom on the big chestnut in the beginning of *Runaway Bride* (1999).

The gelding's most difficult role was in 1998's *The Horse Whisperer*. Hightower had to play a horse who had been severely injured and traumatized after being hit by a truck. Robert Redford's "horse whisperer" character brings the psychotic horse back to normal. The script required the horse to act vicious and charge Redford's character. Rex auditioned Hightower by charging him at Redford and stopping him inches in front of the star. Hightower has the amazing ability to look ferocious one second and then drop the façade and be instantly docile. Recognizing the sorrel gelding's extraordinary talent, Robert Redford cast Hightower as the lead horse.

No Horses Were Harmed . . .

Hightower and stablemate Doc's Keepin Time, nicknamed Justin, both performed in The Horse Whisperer's harrowing truck accident scene, carefully choreographed with the American Humane's participation. Justin was required to lie in the snow and then get up on cue as the truck approaches and drags a girl, stunt-double Shelley Boyle, across the road. Because a horse will not lie on cold, hard ground for long, the road was warmed up and softened with a white rug placed over sand and only lightly covered with snow. As the truck approached and the wind machines whirled, Rex admits he was nervous—not only was his prized stallion at risk, so was Shelley, his sister. To everyone's great relief, Justin ignored the surrounding mayhem and, listening only to Peterson, got up on cue and dragged Shelley to safety.

ANIMATRONICS

State-of-the-art robot horses are often used in dangerous scenes. In *The Horse Whisperer* sequence leading to the accident, two girls ride up a snow-covered hill, and their horses slip on the icy snow. The stunt doubles rode animatronic horses for the most dangerous shots down a specially constructed slide. Another animatronic, doubling Hightower, is hit by the truck. The animatronics were so realistic that an American Humane safety representative was fooled. He led Rex Peterson to a black horse lying in the snow, apparently struggling to get up. The "injured" horse even raised his head to look at the panicked safety representative. Nearby, the special effects man radio operating Justin's realistic robotic double couldn't hold back his laughter. The entire accident sequence is so real that when the film was over, Peterson said, "I had people swear to me that we hurt horses. We never injured a horse." He added, "That is the magic of making movies."

Animatronic horses were also used in 1995's Best Picture *Braveheart* and *The Patriot* (2001). *Braveheart* director Mel Gibson wanted to depict enemy horses being impaled on wooden stakes.

Gibson would never subject a horse to danger, yet he insisted on graphic realism. Animatronic horses were built for the brutal scenes with horrifying results. A similar scene of horse impalement can be seen in *The Patriot*. Interestingly, the horse used in this film did not come from a Hollywood special effects shop but was built by Alabama artist Bruce Larsen. The robot horse, named Brock, was also featured in the 2002 remake of *Planet of the Apes*.

WATER WORK

For jumps or falls into water, horses are, of course, no longer obliged to take the kinds of risks they faced in *Jesse James*. For the 1991 Disney movie *Wild Hearts Can't Be Broken*, the true story of Sonora Carver, the first woman to ride performing diving horses in Atlantic City, New Jersey, Corky Randall was hired to train the horses. He set up a tank at his peaceful Newhall, California, ranch, where he began by getting the horses accustomed to div-

In training for **Wild**

Hearts Can't Be Broken
(1991), Chad eagerly
dives in—but notice how
he braces his neck.

ing into the pool from a short platform. Corky gradually increased the diving height to 10 feet, the maximum as mandated by American Humane. A beautiful white Arabian, Chad, loved diving, but he had a habit of sticking his neck out when he hit the water. If the platform had been any higher, Chad might have broken his neck. "Thank God the Humane made us stop at 10 feet," said Corky in 2001, "otherwise we'd have stood a chance of killing a horse." A testament to Corky's training, Chad gallops at liberty through the fairgrounds in the film's climactic scene and voluntarily runs up the ramp to the dive platform, where the actress playing Sonora Carver, Gabrielle Anwar, leaps on his back for a spectacular dive. In the longer diving shot, it is stuntwoman

Shelley Boyle aboard Chad. Their descent into the water is enhanced through computer animation to appear longer, but the brave little horse's willing spirit and graceful motion are breathtakingly real.

Corky had faced another challenge involving water as the head trainer on *The Black Stallion* (1980). A difficult scene involving the title character, largely played by the stunning black Arabian Cass Olé, required the horse to jump from a burning ship and risk his life to rescue a young boy. The scene was shot in Rome in a large indoor tank. Cass Olé was doubled by two French Camargue horses who were natural swimmers. All Camargues are white, and so the doubles had

to be dyed black. In the water, a filament cable secured the horses. Everything went smoothly until one of the animals suddenly flipped upside down. Corky was in the water like a shot. He was able to right the horse and maneuver it to a ramp so it could walk out of the pool. After comforting the frightened horse, Corky stopped production. "That's it for tonight," he said, "I will not put another horse in the water until I know what our problem is and why we had a horse upside down." The producer wisely acquiesced to Randall. The next morning, Corky went in the tank himself with the filament cable attached to his leg and discovered that the deceptively thin wire created a tremendous drag in the water when pulled sideways. He devised a way to use the cable to direct the horse in the water without creating the drag that toppled him. The time spent in closing down the production and figuring out the logistics of the scene proved costly, but the alternative might have been far costlier.

In the horror film *The Ring* (2002), a horse is seen breaking out of a trailer on a ferryboat and jumping over several cars, then over the railing into the water. Trainers Rex Peterson and Rusty Hendrickson prepared a number of black horses, owned by supplier Mike Boyle, to do the required stunts. Working in tranquility on Boyle's California ranch, the men taught the horses to fight through a barricade of cardboard boxes, to jump large objects at liberty, and finally to leap off a platform.

When the sequence was filmed, several horses were used on location for the different aspects of the scene, but the final shot, of the horse going over the ferry's railing, was done in a controlled setting against a "blue screen." Filmmakers often employ the blue (or green) screen technique when the real action is too dangerous or costly to produce. In the case of *The Ring*, the horse was jumped over a railing on a platform far from the water. The shot was then digitally inserted in the scene to make it look as if a horse had jumped overboard. The animal seen thrashing about in the water is from found footage and was digitally inserted in the film. Later the horse appears apparently dead on a beach. The "dead" horse is actually a fake, or "stuffy," in American Humane terminology, designed to look amazingly real.

Natural Enemies

Sometimes horses are called upon to work with their natural enemies, which include bears, wolves, large cats, and snakes. Before the blue screen process, the opposing animals were either tame and highly trained or tranquilized. German Shepherds portrayed wolves, and fake animals were often used, with varying success.

In *The Black Stallion*, the black stomps a cobra to death. Intercuts between a real snake menacing from behind a protective Plexiglas barrier and Cass Olé's stomping a dummy snake created a realistic sequence. Today, however, these types of predator/prey scenes are usually achieved with the help of computer-generated images (CGI). In *Hidalgo* (2004), a scene takes place in which two leopards attack the lead horses, the Paint Hidalgo and a gray mare named Ghost. The horses were filmed whirling and backing, moving forward aggressively, and stomping while trainer Rex Peterson cued them. The trainer was digitally removed from the scene, and the separately photographed leopards met their potential prey in the editing room for a frighteningly realistic sequence.

Highly trained equine actors, animatronics, stuffies, the blue screen process, computer-generated imagery, and the effective use of special props and makeup have done away with the need to ever subject a movie horse to danger for the sake of entertainment. In addition to all the technological advances, American Humane's guidelines dictate an animal's working schedule, feed, care, and veterinary requirements. Humane-conscious filmmakers, such as Robert Redford, welcome American Humane on their sets. "Because it's important to me that the animals in my films are well treated, I choose to ensure it by working with the American Humane Association," Redford has stated. The film-

Yakima Canutt springs from horseback to wagon bed in an episode of *The Three Mesquiteers, Code of the Outlaw* (1942), a demonstration of the trust a stuntman can place in a well-trained horse.

makers' voluntary compliance with American Humane's high standards earns the coveted "No Animals Were Harmed" end credit disclaimer that concerned moviegoers look for at the end of every film with an equine or other animal actor.

THE BIG PICTURE

Unfortunately, American Humane cannot always give the disclaimer, and some films are categorized as "questionable" and even "unacceptable." This sometimes occurs with overseas productions when the animal action cannot be monitored by American Humane or one of its affiliates, usually because of budgetary restraints. American Humane is funded by a grant bequeathed by a fund controlled by the Screen Actor's Guild and the Motion Picture and Television Producer's Association. Its safety representatives' salaries and expenses are not part of a film's overall budget. While this system allows American Humane to enjoy impartial autonomy, it makes far-flung locations often impossible to monitor. Many countries, such as Canada, Australia, the United Kingdom, and New Zealand, either have animal protection agencies or American Humane-trained–representatives who work with the association's guidelines, but others do not. Cultural differences also make the humane treatment of horses in some countries more challenging. Furthermore, while it is difficult to believe, there are still unscrupulous filmmakers willing to put animals at risk to achieve spectacular stunts. Incredibly, one such director even had the audacity to create his own disclaimer avowing humane treatment of animals in an expensive 2004 production after American Humane deemed it unacceptable. However, the questionable treatment was noted in the film review on the American Humane Web site.

One problem is that since fewer movies with horse action are made these days, there are fewer trained movie horses awaiting a casting call. Filmmakers, used to the "time is money" pressure that drives the industry, often do not understand the amount of time needed to prepare horses, especially for liberty work. Trainers sometimes resort to shock collars to achieve results quickly. Shock collars are readily available to the public and are used in aversion training to cure chronic bad habits. The problem with using such devices is that the horse learns to respond to a shock, but in training for performance, the learned behavior is not lasting. In the long run, shock collars can create horses with poor attitudes. American Humane has banned the use of these questionable devices, but it is impossible for its safey representatives to be present at all training and filming sessions.

Although, many strides have been made toward making sure our four-legged actor friends are treated as well as their human costars, room for improvement remains. It's up to audience members to let producers know their films will not be supported if they don't treat their hardworking equine and other animal cast members with the respect they so richly deserve.

1116-26

WORKING STEEDS OF THE WESTERNS

"To me, a Western is gunplay and horses."

—Howard Hawks, Director

Ray "Crash" Corrigan, Max Terhune, and Yakima Canutt (doubling John Wayne, center) on three hardworking steeds in Republic's 1938 episode of *The Three Mesquiteers, Santa Fe Stampede.*

HEN THE VISIONARY THOMAS EDISON turned his cameras on a bucking bronc in Buffalo Bill's Wild West Show in 1894, it's doubtful even he could have imagined the stampede of movie horses to come. In the decades since, Hollywood has produced more than 20,000 Westerns and employed thousands of horses. Where did all these horses come from? The mares and geldings that made up the galloping herds? The mounts of the posse, the cavalry, the Indians? The teams that pulled the wagons? The glamorous star horses who appeared in multiple roles? The many doubles who filled in for the stars? These horses who formed the four-legged foundation on which most Westerns were built were largely procured and rented by a handful of savvy entrepreneurs.

Above, Clarence "Fat" Jones, in his office. Opposite page, hundreds of horses and wagons dash across the dusty plain, recreating the Oklahoma Land Rush for the movie *Cimarron* (1930).

THE BIG BARNS

While wintering in California in 1911, a troupe from the Millers Brothers 101 Ranch Wild West teamed with Thomas Ince's Bison Movie Company to form Bison 101. Thus Ince acquired herds of cattle, buffalo, trained horses, and authentic props such as stagecoaches and teepees, all utilized in his early Westerns. Bison 101 originally occupied 18,000 acres near Santa Monica, California. In 1915, Inceville, as the ranch was called, moved to the Culver City site that would later become MGM Studios.

In the teens and 1920s, the back lot of Universal Studios was home to huge herds of horses, which grazed peacefully between jobs. Since Universal had a galaxy of cowboy stars under contract, including genuine buckaroos Hoot Gibson and Art Accord, it was to the studio's advantage to keep its own supply of horses.

With all the Westerns being made, however, there was plenty of opportunity for ambitious horse dealers.

FAT JONES STABLE

As a teenager, Clarence "Fat" Jones operated a burro-drawn grocery cart. Growing tired of the burros, he traded them for a buckskin gelding, Chick, and later purchased another, Buck. In 1912, the nineteen-year-old Jones rented the buckskins to the Pathé production company for a two-reeler film. He eventually parlayed that simple transaction into a million-dollar business.

In the early days, Fat Jones furnished horses for films starring Tom Mix, William S. Hart, and Ken Maynard. After supplying horses on a relatively small scale for low-budget "oaters" (Hollywood shorthand for a film with lots of oat eaters: horses), Jones was tapped to provide 1,100 horses to RKO Pictures for *Cimarron* (1930). He was also contracted to provide four hundred wagons for the film's famous Oklahoma Land Rush sequence.

Horses, culled from various ranches, were relatively easy to come by. The wagons were more problematic. Jones and his employees scoured the Southwest for authentic vehicles, but many of those they found required expensive repairs. Once he had procured the horses and refurbished the wagons, Jones faced the monumental task of teaching both humans and horses the art of driving. His Herculean ability to deliver the goods established Fat Jones as the most reliable supply stable in Hollywood. *Cimarron*, meanwhile, became the first Western to win the Academy Award for best picture in 1931. Six decades passed before another Western, *Dances with Wolves*, won the Oscar in 1991. Western fans only had to wait a year before Clint Eastwood's masterpiece, *Unforgiven*, won the Best Picture award in 1992.

From the 1920s to the 1960s, Fat Jones furnished livestock and equipment for a vast number of films and television shows. The Fat Jones Stable became a hangout for wranglers such as Alan Lee, who had supplied the company

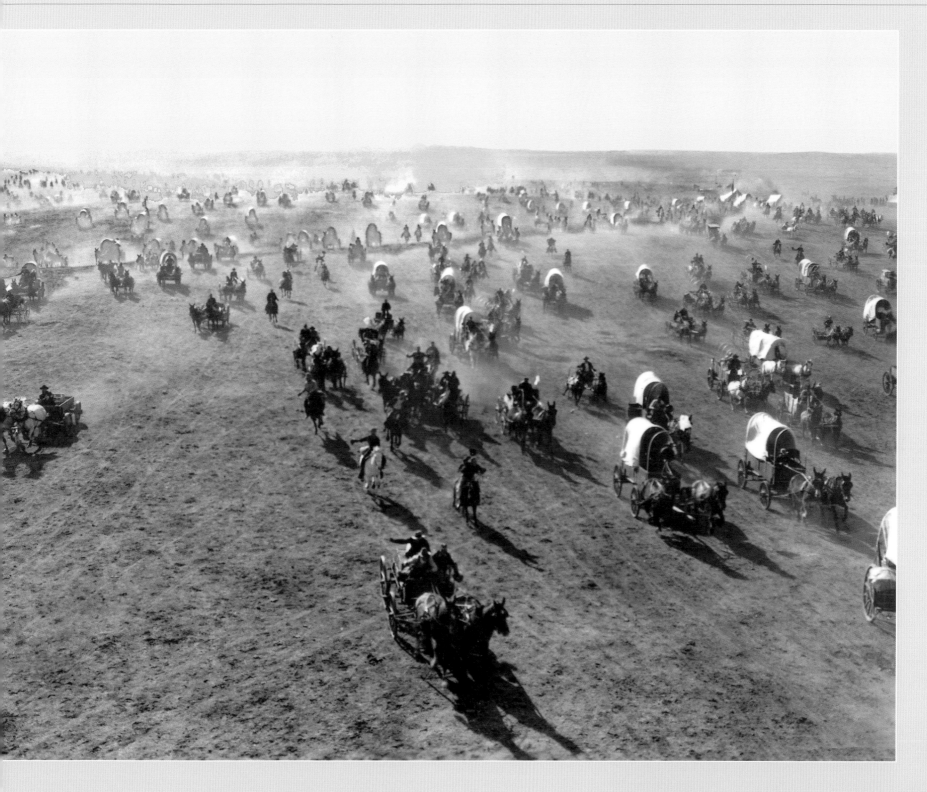

with horses from his Arizona ranch for 1930's *The Big Trail*. Jones persuaded Lee to move to California so he could take advantage of the wrangler's stock and expertise. Lee's son, Ken, only five when his family relocated, virtually grew up at the Fat Jones Stable and followed in his father's boot steps to become a top stuntman and wrangler. In addition to schooling the horses to keep them in shape, the wranglers gave riding lessons to tenderfoot actors. This involved wrangling egos as well: most actors listed "expert horseman" on their resumes, but few actually knew the first thing about horsemanship.

Top trainers gravitated to the Fat Jones Stable and were hired by the studios to work with the star horses. One of the best was Jack "Swede" Lindell, described by Ken Lee as "the granddaddy of all horse trainers." As a young boy in Sweden, Lindell had been intrigued by the American West. In his early teens, he immigrated to the States and headed straight to Texas. He found work as a cowboy and later trained horses for the Barnes Circus. Traveling with the circus to California, he met rodeo roper Buff Jones and his brother, Fat. Fat Jones recognized Lindell's extraordinary talent and hired him away from the circus. Lindell is credited with developing new techniques to cue liberty horses with all the distractions of motion picture equipment between the trainer and his subjects.

In its heyday, the Fat Jones Stable occupied eleven acres in North Hollywood, where barns, corrals, a blacksmith shop, an extensive collection of wagons, and more than a hundred resident horses, plus mules, burros, oxen, and even a small herd of Spanish Longhorn cattle formed the most successful rental stable in the picture business. Stars and specialty horses had their own box stalls, with their names on the doors. Swede Lindell's first movie star pupil, the wild and charismatic Rex, resided in a special stall constructed from thick logs to keep the stallion from chomping through the walls. Performers such as Baldy, Banner (John Wayne's favorite mount from 1940 to 1954), Black Diamond, Blanco, Crown Prince, Flicka, Misty, Steel, Sunny Jim, and Thunderhead all had their nameplates proudly displayed in the Jones barn aisle.

Fat Jones passed away in 1963, but his stable continued to provide horses for film and television under the direction of Dyke Johnson until 1969.

HUDKINS BROTHERS STABLE

Fat Jones's chief rival was an outfit run by four brothers from Nebraska: champion boxer Ace Hudkins, who bankrolled the enterprise, and Art, Clyde, and Ode, who operated it. Roy Rogers's Trigger came from the Hudkins Brothers Stable, as did Gene Autry's original Champion. Known simply as Hudkins within the industry, the stable provided the cast, stunt, and extra horses for both Rogers's and Autry's films. It was also contracted to furnish horses to Warner Brothers, Columbia, and Republic Studios. Although well known for their stunt horses, such as the hardworking Jerry Brown Falling Horse, the Hudkins brothers owned several stars, including Black Ace, the horse who played Challenger in *Dark Victory* (1939), with Bette Davis.

Hudkins competed with Fat Jones on a grand scale as well. The brothers supplied about one thousand horses for both *The Charge of the Light Brigade* (1936) and *They Died with Their Boots On* (1942). One of their last big jobs was providing five hundred horses for *Springfield Rifle* (1952), with Gary Cooper. Of course, such vast numbers of horses were no longer kept in the Los Angeles area. Instead Hudkins, like Fat Jones and others, rented them from various ranchers in popular movie locations, such as northern California, Arizona, and Utah. Hudkins was originally located at the Providencia Ranch in the Hollywood Hills,

previously owned by movie pioneer Max Sennett. Many early films were shot at the ranch (today the site of Forest Lawn Cemetery). Hudkins eventually moved deeper into the San Fernando Valley, where it occupied less than ten acres at the time of its closing in the mid-1960s.

RANDALL RANCH

The Hudkins brothers gave legendary trainer Glenn Randall his start in show business. Born in 1907 and raised on a Nebraska farm, Randall became a lifelong student of equine psychology. Today he might be called a "horse whisperer." His mother used to say he talked to horses. As a young man he was delivering Thoroughbreds from Wyoming to California racetracks when he met Hollywood wrangler Buddy Sherwood. Sherwood introduced him to Ace and Art Hudkins. Randall sold them a horse, Rags, whom he had raised from an orphan colt. Impressed by Rags's repertoire of tricks, the brothers hired Randall to train a palomino stallion for a young cowboy actor named Roy Rogers. Thus Randall's long career as a celebrity horse trainer was launched in 1941 with Trigger.

When the Hudkins Brothers Stable folded, Glenn Randall bought their collection of horse-drawn vehicles for his competing Randall Ranch, which he ran with his sons J. R. and Corky. When the Fat Jones Stable closed, Randall purchased a number of horses and horse-drawn vehicles at its October 1969 auction. He acquired even more from a Fox Studios' public auction.

Located in Newhall, just north of Los Angeles, Randall Ranch maintained a head of 250 movie horses. One of its biggest jobs was to supply 300 horses and vehicles for *Paint Your Wagon* (1969). The ranch provided horses and equipment for films and television until the mid-1970s, when the Western hit a major slump and the need

for movie horses declined sharply. The legendary Glenn Randall passed away in 1993.

SMALLER STABLES

Several smaller supply stables enjoyed the Western boom during the 1930s, '40s, and '50s. Charlie Flores had a barn in Culver City and supplied horses to nearby MGM Studios. His brother Joe Flores ran a North Hollywood livery stable that also furnished horses to movies.

Partners George Myers and Henry Wills specialized in renting jumping and stunt horses, including Flash, a falling horse who won the Craven Award in 1955. Henry Wills, who also worked as a stuntman, actor, and second unit director, trained Flash. Wills doubled many Western stars, such as Roy Rogers, Alan Ladd, and Marlon Brando, and performed more than 1,400 horse falls in his long career. Myers owned at least one star horse, the splendid

Above left, a Randall Ranch brochure touts the many horses and wagons available for rent to the motion picture industry. Above right, a horse from competitor Fat Jones Stable waits to be auctioned off in 1969, when the legendary establishment closed its doors.

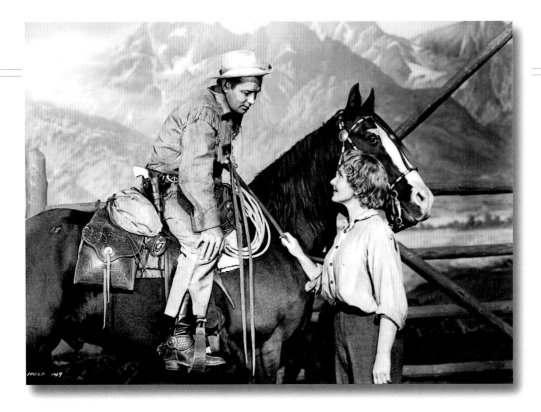

blaze-faced sorrel that carried Alan Ladd in *Shane* (1953). The sorrel contributed to one of the Western's most iconic images, as Ladd's mysterious handsome stranger makes his entrance on the magnificent horse.

A former forest ranger, Ralph McCutcheon had a small but potent stable of stunt and star horses. In the early 1950s, McCutcheon trained on his small spread in Panorama City. He was known for using voice commands and subtle hand signals once the horses were traditionally trained with whip cues. He also reportedly trained at night to prevent prying eyes from learning his secret methods.

In 2003, California equestrienne Penny Bernard recalled spending time at McCutcheon's as a kid. Her father had purchased two palomino former movie horses, Sunny and Champ, from McCutcheon. Penny remembered hanging out in McCutcheon's comfortable tack room, admiring his silver saddles and trophies while her father and the trainer swapped stories. Occasionally, one of the star horses would open the screen door, stroll over

to the refrigerator, open it by its rope handle, and help himself to a few carrots, then shut the refrigerator and stroll back outside and into his stall.

McCutcheon had a penchant for American Saddlebred horses, and he preferred to work with stallions. He loved palominos, pintos, and shiny blacks. His most famous horse was Highland Dale, a gorgeous black Saddlebred stallion who starred in a number of films, beginning with the 1946 version of *Black Beauty* and culminating with the successful television series *Fury*, which ran from 1955 to 1960. Highland Dale, known around the barn as Beaut, also made some memorable cameo appearances in Westerns. In one, McCutcheon and Beaut pulled an astonishing reverse train transfer. In a normal transfer, the rider jumps from his galloping horse to the train. In this instance, McCutcheon, doubling an actor, called Beaut to the train and leaped from the moving vehicle onto the galloping horse. The confidence Beaut had in McCutcheon is extremely rare.

Like the other great Hollywood horse trainers, Jack "Swede" Lindell, Les Hilton, and Glenn Randall, Ralph McCutcheon had a natural talent for communicating with animals. These few gifted men, and the many skilled wranglers, stuntmen, and women who worked with the horses of the Western's golden era, are responsible for some of the most exciting equine entertainment ever filmed.

THE "A" LIST HORSES

Just like their human counterparts, horse actors fall into three categories: stars, supporting characters, and extras. The following horses are standouts from the Hollywood herd from the 1930s to the 1960s.

MISTY

One of Fat Jones's best horses was a black Thoroughbred stallion named Missed-a-Shot, Misty for short. A racehorse,

Black Diamond displays
the fire that fueled his award-
winning performances in
Black Midnight and *Flame of
Araby.*

Misty was "discovered" when he was laid up at Fat Jones's stable with a bowed tendon. Misty would never race again, but Jones had a hunch that the sleek black stallion would make a good actor. Misty proved him right. After his tendon healed, the horse appeared in almost seventy films, spanning a twenty-five-year career.

The wild stallion is a staple of many an old Western plot, and Misty was born for the role. He began as a double for Rex in *Smoky* (1933), when just two years old. Far too talented to remain in the shadows, Misty quickly graduated to featured roles as the wild stallion in numerous early Westerns.

Misty's most famous performances came late in his career. Playing the wild stallion "Banner" in *My Friend Flicka* (1943) and *Thunderhead, Son of Flicka* (1945), Misty displayed his greatest talent: fighting. Trained by Swede Lindell's protégé, Les Hilton, he had the ability to look truly frightening. Fat Jones once said, "No horse could snake out his neck, show his teeth, and fight like Misty. You knew he meant business when he was cued to fight." Off camera, however, he was a kind and gentle horse.

Misty was so attuned to his trainer that Hilton could call him from a herd of horses. When he heard the trainer's voice, Misty would come directly to Hilton, ignoring the mares. It is most unusual for a stallion to respond this way, and Hilton modestly attributed the phenomenon to the horse's superior intelligence. Misty was so popular with audiences that his performances as Banner in *My Friend Flicka* and *Thunderhead, Son of Flicka* prompted more fan mail than the performances of Flicka and Thunderhead combined.

One of Misty's last films is the melodramatic Western *Duel in the Sun* (1946). Misty makes a cameo appearance opposite star Gregory Peck when Peck's

character is forced into a "hand to hoof" battle with a wild black stallion. Because Misty was so gentle, Peck did not need a stunt double. The cooperative stallion allowed the complicated sequence to be shot in just one day.

A few months after his appearance in *Duel in the Sun*, Misty began to decline rapidly. Hobbled by arthritis, the once noble stallion was in pitiful condition. Jones knew it was time to say goodbye to his beloved equine star. He called for the truck to take him to the slaughterhouse, but he made special arrangements for Misty to be euthanized so he would not suffer. Those who worked at the stable say that Jones locked himself in his office for the entire day after Misty was gone.

It may seem unthinkable that many movie horses were slaughtered once they outlived their usefulness, but businessmen such as Jones could not afford to summon a veterinarian to put down each and every one of the many animals they owned. Misty was one of the lucky ones.

BLACK DIAMOND

A large black American Saddlebred stallion, Black Diamond, started his career as Misty did, doubling Rex in *Smoky*. He was purchased by Fat Jones to make some liberty runs in the 1933 film and groomed for stardom in the type of wild stallion roles made famous by Rex and Misty. Les Hilton claimed that Black Diamond could do more work without doubles than any other horse. His uncanny ability to track himself made him especially valuable. Hilton would lead him at a walk along the route mapped out for a particular shot up to distances of a quarter of a mile. When taken back to the starting point and released, Diamond would gallop along the exact same path, making the cameraman's job very easy. An unusually versatile performer, Black Diamond could fight, work at liberty, and be an actor's spirited, yet safe, steed. He won special American Humane Awards of Excellence for his roles in *Black Midnight* (1950) and *Flame of Araby* (1951), in which his work as a tempestuous stallion is especially riveting. Other notable roles include Robert Mitchum's mount in *The Track of the Cat* (1954), in which his ebony coat and high-stepping gait are striking in snow scenes, and the leader of a band of wild horses in *Black Horse Canyon* (1954), with Joel McCrea. Black Diamond lent his majestic presence to the movies for twenty years.

STEEL

Most actors accepted whichever mount was doled out to them by the production's boss wrangler. To a star, howev-

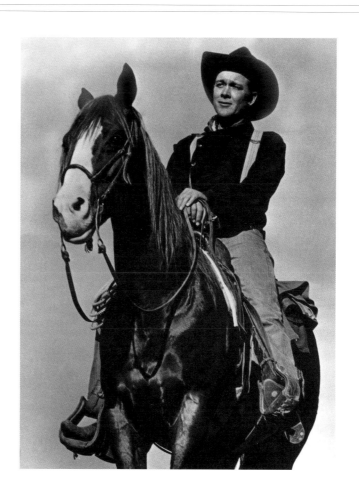

Steel and Ben Johnson

er, the right horse was almost as important as the right leading lady—in male-dominated Westerns, often more important. An actor's image, after all, could be complemented or diminished by the quality of horse he rode. The most desirable horses were smooth gaited and had wonderful dispositions and handsome appearances. A Quarter-type stallion named Steel was by far the most popular star mount of the 1940s and '50s. During his career, he carried the likes of Gary Cooper, Henry Fonda, Clark Gable, Ben Johnson, Joel McCrea, Robert Mitchum, Gregory Peck, Randolph Scott, Robert Taylor, John Wayne, and Richard Widmark across miles of cinematic terrain. Owned by Fat Jones, Steel was a goldmine for the stable: to guarantee

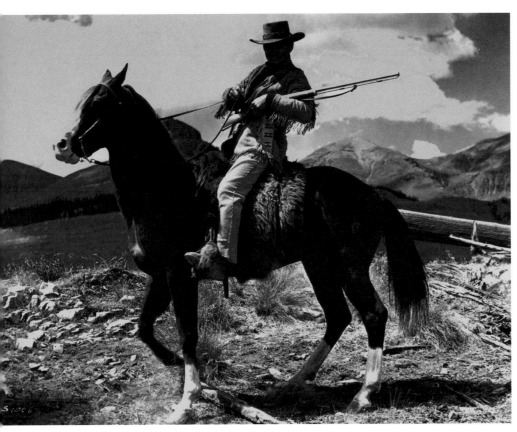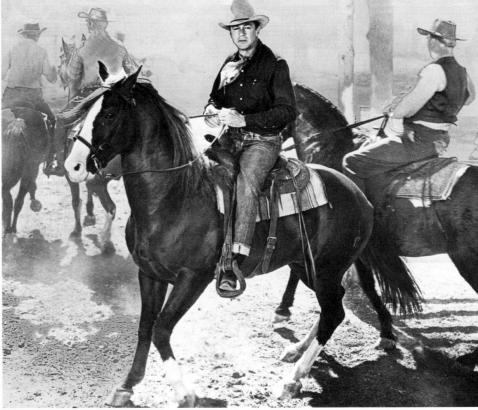

Steel with more of his famous costars—Clark Gable, Gary Cooper, Gregory Peck, and Joel McCrea.

that the star could ride the popular stallion, the studio was obliged to rent all the production horses from the shrewd Mr. Jones.

A flashy sorrel with a wide blaze and three stockings, Steel was distinguished by his flowing mane and long forelock. Born on Hyde Merritt's ranch in Arizona, Steel most likely acquired his name as a result of his pedigree. Steel Dust was one of the earliest acknowledged sires of Quarter Horses. Steel was discovered by rodeo producer Andy Jaurequi, who brought him to California. He showed the stallion to Joel McCrea as he was preparing to portray Buffalo Bill Cody in 1944's *Buffalo Bill*. Steel was immediately cast as Cody's horse, Powderface. McCrea and Steel got along famously, and the star wanted to buy the stal-

lion. However, Steel had caught the eye of Fat Jones, who knew a moneymaker when he saw one. He purchased the stallion with the promise that McCrea could ride him in any picture he wanted. McCrea rode Steel in just one more Western, *Four Faces West* (1948).

Steel's striking looks and easygoing personality made him an ideal picture horse. Unfazed by the glaring lights, cables, overhead swinging microphone booms, and the general commotion of a movie set, he reportedly became quite a ham. Steel kept his eye on the camera: when the little red power light came on, he came to life. His many film credits include *Tall in the Saddle* (1944), with John Wayne, *Yellow Sky* (1948), with Gregory Peck, and *Across the Wide Missouri* (1951), with Clark Gable. He was the

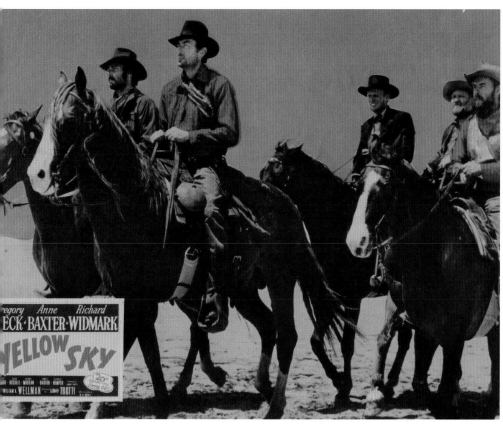

only horse Gary Cooper considered for a mount in *It's a Big Country* (1951).

One of Steel's most ardent champions was stuntman-turned-actor Ben Johnson, who was married to Fat Jones's daughter Carole. An expert horseman, Johnson even rode Steel in his spare time, using him for calf-roping competitions.

Johnson chose the stallion for several John Ford Westerns, including two films out of three in his horse-heavy Cavalry trilogy: *She Wore A Yellow Ribbon* (1949) and *Rio Grande* (1950). In *She Wore A Yellow Ribbon*, shots of Ben Johnson and Steel galloping across Arizona's picturesque Monument Valley are quintessential Ford action. Johnson's frequent Ford film costar, Harry Carey Jr., related an anec-

dote about 1950's *Wagonmaster* in a 2001 interview. A scene called for Johnson to be bucked off by the supertame Steel, who, according to Carey, "wouldn't buck if you put a firecracker under him and lit it!" Steel was doubled by a rank bucking horse, and poor Ben Johnson had to take the fall twice after a well-meaning observer ruined the first take.

Unfortunately, all of Steel's human costars were not as competent as Ben Johnson. The stallion eventually developed a nervous tic as a result of being ridden by too many heavy-handed actors and having guns fired close to his ears. When his habit of constant head tossing began ruining his appearance, Fat Jones knew it was time to retire the stallion. Like Misty, Steel was euthanized. He was eighteen, not particularly old for a movie horse but the

many chase scenes and shoot 'em ups had taken their toll on the magnificent stallion.

DICE

Ralph McCutcheon's superstar pinto Dice was the fortunate son of an Arabian/Thoroughbred stallion and an American Saddlebred/Thoroughbred mare. The flashy black-and-white stallion was discovered at a Colorado horse show in 1935, by the head of livestock procurement for MGM Studios. McCutcheon, then a forest ranger, had taught the stallion a number of amusing tricks and agreed to let Dice be tested for a role in *It Happened in Hollywood* (1937). Dice beat out eight horses for the role of Toby, sidekick to a fictitious Tom Mix–style star, played by Richard Dix. Dice's few tricks in the film, including bowing and pawing, caught Hollywood's fancy, and McCutcheon was suddenly a movie horse trainer.

McCutcheon taught Dice to push someone with his nose, pick up a hat, pull a revolver out of its holster, lie down and play dead, kneel, count, bow, smile, and yawn on command. The showy scene-stealer was instrumental to Gregory Peck's seduction of Jennifer Jones in *A Duel in the Sun* (1946) and prompted *Life* magazine to cite him as "one of Hollywood's finest performing horses." In *It's a Great Life* (1943), Dice sauntered through a hotel lobby, entered an elevator, changed his mind and backed out, and climbed the stairs. Venturing into buildings was apparently no big deal for the pinto, who probably learned the trick by carrot mooching in McCutcheon's tack room. While on location for *A Duel in the Sun* in Arizona, Gregory Peck rode Dice into the dining room of the Hotel Rita, causing quite a stir.

Columbia Studios was so protective of Dice's image that they kept him under contract for eighty-four weeks after *A Duel in the Sun* was released so his fans would have

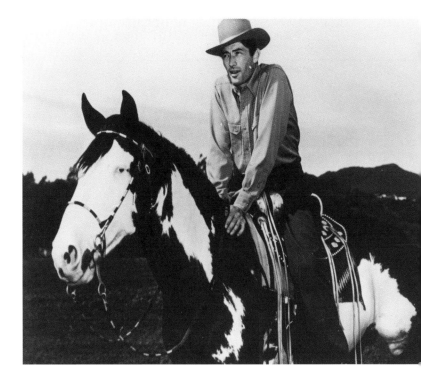

no other opportunity to see the exciting stallion in action. Dice's final film was an offbeat Western called *Thunderhoof* (1948), in which he starred as an elusive wild stallion. Dice had trouble taking direction in *Thunderhoof*, and McCutcheon realized he was becoming a bit senile. He retired his famous horse to pasture, where he cruised through the next ten years. When he was no longer able to enjoy life, Dice was euthanized in 1958 at the age of thirty. He lives on in many Westerns from the 1930s and 1940s; his coat and character make him impossible to miss.

PIE

In 1987, Stewart recalled his first meeting with the horse who was to become his trusty companion for twenty-two years. Their first picture together was *Winchester 73* (1950). An elegant horse with a graceful arching neck and a white star, Pie was the perfect complement to the handsome,

lanky actor. The gelding, described by Stewart as half Arabian/half Quarter Horse, belonged to Stevie Myers, the daughter of wrangler George Myers.

In 1987, Stewart recalled his first meeting with the horse who was to become his trusty companion for twenty-two years. It took place on the Universal lot in 1949. Stevie Meyers had brought three horses for Stewart to try for *Winchester 73*. Stewart wasn't impressed with any of them. Then he noticed a sorrel horse peeking around a building, looking for Stevie. She called his name, "Pie!" According to Stewart, "He came around, and I said, 'Well, how 'bout can I ride him?' Stevie said, 'You can ride him but he's my horse.' Of course, it was love at first sight."

Pie was a feisty horse who had reportedly almost killed actor Glenn Ford by running him into a tree. Stewart, however, instantly felt at ease with the gelding. Their chemistry must have been obvious to Stevie Myers because she allowed the actor to ride Pie in all those Westerns. Stewart attempted to purchase Pie from Stevie, but she refused to sell. According to the actor, she loved Pie like a son.

"I got to know him like a friend," Stewart recalled in 1972. "I actually believed that he understood about making pictures. I ran at a full gallop, straight towards the camera, pulled him up and then did a lot of dialogue and he stood absolutely still. He never moved. He knew when the camera would start rolling and when they did the slates. He knew that because his ears came up. I could feel him under me, getting ready."

By the time they made *The Far Country* (1954), Stewart had developed such a rapport with Pie that he was able to direct him at liberty. In this movie, Stewart's character's trademark is a little bell tied to his saddle horn. Whenever the distinctive bell is heard, the audience—and bad guys—know Stewart and Pie are approaching. In the

crucial scene, Stewart uses the horse as a decoy, sending him riderless down the street to fool the villains. With no trainer on the set, the assistant director asked Stewart if he could get Pie to do this scene. Assuring him he could, the actor simply led the gelding to his mark and explained in plain English what was expected of him. The moment he heard "Action!" Pie did exactly what he had been told, and the scene was shot in one take. Everyone except Stewart was astonished. "That was Pie," he said simply.

Pie's last movie with Stewart was *Bandolero* (1968). When Stewart and Henry Fonda went to Santa Fe, New Mexico, to costar in *The Cheyenne Social Club* (1970), Stewart insisted on taking Pie even though Stevie Myers was worried about the altitude affecting the aged gelding. Despite her concerns, Pie was transported there in his own private trailer. (One of his quirks was that unlike most horses, he preferred to travel alone.) The altitude did

James Stewart and Pie ride as one in *The Far Country* (1954).

prove too much for Pie to work, but he was content to watch the proceedings from a nearby corral. Meanwhile, in his spare time, unbeknown to Stewart, Henry Fonda painted a watercolor portrait of Pie. According to Stewart, "When we got home, he brought me the picture, and two days later Pie died. It was a great loss."

After Pie's death, Stewart arranged to have the horse buried in a secret grave in the San Fernando Valley. The actor enjoyed Fonda's portrait of Pie until his own death on July 2, 1997. It is still a treasured possession of the Stewart family.

STANDOUT PERFORMANCES

It's impossible, of course, to cite all the great horse work in thousands of Westerns. The following examples are some of the most stellar performances by horses in the genre.

SMOKY

If the PATSY Award had been given in the 1940s, a seal brown Thoroughbred stallion named Country Gentleman would surely have won for his role in the 1946 version of Will James's classic horse story *Smoky*. The scenario follows the life of a wild horse, from colthood to old age. In the title role first made famous by Rex, Country Gentleman, whose barn name at the Fat Jones Stable was, naturally, Smoky, gives a stellar performance opposite costar Fred McMurray.

Trained by Jack "Swede" Lindell, who received screen credit as "Equine Consultant," Smoky portrays an exceptionally wild stallion who, captured by a compassionate wrangler played by McMurray, is gentled into becoming a working cow pony. Smoky trusts only McMurray's character and, in one of the most memorable scenes, helps him get back to the ranch after a debilitating fall. Smoky was required to carefully drag the cowboy

through the countryside and even ford a stream. Lindell trained the stallion with a dummy tied to his saddle. Once Smoky accepted the weight without kicking at it, actor and stuntman Ben Johnson, who doubled McMurray, looped his arm through the right stirrup for the drag. Lindell stood off-camera to cue Smoky, who would take a few steps then halt and look back at his charge with concern before proceeding. The horse kept his head slightly turned to the right during this sequence, to keep an eye on Lindell. His very distinctive foxy ears twitched slightly when he took his cues.

Smoky was also trained to fight. In one frightening scene, he stomps the villain to death. Escaping back to the wilds, he is hunted down and sold as a rodeo bronc. Injured and exhausted, he winds up pulling a junkman's wagon. He finally wanders into a parade, made up to look old and starved, where he is spotted by his old friend, McMurray, and rescued at last. A double horse

The Untold Story behind the West's Strangest Legend!

WALT DISNEY'S TONKA
TECHNICOLOR

SAL MINEO
IN A DIFFERENT KIND OF ROLE!
JEROME COURTLAND
PHILIP CAREY · RAFAEL CAMPOS

JOY PAGE · BRITT LOMOND · H. M. WYNANT
LEWIS R. FOSTER · LEWIS R. FOSTER & LILLIE HAYWARD · COMANCHE by DAVID APPEL · JAMES PRATT

had to be used in the final scene as the real Smoky was suffering from a cold and kept ruining takes by coughing. Fans wrote to the studio, concerned by the switch. They had easily spotted the double as Smoky's ears curled in at the tips and the double's ears were straight. Smoky, meanwhile, recovered to appear in more films, but none were as demanding as the vehicle that gave him his nickname.

Smoky was remade again, in 1966, with Fess Parker in the McMurrray role. This time the Thoroughbred gelding Diamond Jet, a former racehorse owned by the Fat Jones Stable, portrayed Smoky. Trained by Les Hilton, Diamond Jet delivered a solid performance in the otherwise mediocre remake.

Unfortunately, Diamond Jet entered the picture business at a time when there were few choice roles for horses. He only appeared in a handful of films. Before he was gelded, however, he sired several foals. One of his

colts, Hud, was featured as Paul Newman's mount in *Butch Cassidy and the Sundance Kid* (1969).

TONKA

Tonka (1958), a Walt Disney production costarring Sal Mineo and a Quarter Horse gelding named Canton, is loosely based on the true story of the lone army survivor of the Battle of Little Big Horn, a cavalry mount named Comanche. Canton was eight years old and had already enjoyed a career as a top-class reining horse when Disney bought him for *Tonka*.

Tonka opens on Canton galloping across the plains, pursued by Sioux braves. The stallion is captured by White Bull (Sal Mineo), who names him Tonka. White Bull develops a strong bond with Tonka and later frees him to save him from the abusive Yellow Bull. The horse is then captured by dealers and sold to the U.S. Cavalry. Renamed Comanche, he becomes the mount of Captain

Tonka's 1958 colorful poster promises lots of horse action and a buff Sal Mineo playing a Native American. The fictionalized story of the horse who survived Little Big Horn was based on the real story of Comanche, seen above left at Fort Lincoln circa 1880.

Miles Keogh (Philip Carey), who is killed at Little Big Horn. After the fateful battle, White Bull joins the cavalry to take care of Comanche in his retirement.

In reality, Comanche *had* been a wild horse. The fifteen-hand buckskin *did* carry Keogh into battle at Little Big Horn and survive. However, the character of White Bull is pure Disney fiction: Comanche was subsequently cared for by Cavalry blacksmith Gustave Korn. Comanche died in 1891 at twenty-nine; his mounted remains can still be seen at the Natural History Museum at the University of Kansas in Lawrence.

As Tonka, Canton received a PATSY Award in 1959 for his starring role. There is some question, however, as to whether Canton really deserved this award. Although he performed a number of difficult stunts and extensive work at liberty, he did have doubles, including the Jerry Brown Falling Horse.

Canton also reportedly had to be replaced after he suddenly quit and literally walked off the set in the middle of filming in Oregon. The frantic filmmakers sent for the reliable star of the television series *Flicka*. The make-up department duplicated Tonka's white markings, and the film was finished with Flicka in the starring role. According to the official press release, Canton was retired to Disney's ranch near Palm Springs, California.

THE BIG COUNTRY

Slim Pickens loaned out his Appaloosa, Dear John, for William Wyler's classic Western *The Big Country* (1958). Gregory Peck portrays an Easterner who comes west to marry a powerful rancher's daughter and finds his masculinity challenged by the local men. One of his tests is to ride a notorious horse named Old Thunder. Peck tackles the bronc in secret with only a friendly Mexican wrangler (Alfonso Bedoya) as witness. In the saddling scene, Dear John gets laughs by snatching off the saddle blanket every time it's placed on his back. The men manage to get the horse saddled, and Peck gingerly mounts "Old Thunder." Dear John's double, Little John, was brought in for the sequence in which Peck sits astride the apparently stubborn Old Thunder, who refuses to budge, despite much kicking by the actor. A quick cut shows Old Thunder suddenly coming to life, bucking violently. It is Dear John doing his best, without a bucking strap, with Slim Pickens doubling Peck in this exquisitely staged and edited sequence.

Incidentally, another horse of color commands attention in *The Big Country*. Peck's main movie challenger, Charleton Heston, rides a black-and-white pinto named Domino. Like the similarly marked Dice, the photogenic Domino was owned and trained by Ralph McCutcheon.

GIANT

Director George Stevens won an Oscar for his direction of the epic Western *Giant* (1956). Meanwhile, Ralph McCutcheon's versatile horse Highland Dale (Beaut), won a PATSY Award for his contribution to the film.

Playing a prized stallion, Warwinds, Beaut was ridden sidesaddle by Elizabeth Taylor in an early foxhunting scene. Rock Hudson stars as a Texas oil baron who comes east to buy Warwinds and returns home with both the horse and a new bride, Taylor. In his final scene, the fatally injured Warwinds limps riderless to the hitching post in front of the ranch house. He stands pitifully on three legs, his flanks bloody from spurring, his bridle hanging broken from his beautiful head. He whinnies softly for his mistress and has a poignant farewell scene with Taylor. Warwinds seems to know he must be destroyed because of his broken leg. It's an amazing performance.

THE MAN WHO SHOT LIBERTY VALANCE

Star James Stewart never throws his leg over a horse in this 1962 John Ford drama that costars John Wayne, but champion trick rider and roper Montie Montana makes a spectacular cameo appearance on his pinto Poncho Rex. Montie rides Poncho into a convention hall filled with people, rears the horse, and rides up several steps to the stage, where he lassoes a politician. Adlibbing, Poncho took a drink from a pitcher of water on the rostrum. John Ford loved it, and the bit stayed in the film.

HOW THE WEST WAS WON

How The West Was Won (1963) is one of the most lavish showcases for horses ever filmed. Directed in three segments by Henry Hathaway, John Ford, and George Marshall, the film follows a pioneer family from 1830 to the end of the century. It also provides a history lesson on how horses helped shape America: hauling pioneers westward, plowing fields, serving in the Civil War and the Pony Express, and providing transportation for everybody—cowboys, Indians, outlaws, mountain men, railroad men, and ladies in horse-drawn carriages.

With an all-star cast, *How the West Was Won* was filmed in Cinerama, a three-camera panoramic process that filled special curved screens with action. This format called for big stunts, including a scene in which veteran stuntman Loren Janes is nearly trampled by six horses who were supposed to leap over him. Although trained to jump at a predetermined spot, the horses failed to recognize the stuntman as an obstacle during the shoot. They ran right over Janes, knocking him unconscious. Janes recovered, and the stunning scene made the final cut.

Except for the falling horses owned by individual stuntmen, the Fat Jones Stable provided all the horses and horse-drawn vehicles for *How The West Was Won*.

THE CLASSIC Bs

Throughout the 1930s, '40s and '50s, movie studios churned out thousands of cheaply made "B" Western features and serials depicting cowboy life in the 1800s—or at least Hollywood's version of it.

Many of the B Westerns continued the tradition of the cowboy-horse partnership with duos such as Tim Holt and Duke, a brown American Saddlebred trained by Swede Lindell. Originally named Strike, Duke appeared with Holt in his pre–World War II films.

"Wild" Bill Elliot appeared in the 1940s *Red Ryder* series aboard a Ralph McCutcheon–trained Morgan named Andy Pershing, renamed Thunder for the movies. In 1946, Elliot sold Thunder to Alan "Rocky" Lane, who

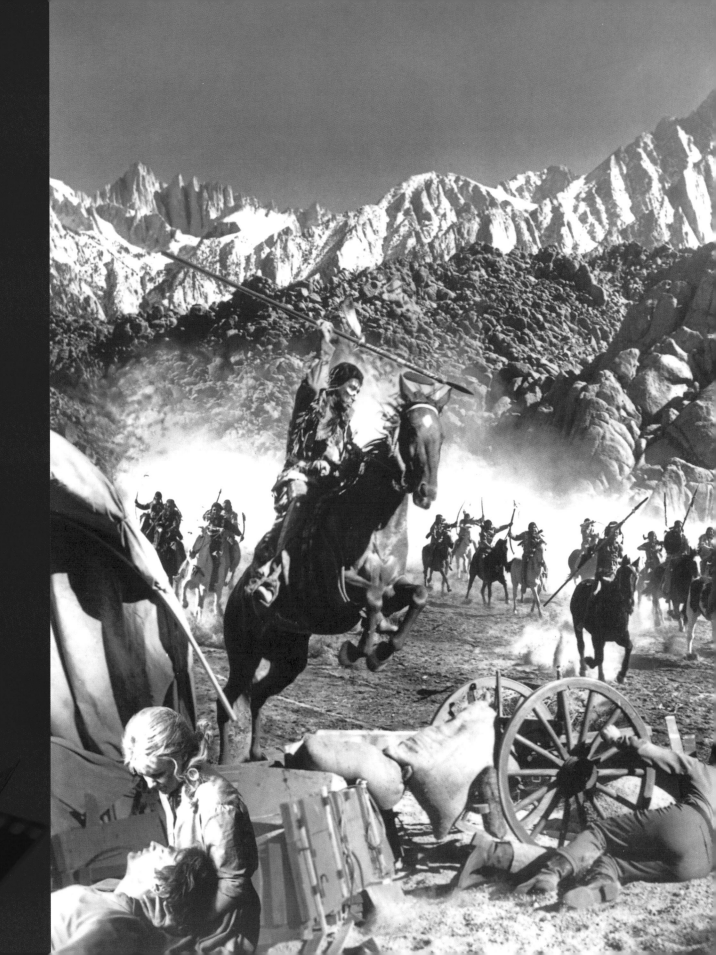

Stuntman John Eppers slapped on the war paint for this *How the West Was Won* (1963) jump. Unfortunately, his horse landed on stuntman Loren Janes, lying in the fore-ground. Janes survived but was glad there was no second take.

also appeared in *Red Ryder*. He changed Thunder's name to Black Jack and rode him in a number of Republic Westerns. Alan Lane later worked with another famous horse, lending his voice to television's "Mr. Ed."

Lash LaRue was known as "King of the Bullwhip" in a series of films in the late 1940s and 1950s. He foiled his enemies with his bullwhip and rode Rush, a magnificent black stallion, in a silver-trimmed saddle.

Duncan Renaldo and Leo Carillo portrayed the Cisco Kid and his sidekick, Poncho, in five feature films. Renaldo rode Ralph McCutcheon's Diablo, an elaborately marked pinto who lived into his forties. Carillo's mount was a palomino named Loco. They all made the transition to television in 1950 with *The Cisco Kid* series, which ran until 1956.

One of the most popular serials was Republic Pictures' *The Three Mesquiteers*. The series of fifty-one films, produced from 1935 through 1943, featured rotating cowboy stars in the title roles, with nine different teams total. The *Mesquiteers* included Ray Corrigan, Rufe Davis, Jimmy Dodd, Raymon Hatton, Bob Livingston, Bob Steele, Max Terhune, Tom Tyler, Duncan Reynoldo, and John Wayne. The cowboy actors rode various mounts from the Hudkins Brothers Stables. They were doubled for many rough stunts, including Running W falls, at least until 1940 when those falls were banned.

Like many B Westerns, *The Three Mequiteers* often featured a horse as a plot device. For example, in *Wild Horse Rodeo* (1937), a wild stallion is captured and trained to be a rodeo star. The horse is stolen by rustlers, reclaimed by the *Mesquiteers*, and freed to live wild once more. The film starred Bob Livingston, Ray Corrigan and Max Terhune, with billing going to Cyclone the Horse.

Beginning in 1935, William Boyd found success as Hopalong Cassidy in a series of films. Boyd's horse was the

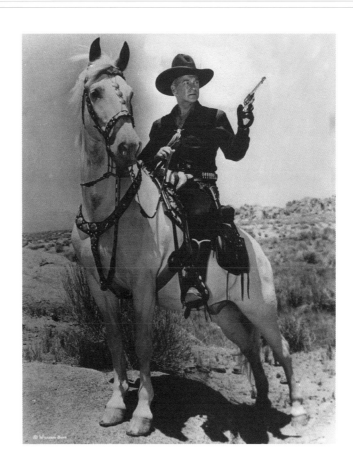

magnificent white stallion Topper, who appeared with him in sixty-six features and fifty-two half-hour television episodes. Possibly a Tennessee Walking Horse, Topper was named in 1937 by Boyd's bride, Grace Bradley Boyd, after the eccentric Cosmo Topper character in a book series authored by Thorne Smith. Boyd and Topper were heroes to millions of children in the 1950s. In 1950, they appeared on the covers of *Time* and *Look* magazines. The duo lent their images to $70 million worth of licensed products aimed at their youthful fan base. Boyd and Topper gave back to their fans, too, making numerous national tours and visiting orphanages and hospitals. On his nineteenth birthday in 1953, Topper enjoyed a carrot cake with seventy-five crippled children at a New York hospital.

The black-and-white
Diablo, ridden by Duncan Renaldo, stood out on the big and small screen, while his palomino cohort, Loco, presented a nice contrast as Leo Carrillo's mount in *The Cisco Kid*.

By his own admission, Boyd was not a great rider, and Topper's primary job was to look good. The star and his stallion were doubled for stunts and tricks. Topper's stark white coat, black-rimmed ears, and blue eyes must have been hard to duplicate, but filmmakers had no choice: Topper was not a highly trained horse.

Topper died in 1961 at age twenty-six, after his annual appearance in the Rose Bowl Parade. He was buried at the Los Angeles Pet Memorial Park in Calabasas, California, now known as S.O.P.H.I.E. (Save Our Pets' History in Eternity). Topper's grave can still be visited there. His headstone reads: "Topper—Hopalong Cassidy's Horse." William Boyd could never trust another horse the way he did Topper and retired the character of Hopalong Cassidy not long after the death of his beloved mount.

TELEVISION WESTERNS

The Roy Rogers Show, The Gene Autry Show and *Adventures of Champion, Hopalong Cassidy, The Cisco Kid,* and *The Lone Ranger* were among the first television series to feature horses in prominent roles. All of these, except *The Lone Ranger,* were spin-offs from movies.

The Lone Ranger began as a radio serial in 1933. The famous fictional partnership between the masked hero and his "fiery horse with the speed of light" began when the Lone Ranger saved Silver, a wild white stallion, from a buffalo attack. Clayton Moore portrayed the Lone Ranger in the television series that debuted in 1949. His trademark cry "Hi Yo Silver!" preceded wild gallops in defense of good. Program owner George Trendle purchased the original Silver, formerly White Cloud, from the Hooker Ranch in the San Fernando Valley. Moore claimed the 17-hand horse was a Morab (Arabian/Morgan), but wranglers who worked with him have said he was a Tennessee Walker. Given his size, that seems more likely. The twelve-year-old, even-tempered Silver was a natural picture horse.

A second Silver was purchased as a four-year-old by Trendle in 1949. Although Moore claimed this horse was also a Morab, he was reportedly actually half Arabian and half Saddlebred. Silver Number Two was extremely high strung and required the magic touch of Glenn Randall, who trained the horse until 1952, when he was finally pronounced ready. Used to double the original Silver in action scenes, he was stamped with Randall's famous near vertical rear. Silver doubles were ridden by stuntmen in dangerous scenes. Of course, as far as the kids were concerned, there was only one Silver. Like Trigger and Champion, the immensely popular Silver had his own Dell comic book series. The Lone Ranger's Indian sidekick, Tonto, rode a brown-and-white pinto named Scout.

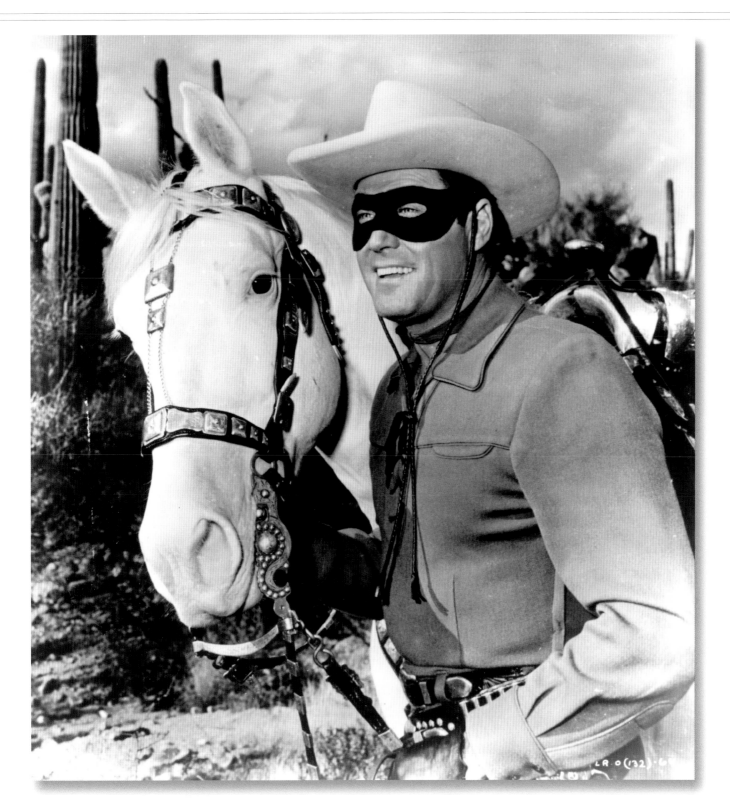

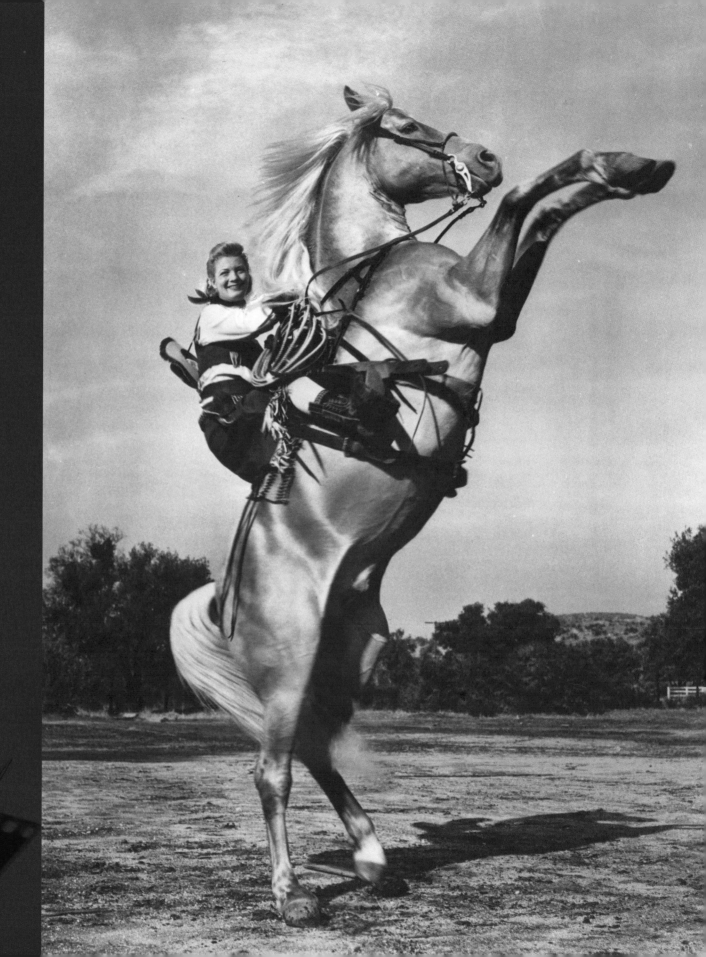

In January 1954, Gene Autry's Flying A Pictures brought the *Annie Oakley* series to television. Gail Davis starred as the rough-riding, straight-shooting cowgirl of historical fame.

In January 1954, Gene Autry's Flying A Pictures brought the *Annie Oakley* series to television. Gail Davis starred as the rough-riding, straight-shooting cowgirl of historical fame. Although Davis was no stranger to the saddle, accomplished stuntwoman and champion trick rider Donna Hall doubled Davis in the show and the series' spectacular opening trick-riding sequence.

In 1955, *Gunsmoke* ushered in a new type of television Western. Kids could still enjoy the action of the new crop of Westerns, but the subject matter was adult. Horses were no longer treated like best pals and sidekicks—just necessary. Shows such as *The Big Valley, Cheyenne, Have Gun Will Travel, Maverick, Rawhide, The Rifleman, The Virginian, Wagon Train,* and *Wanted: Dead or Alive* continued the Western tradition on TV, with horses used mainly as transportation.

Bonanza, which debuted on NBC on September 12, 1959, would become the second longest running prime-time television series in history. The first hour-long TV Western shot in color, Bonanza centered on ranch owner Ben Cartwright (Lorne Greene) and his three sons. Their horses were chosen in large part for how their coats looked in color. Rented from the Fat Jones Stable, the cast mounts were simply good solid riding horses.

Lorne Greene rode a 15.1-hand buckskin Quarter Horse named—what else?—Buck. Buck's registered name was Dunny Waggoner. By the time the series ended, Greene had grown so attached to Dunny that he bought the horse for himself.

Dan Blocker, who played Hoss, rode Chub, a dark brown Thoroughbred/Quarter Horse with a white blaze. Standing about 15.3-hands high, Chub was stocky enough to carry Blocker's heavy frame. As Adam, Pernell Roberts rode a bright sorrel part Thoroughbred gelding named Candy for three seasons, then a similar-looking horse named Sport. Little Joe, played by Michael Landon, rode more than ten

different pintos over the program's fourteen years, all named Cochise. Sadly, in 1964, Cochise was mutilated by vandals who broke into the Jones barn where the *Bonanza* horses were stabled. Although several horses were injured, only Cochise had to be euthanized. Landon offered a generous reward for information, but the vicious crime was never solved.

After Cochise's passing, Landon's other pintos were used for less than three seasons each. These horses were chosen according to the action demanded by the show. When *Bonanza* went off the air in 1973, the Western pretty much faded from the small screen.

The cast of Bonanza on location in Lake Tahoe in 1968: (from left) Dan Blocker, Lorne Greene, David Canary (in back), Michael Landon, and an additional cast member.

THE MODERN WESTERN

"Planes, automobiles, trains, they are great, but when it comes to getting the audience's heart going, they can't touch a horse."

—John Wayne

Boots gives Clark Gable's double a lift in John Huston's unflinching 1961 Western drama *The Misfits*.

AS AMERICA ENTERED THE political and social minefield of the 1960s, the entertainment industry mirrored the public's mood with harder-edged films. The squeaky clean cowboy and his clever trick horse went the way of the dinosaur, and filmmaking technology advanced to embrace popular taste for pyrotechnics. Car chases replaced horse chases as the currency of action movies, while spaceships and James Bond gizmos upped the entertainment ante. The Western had to adapt or be left in the dust. Modern elements were introduced to make the genre more relevant, but good old-fashioned oaters still surfaced, usually driven by powerful directors and stars lured by romantic tales of the West and the sheer fun of playing cowboys on horseback.

KIRK DOUGLAS "Lonely are the Brave"

co-starring

GENA ROWLANDS
WALTER MATTHAU

MICHAEL KANE
with
CARROLL O'CONNOR · WILLIAM SCHALLERT

Screenplay by DALTON TRUMBO · Directed by DAVID MILLER
Produced by EDWARD LEWIS · Based on the novel by EDWARD ABBEY
A Joel Production · A Universal International Release

IN PANAVISION®

Two stylized black-and-white films examined the disappearance of the good old days with an unflinching eye. In 1961, director John Huston dispelled the myth of the West with the harsh romantic drama *The Misfits*. The violent capturing of wild horses for slaughter, utilizing trucks in a stark landscape, represents a shocking transgression of the carnal over the spiritual. Man's brutish domination of nature is exemplified by hard-bitten cowboy Clark Gable's battle with the doomed horses. Like Marilyn Monroe's character, who is forced to witness the heartbreaking scene, audiences can only watch in horror.

The disturbing action was accomplished with Hollywood horses. Boots, a gelding trained to fight by Corky Randall, worked with Gable's stunt double. Although reportedly easy to handle when not revved up for a scene, Boots nailed Gable's double three times with his hooves and knocked the lens shade off the camera in a close shot. Movie horses are well trained, but there are always risks involved in working with them, especially in fighting scenes.

In *Lonely Are the Brave* (1963), Kirk Douglas plays Jack Burns, an altruistic outlaw cowboy on a collision course with the modern world. He starts a fight in order to be jailed with his best friend so he can engineer an escape. His friend prefers to do his time, and Jack goes on the run with his beautiful young mare, Whiskey. Described in the movie as "part range stock, part Appaloosa," the trick-trained mare looks more like a Saddlebred, with a dark copper coat and flaxen mane and tail. Whiskey was actually a gelding, owned by the Myers and Wills Stables and trained by Drew Stanfield.

Jack dearly loves his horse, who embodies the freedom being usurped by "No Trespassing" signs, barbed wire, and other symbols of "progress." Jack and Whiskey are pursued by Sheriff Johnson (Walter Matthau), whose closest tie to nature is a stray dog he watches through the bars of his office window. Chased by jeeps and helicopters, Jack and Whiskey make it over a treacherous mountain pass only to be struck on a rain-slicked freeway by a semitruck carrying a load of toilets. Badly battered, Jack survives, but Whiskey is severely injured and shot by the sheriff's deputy. The look on Kirk Douglas's face as he hears his beloved mare dying is excruciating. The heavy symbolism of *Lonely Are the Brave* signifies the death of the romantic Wild West.

The Western film, however, refused to die. Challenged by the legacy created by masters of the genre, many of Hollywood's greatest talents have dared to saddle up in the past forty-some years. Like John Wayne, they've known that despite the razzle-dazzle of technology, nothing can replace the romantic allure of the all-American cowboy and the thrill of seeing fine horses going full throttle.

BIG GUNS ON HORSEBACK

Wayne, of course, continued to make old-fashioned Westerns into the 1970s. His performance as the salty aging cowboy Rooster Cogburn in 1969's *True Grit* won Wayne a Best Actor Academy Award. One of the most endearing scenes in the movie comes at the end, when he jumps his horse over a fence to prove his virility. The horse was a wide blaze-faced sorrel Quarter Horse named Dollor. Though his name was a derivative of the Spanish word for sorrow, *dolor*, the sorrel gelding was a joy for Wayne to ride. In *Rio Lobo*, released in 1971, Wayne rode Cowboy, a dark reddish-brown horse with a bald face and three stockings owned by the Randall Ranch. For 1972's *The Cowboys*, Randall Ranch supplied the actor with a buckskin gelding. In 1971's *Big Jake*, Wayne rode another sorrel, this one with a narrow blaze and high hind stockings. This gelding, named Dollor, belonged to Stevie Meyers, who also owned James Stewart's favorite horse, Pie. Wayne rode Dollor in several more films, including 1973's *Cahill, United States Marshall*, 1975's *Rooster Cogburn*, and his final film, *The Shootist*, released in 1976. Because

The conflict between the cowboy way and technology is illustrated beautifully as Whiskey confronts a chopper on this lobby card of *Lonely Are the Brave* (1963).

of the similarities of the names Dollor and Dollar, the two horses have sometimes been confused, but careful scrutiny of their markings leaves no doubt as to which horse is which.

Though partial to sorrel horses, John Wayne rode an Appaloosa stallion, Zip Cochise, in director Howard Hawks's 1969 Western *El Dorado*. A colorful brown with a large spotted blanket, Zip Cochise was owned by Chub Ralstin of Lapwai, Idaho. Because of his height, Wayne actually looked fairly ridiculous on the stout little Appaloosa, but Cochise, as the star called him in the movie, didn't seem to mind. Obviously well trained, he stands patiently when Wayne takes a fall and comes when beckoned to be remounted.

El Dorado is resplendent with wonderful horses, but Wayne's costar Robert Mitchum, portraying a drunken sheriff, doesn't ride at all in the film. In real life, the actor was a fancier of the Quarter Horse breed. He began acquiring his own stock in 1960 and bred cutting horses on his Maryland farm until 1966, when he moved the horses to a ranch in Paso Robles,

California. Although he later bred racing Quarter Horses, Mitchum kept some of his original cutting stock and rode his own buckskin, Bull's Eye Bee (aka Buck), in the 1969 Westerns *Young Billy Young* and *The Good Guys and the Bad Guys*.

Another superstar, Marlon Brando donned his spurs for 1966's *The Appaloosa*. Brando plays the owner of Osaca, a prized Appaloosa stallion he plans to use as the foundation sire of a horse ranch. When Osaca is stolen by a ruthless Mexican bandit, Brando's character, Fletcher, braves great danger to reclaim him.

Osaca was played by Cojo Rojo, a stallion originally from Lompoc, California, who had been retired from the racetrack to star in the film. Cojo Rojo was a bay with a spotted rump. Because the director, Sidney J. Furie, wanted a predominately black horse, presumably so he would be more striking on film, Cojo Rojo's bay coloring was dyed black.

Although it took the star power of actor Kirk Douglas—in dual roles as feuding brothers—to garner international atten-

tion for 1982's Australian production of *The Man from Snowy River*, it was the horse work that captivated the movie's many fans. The movie, based on a poem by A. B. "Banjo" Paterson, was helmed by a Scottish-born television director named George Miller (not to be confused with the Australian director of *Mad Max* fame).

Young actor Tom Burlinson had little riding experience before being cast in the lead as Jim Craig, an eighteen-year-old who goes to work for wealthy rancher Harrison (Douglas) after his father is killed by a stampeding herd of brumbies, Australia's wild horses. Burlinson trained intensely for six weeks with horse master Charlie Lovick. At first, the actor took lessons on the quiet, twenty-eight-year-old Cheeky. Once he mastered the basics, Burlinson rode the buckskin Denny, a mountain horse owned by Lovik's father. Denny, making his movie debut in *The Man from Snowy River*, was Burlinson's main mount. The bond he forged with the actor ahead of time during week-long trail safaris helped the two through the difficult production. "We were once eight days away," said Burlinson, recalling one safari, "and there's nothing like getting used to a horse in that time."

As the more difficult riding scenes came toward the end of filming, Burlinson was able to hone his skills even more during production. "There were a couple of really dangerous stunts they wouldn't let me try," said the actor, "but I actually did do the 'terrible descent' after much convincing of the producers." He is talking about the nearly vertical downhill run after the brumbies. Veteran Australian stuntman and wrangler Heath Harris was hired to help stage the memorable scene. Mounted on Denny's stunt double, Burlinson followed Heath's instructions, giving the horse rein and leaning back in the saddle like a pro. Although the filmmakers enhanced the breathtaking sequence by tilting the camera slightly, the actual incline was really quite steep. The duo made it to the bottom without mishap. Burlinson continued the rest of the lengthy chase, which concludes with his dramatic solo roundup of

the wild horses aboard Denny. Said Burlinson at the end of the film, "I found great joy working with the horses, and I developed a great bond with the buckskin. I loved him."

In addition to Charlie Lovick and Heath Harris, American trainer Denzil Cameron was contracted to train a young stallion owned by rancher Harrison in the film. The prized stallion, known from the poem as "the colt from old Regret," was played by a black horse with a white muzzle. The stallion had been named Dollar in homage to John Wayne's movie horse.

Superstar Kirk Douglas doesn't do much riding in the film, but when he does it's impressive. As Spur, a peg-legged gold miner, he drives a cart pulled by a flea-bitten gray. As Harrison, however, Douglas is mounted on a striking dark dappled gray and leads a pack of men on the hunt for his colt who has run off with the wild horses. Sixty-six at the time of filming, the regal actor looks every inch the star on the beautiful gray.

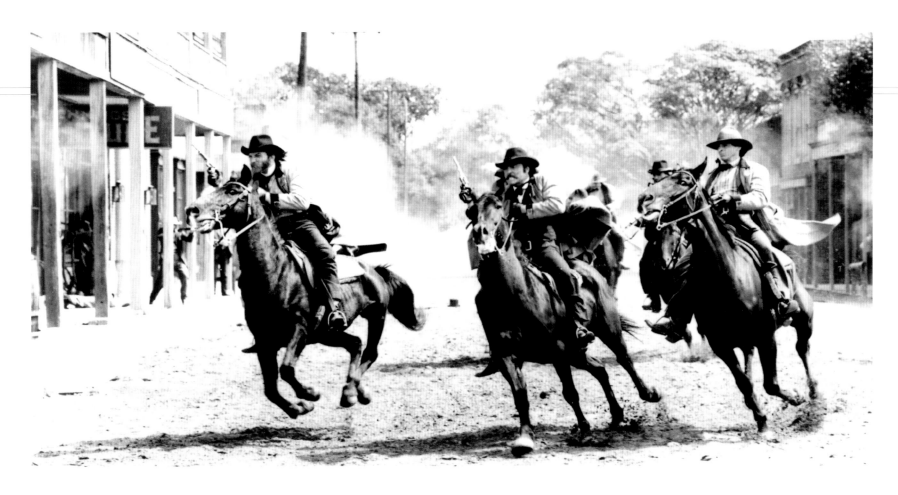

Hell-bent for trouble, the James gang, led by James Keach, Stacy Keach, and Robert Carradine, thunder through town on their wild-eyed black horses.

A NEW BREED

In 1969, director George Roy Hill's *Butch Cassidy and the Sundance Kid* ushered in a new breed of Western, presenting modern, self-aware heroes—not unlike James Bond in cowboy boots. As Butch and Sundance, Paul Newman and Robert Redford are smart-aleck outlaws with sexy devil-may-care attitudes. Paul Newman rides a bay named Hud, the Thoroughbred son of Diamond Jet, star of 1966's *Smoky*, while Robert Redford rides a chestnut gelding for most of the picture. Both horses were likely rented from the Fat Jones Stables in its last year of operation.

The film's high-octane horse work is superb. In one scene, the arrival of the "super posse" tracking down Butch and Sundance sets a unique stunt in motion, one requiring their horses to make a running jump from a railroad car. The car was custom built, with the door opening three feet higher than usual so the stuntmen would not be decapitated on the way out. A ramp was built on the other side of the car to give the horses a running

start and allow them to gallop through the car. The scene was shot with multiple cameras, including one buried beneath the open door to catch the jumps from below. With a price tag of $1,000 per jump for the stuntmen and their horses, director George Roy Hill wanted to be sure he covered the sequence only once.

Filmed away from the American Humane Association's watchful eye, and during a time when studio compliance with animal safety guidelines was voluntary at best, some of the stunts were extra-risky. On location in Mexico, a white mule was rigged with a Running W for a scene in which she was tied to a brown horse and Butch (Paul Newman and his stunt double Jim Arnett) hides between the two animals as they run. The mule does a painful looking nosedive into the dirt but fortunately was not seriously harmed.

A decade later, Redford teamed up with director Sydney Pollack and wrangler Ken Lee for a Western set in more contem-

porary times. *The Electric Horseman* (1979) features a horse in a pivotal role. Redford stars as Sonny Steele, former rodeo champion turned breakfast cereal pitchman. His sidekick in the ad campaign is Rising Star, a million-dollar Triple Crown–winning stallion. Disillusioned by corporate greed, Steele kidnaps Rising Star to protest the stallion's exploitation during a Las Vegas sales convention. Going AWOL from the convention, Steele, ridiculously resplendent in a garish purple cowboy outfit, glittering with twinkling lights, rides Rising Star through a crowded casino and outside onto the neon night street. The stallion's tack is also lit up like a Christmas tree. The entire electric ensemble, powered by a battery pack hidden in the saddle, cost $35,000.

With journalist Hallie Martin (Jane Fonda) tagging along, Steele and Rising Star go on the run. In the final sequence, Steele releases the stallion to join a band of wild horses, reclaiming his own dignity and freedom in the process. The stirring sight of the beautiful blood bay stallion running free at last is a guaranteed lump in the throat. To make sure the stallion could be caught after filming the scene, a mare in heat was tied to an off-camera tree. Wranglers snatched the ardent stallion before romance could develop.

The character of "Rising Star" was played by Let's Merge, a five-year-old Thoroughbred sired by racehorse Urge to Merge. He was purchased at a Pomona, California, auction as a yearling by dressage trainer Barbara Parkening of Burbank. She renamed him High Country and put him in dressage training. When Parkening learned wrangler Lee was looking for a stallion to play a racehorse, she knew High Country could do the job. Nicknamed High C by the production company, the stallion was given to Robert Redford after the film and retired to his ranch in Sundance, Utah.

Three years before *The Electric Horseman*, Paul Newman had saddled up again to play Buffalo Bill Cody in Robert Altman's Western comedy *Buffalo Bill and the Indians, or Sitting Bull's History Lesson* (1976). As Cody, Newman rode a white Lippizan named Pluto from Washington State. Wrangler John Scott was in charge of the horse work. A former rodeo contender from Alberta, Canada, Scott had gotten his start in movies as a riding extra in director Arthur Penn's acclaimed historical Western *Little Big Man* (1970), which starred Dustin Hoffman.

ACTION DIRECTORS TAKE THE REINS

The same year *Butch Cassidy and the Sundance Kid* rode into movie theaters, Sam Peckinpah's *The Wild Bunch* exploded on the big screen. With its own band of cocky heroes and masterfully staged stunts, *The Wild Bunch* utilized horses for maximum visual impact. Later, director Peckinpah teamed with superstar Steve McQueen to tell the story of an aging rodeo champion in 1972's *Junior Bonner*, set largely at a rodeo in Prescott, Arizona. The horse action was coordinated by two-time All-Around World Champion Cowboy rodeo star Casey Tibbs. Ken Lee was credited as "ramrod"—a term borrowed from cattle drives to describe the outfit's boss. In the film's most lighthearted sequence, McQueen and his movie father, Ace Bonner (Robert Preston), ride double on Junior's roan horse in the rodeo parade. Breaking away from the crowd, they go on a wild romp though backyards. Although the big stocking-legged roan with a T-shaped wide blaze doesn't even have a name in the movie, he was a more important supporting character than some of the humans who received screen credit.

The roan was Ken Lee's own Quarter Horse, Pie—not to be confused with Jimmy Stewart's favorite movie mount. Purchased as a five-year-old, the gelding was just a good all-around saddle horse, gentle enough for Lee's children to ride. Another of Ken Lee's own horses, Soldier, doubled Pie in his big scene, jumping large obstacles. Pie had previously appeared in the 1968 Sidney Pollack Western *The Scalphunters*, starring Burt Lancaster. Pie died prematurely from complications of colic while on hiatus from movie

work. It was a great loss for the Lee family as Pie was not only a great movie horse but also a beloved pet.

Nearly a decade later, director Walter Hill brought the story of the James Gang to the screen, casting real-life brothers as the legendary outlaw brothers. *The Long Riders*, released in 1980, starred James and Stacey Keach as Jesse and Frank James; David, Keith, and Robert Carradine as Cole, Jim, and Bob Younger, and Dennis and Randy Quaid as Ed and Clell Miller. Although authentic in its period detail, the film is a departure from staid Westerns of yesteryear, largely because of its stylish staging, hip Ry Cooder soundtrack, and crisply choreographed action—which included some dangerous stunts. Although one horse was clearly trip-wired for a dramatic solo somersault in the middle of a street, no injuries were reported.

One of the film's most spectacular sequences is a slow-motion shot of the gang jumping their horses through plate glass windows—twice—as they escape through a building. Wrangler Jimmy Sherwood, who worked with head wrangler Jimmy Medearis, spent six weeks prepping the horses to build their confidence. They were trained to jump in tandem over low obstacles. To get them used to something hitting their bodies as they ran, the horses were run through tape strung between posts. They practiced jumping through the windows without glass and finally did the shots, jumping through candy glass. All the main movie horses were shipped to the South Carolina location from veteran wrangler Rudy Ugland's California ranch. Because Hill wanted the gang's horses to be uniformly and dramatically black, they were dyed to match one another.

Rudy Ugland served as head wrangler on Walter Hill's *Geronimo: An American Legend* (1993). Gene Hackman, Robert Duvall, Jason Patric, and Matt Damon costarred, proving once again that great actors love to play movie cowboys. Matt Damon rode the sorrel gelding 101, named after the famous old Miller Brothers 101 Ranch. Gene Hackman rode a mule named Susie, who had made her movie debut in *Dances with Wolves*. Robert

Duvall, who Rudy Ugland has said is "probably the best rider of all the actors I ever mounted on a horse," rode the sorrel Quarter Horse gelding Gino, a veteran of many films.

In the title role of Geronimo, Wes Studi rode one of Ugland's own horses, Ajax, a white trained rearing horse. Because of his ultra-sensitive mouth, Ajax could inadvertently be pulled into a rear by a heavy-handed rider. Studi, however, had very lights hands and impressed Ugland with his excellent horsemanship. Ajax had previously appeared as Gregory Peck's mount in 1989's *Old Gringo*. After *Geronimo*, Ajax continued to work in commercials and television movies. In his later years, he was, like many light-colored horses, vulnerable to skin cancer. Sadly, he was put down because of complications from the disease in 2003, at age twenty-three.

Hill's most recent foray into the Old West was directing the pilot episode of HBO's series *Deadwood* (2004), featuring Keith Carradine as Wild Bill Hickok. The horses for *Deadwood* come from Jack Lilley's Movin On Livestock in Canyon Country, California.

MEETING THE WESTERN CHALLENGE

Horses are integral to the plot in director Lawrence Kasdan's slickly produced 1985 homage to the Western *Silverado*. The very first sound in the movie is a horse's soft nicker, which signals the imminent attack of vengeful villains on the sleeping hero, Emmett, played by Scott Glenn. Soon Emmett is on the trail, mounted on a husky dapple gray and ponying a bay tobiano pinto left behind by the villains. His mission is to find his brother, then join his sister in the town of Silverado. En route, he revives the nearly dead Paden (Kevin Kline), who has been robbed of everything except his red long underwear. Paden confesses that all he really cares about is recovering his stolen bay horse. Joining forces with Emmet, Paden soon recovers his bay and expresses his affection for the horse by kissing him on the mouth.

Kicking Bird's white
Indian pony and Cisco appear to be listening for trouble sneaking up from behind in this shot from Kevin Costner's *Dances with Wolves* (1990). Opposite page, For the Moment's dark-and-light coloring reflects the dual nature of Clint Eastwood's Preacher in 1985's *Pale Rider*.

Paden lands in jail, where Emmett's brother Jake (Kevin Costner) awaits hanging after an unjust trial. Paden and Jake engineer a clever escape, and soon Paden and the brothers are galloping off on the gray, the bay, and the pinto. The bay, however, changes from scene to scene. The first horse has a narrow blaze, another has a star and a white muzzle, and a third has a wider blaze. According to wrangler Ken Lee, the main cast horse had weak knees so although he was gentle enough to work with Kevin Kline in the "love" scene, he was not strong enough for the galloping sequences. The other two bays were doubles, and apparently director Kasdan assumed the action was so fast that no one would notice the different face markings.

A fourth man, Mal (Danny Glover), joins the heroes; he rides a big blaze-faced sorrel. All the cast horses, with the exception of the pinto and the big gray Quarter Horse ridden by Scott Glenn, were supplied by Corky Randall. The gray was a calf-roping horse owned by a wrangler from Oklahoma. The pinto was a veteran movie horse owned by supplier Denny Allen. Another pinto, Tarzan, also appeared. The most stunning stunt in *Silverado* occurs in the final gun battle, when Emmett, disarmed, uses the gray to leap out of a barn on top of his nemesis, who is killed.

Lawrence Kasdan returned to the Old West for 1994's *Wyatt Earp*, starring Kevin Costner. Head wrangler Rusty Hendrickson provided the horses. Wyatt Earp rode many horses over the course of his life in the film, but when Earp achieved legend status, Costner rode Baby, a registered Paint red roan with a blaze, a long, narrow body, a good mind, and smooth gaits. Hendrickson originally purchased Baby as a colt for *Dances with Wolves* and worked with him for four years to turn him into an ideal cast mount for Costner in *Wyatt Earp*.

DANCING WITH COSTNER

Rusty Hendrickson learned about horses from his dad, a rodeo contractor and racehorse trainer. Veteran wrangler Rudy Ugland handpicked Rusty as his protégé after working with him on the controversial *Heaven's Gate* in 1979. After learning the ropes and toiling uncredited on many films, Hendrickson finally became a head wrangler on 1990's *Dances with Wolves*.

Kevin Costner's *Dances with Wolves* won a Best Picture award for its producer-director-star. The first Western to receive the honor since 1930's *Cimarron*, it also marked a victory for its equine star, the buckskin Quarter Horse Plain Justin Bar, who played Cisco. For the first time in many years, a horse received billing in the end credits, albeit next to last, just above Teddy and Buck who played the wolf, "Two Socks." A strong character in the film, Cisco bonds with Costner's character, Lt. John Dunbar, who spends much of his time without human companionship.

Costner definitely wanted a buckskin for Cisco. After looking at a number of them, Hendrickson finally found the right gelding, bred by Amy Jo and Earl Udy Warren of Heyburn, Idaho. Sired by Impressive Dan, out of Plain Pearl Bar,

and foaled on May 1, 1983, Plain Justin Bar was chosen for his color, conformation, and temperament. "He had a certain presence," Hendrickson later recalled. "He was interested in people and not afraid of things." A soft-spoken cowboy of John Wayne proportions, Hendrickson approaches training movie horses just as he does his ranch horses—with gentleness and common sense. The result is a good all-around horse who, in Plain Justin Bar's case, just happens to be a movie star. After production, the handsome gelding was sold to a private party in Pilot Point, Texas.

As Kicking Bird, Graham Greene rode a pure white Indian pony with blue eyes. The choice was inspired by a poster of a Lakota chief Kevin Costner gave Rusty Hendrickson. In general, blue-eyed horses don't make good movie horses as their eyes can't handle the lights for very long. Fortunately, this particular horse did not have to stand for many close-ups so he was fine. He was purchased from a South Dakota man with the proviso that the owner could buy his horse back at the end of the movie. After his brief career in show business, the distinctive white horse was returned to his original owner.

EASTWOOD GOES WEST

After making a name for himself as a mysterious loner in Sergio Leone's ultra-violent Italian "spaghetti westerns," Clint Eastwood returned to Hollywood to star in *Hang 'Em High* (1967). Departing from his tough-guy image to appear in the movie version of the hit Western musical *Paint Your Wagon* (1969), a throwback to more naïve times, Eastwood went on to contribute a fistful of Westerns as both star and director. *High Plains Drifter* (1973), *The Outlaw Josey Wales* (1976), *Bronco Billy* (1980), and *Pale Rider* (1985) all helped keep the genre—and the Western movie horse—alive.

Eastwood's mount in *The Outlaw Josey Wales* was a well-bred Quarter Horse stallion called Parsons. The stallion had originally been purchased by wrangler Rudy Ugland to play Tom Mix's

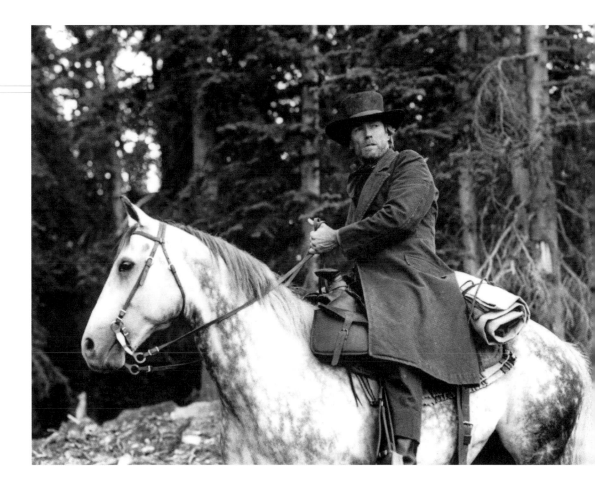

horse Tony in a film about the silent star. Parsons, a sorrel with a blaze and stockings like Tony's, was taught all the tricks necessary to play the famous horse. Although the Mix film never happened, Parsons would go on to be ridden by some of the world's greatest movie stars. After working with Eastwood, he was Jane Fonda's mount in 1978's *Comes a Horseman*. Steve McQueen rode Parsons in 1979's *Tom Horn*. After appearing in many more films, Parsons—who was gelded after his role in *The Outlaw Josey Wales*—was retired to Ugland's California ranch.

In *Pale Rider*, Eastwood plays Preacher, a sort of avenging angel-gunfighter. Symbolizing both good and evil with his dramatic light and dark coloring, Preacher's mount is a beautiful dappled gray. Eastwood told wrangler Jay Fishburn, a former jockey, that he wanted the specifically colored horse to have "a lot of star quality." Fishburn found the striking young gelding, For the Moment, at a Los Angeles area racetrack. Fishburn's friend Spud Proctor, a track outrider, was using the gelding to lead the hors-

Eastwood chose the flea-bitten gray Jerry to subtly underscore his *Unforgiven* character's well-worn appearance. Opposite page, after laying Pilgrim (Hightower) down, Tom Booker (Robert Redford) aids Grace MacLean (Scarlett Johansson) in mounting her horse for the first time since their traumatic accident in *The Horse Whisperer* (1998).

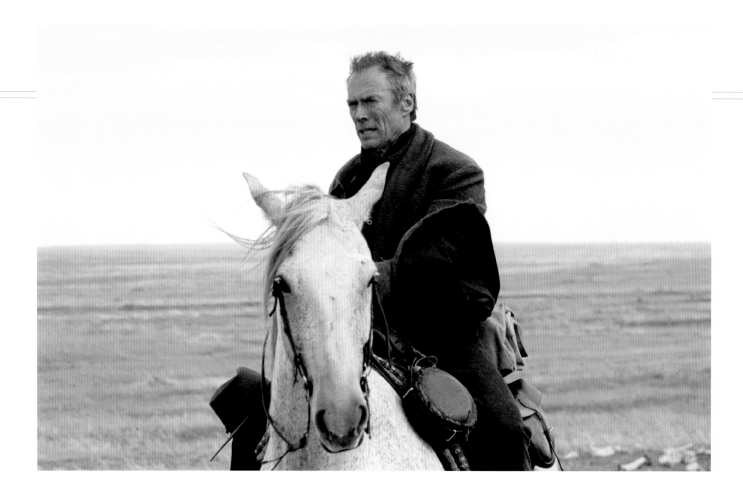

es to the starting gate. Although he had never worked in a movie, the gray had the requisite coloring and charisma. After working with the gelding for a few weeks, Fishburn knew For the Moment also had the right temperament. When filming wrapped, the gray resumed his career as a racetrack lead pony.

As Will Munny, a repentant gunfighter lured back into action, Clint Eastwood rides a less glamorous gray in *Unforgiven* (1992), a dark, gritty film about violence that won the Best Picture Academy Award for its producer-director-star. This time, Eastwood specifically wanted a flea-bitten gray to match his character's over-the-hill demeanor. Wrangler John Scott looked long and hard for the right horse and finally found a little gelding named Jerry on the Hobem Indian reservation in Alberta, Canada. Two doubles were also acquired. All the grays were what Scott calls cold-blooded horses of no particular pedigree and thus met Eastwood's desire to create an unromantic image for himself. The film's

only levity comes from a running gag of the rusty Will having difficulty mounting his equally rusty old horse. After filming, Jerry found a good home as a lesson horse.

BEST-SELLERS MOUNT UP

Robert Redford's adaptation of the best-selling book by Nicholas Evans *The Horse Whisperer* (1998) featured seventeen American Quarter Horses provided by trainers Rex Peterson and Buck Brannaman. In addition to Peterson's accomplished horse, Hightower, as the lead horse Pilgrim, four others were used as doubles. Top Decker Special, Whynotcash, Sierra Ghost, and Maverick all played Pilgrim during different phases of his healing process in the movie. Hightower was in the initial accident scene, the close scenes with Redford, and the final scene when Grace (Scarlett Johansson) regains her confidence to ride Pilgrim again. Peterson's black stallion, Doc's Keepin Time (aka Justin) played Gulliver, the horse killed in the truck accident. Robert Redford's

mount, called Rimrock in the film, was played by Rambo Roman, one of Buck Brannaman's own horses.

In 2000, Miramax Films and Columbia Pictures released *All the Pretty Horses*, directed by Billy Bob Thornton and starring Matt Damon as John Grady Cole. In the screen adaptation of Cormac McCarthy's popular book, the story focuses on the adventures of the Texas teenager John Grady and his friend Lacey Rawlins (Henry Thomas), who are hired to break mustangs on a Mexican hacienda. Grady falls in love with the ranch owner's daughter, Alejandra (Penelope Cruz), an excellent equestrienne. Their star-crossed romance is the centerpiece of the movie, yet horses play significant roles throughout.

Head wrangler Rusty Hendrickson provided his own saddle horse, Dollar, for Matt Damon's mount, Redbo. In 1983, Rusty bought the sorrel Quarter Horse gelding, registered as Cutter Bailey, as a yearling in Montana. Dollar's experience as Rusty's ranch horse made him perfect for the role of Redbo.

Another of Hendrickson's Quarter Horses, Ghost, is the gray ridden by Henry Thomas and called Junior in the film. A third horse was needed as a mount for Lucas Black, who plays the misfit thirteen-year-old Jimmy Blevins. After looking at Saddlebreds, Thoroughbreds, and Walking Horses, Hendrickson chose a charismatic little bay Quarter Horse who appealed to director Thornton.

Matt Damon, Henry Thomas, Penelope Cruz, and Lucas Black trained for five weeks on horseback before shooting began in Texas. Working with Hendrickson and wranglers Rex Peterson and Monty Stuart, the actors spent eight hours a day in the saddle. They also learned to care for their mounts and did their own saddling, unsaddling, and grooming. The hard work paid off: the actors look completely at ease on and around their movie mounts, about whom Matt Damon has said, "They're better actors than we are. They've been in lots of movies and nothing ruffles them."

YOUNG GUNS RIDE

More than a decade earlier, another group of Hollywood's hottest young actors had also learned to ride for 1988's *Young Guns*. Working with wrangler Jack Lilley, Emilio Estevez, Keifer Sutherland, Lou Diamond Phillips, Charlie Sheen, Dermot Mulroney, and Casey Siemaszko were transformed into a hard-riding band of outlaws. As Billy the Kid, Estevez survived to appear in the 1990 sequel, *Young Guns II*, along with Kiefer Sutherland as "Doc" Scurlock, Lou Diamond Phillips as Jose Chavez y Chavez, and new gang member Christian Slater as Arkansas Dave Rudabaugh. With sexy young actors, rock-and-roll soundtracks, fast-paced action, and clever dialogue by screenwriter–executive producer John Fusco, the *Young Guns* movies introduced the Western to a new generation of filmgoers. The horse action in both films is excellent and features registered Quarter Horses owned by Jack Lilley as cast mounts and many trained falling horses.

In *Young Guns*, Jack Palance, playing the villain Murphy, was assigned to a frisky horse who made it difficult for the then seventy-one-year-old actor to hit his marks and deliver his lines properly. Palance requested another horse, Tarzan, a sorrel tobiano Paint gelding on the picket line that had caught his eye. Owned by Derwood Herring of Clovis, New Mexico, where the film was shot, Tarzan had previously worked in *Silverado* and 1986's Western spoof *Three Amigos!* The gentle veteran equine actor was brought to the set for the actor, who had no further horse trouble.

John Fusco and his wife, Richela, were also attracted by Tarzan's striking looks and obvious intelligence. They took turns riding him between set-ups and were so smitten that they ended up purchasing him. Renamed Chato, he accompanied the Fuscos to their Vermont farm after filming wrapped. John Fusco intended to retire Chato from movie work, but the gelding was called back into action when *Young Guns II* was produced. In that film, Chato plays the horse flamboyant brothel owner Jane

Greathouse (Jenny Wright) rides nude, à la Lady Godiva, when do-gooders force her out of town. Twenty-three in 2005, Chato was still going strong, ruling the Fusco farm. Another of Fusco's horses, the sorrel overo paint mare Wakaya, played the Spirit Horse in *Young Guns II*.

BILLY CRYSTAL AND BEECHNUT

Jack Lilley also provided horses for the comedic contemporary Western *City Slickers* (1991). Billy Crystal's blaze-faced black horse, the 15-hand Beechnut, was about eleven years old when Lilley leased him from Oregon breeder Frank Russell for the movie. Surprisingly, Beechnut's dam was a sorrel and white overo pinto mare. As a colt, Beechnut had been a gift for Frank's young son Charley. Named Charley's Surprise, the horse acquired his nickname, Beechnut, from a brand of chewing tobacco. He grew up a ranch horse, used for roping and gathering cattle, and was unfazed by the distractions of a movie set.

Beechnut's main double for the chase scenes was Licorice, a black roping and cutting Quarter Horse. Jerry Gatlin along with wrangler Jack Lilley and his son Clay taught Billy Crystal how to ride and rope. A natural athlete with great hand-eye coordination, Crystal roped the first steer he tried.

The actor was so pleased with Beechnut in the first movie that he purchased him from the Russells. He wanted to ride him in 1994's *City Slickers II*. To make it appear that Crystal was on a new mount, Beechnut's white blaze was dyed black.

When hosting the sixty-third Academy Awards in 1991, Crystal made his grand entrance riding Beechnut on stage, sending up the year's big winner, *Dances with Wolves*. Horse trainer Lisa Brown, who had looked after Beechnut since *City Slickers*, spent three days prepping him for his Academy appearance. Unlike most of the stars on the stage, the horse did not require any special make-up: his

ears were left untrimmed and his hooves were dressed with clear oil, not hoof black. Crystal wanted Beechnut to look like the real ranch horse he was.

Beechnut was retired to an idyllic boarding ranch in Malibu to spend his golden years cruising around a large pasture

with a bunch of good old horse buddies. He continued to be cared for by Lisa Brown, who has worked with many celebrity clients. She assisted wrangler Rusty Hendrickson on *Seabiscuit* (2003) and trainer Rex Peterson on *Hidalgo* (2004) and has said, "I'm always thankful to share time with the glorious movie horse whose character is unmatched."

FAR EAST MEETS WEST—IN THE SOUTH

Chinese born director Ang Lee has proven himself adept in a variety of genres. His Civil War–era Western *Ride with the Devil* (1999) starred Tobey Maguire as Jake Roedel, a young man who joins the Southern loyalist Bushwackers after Union soldiers murder the father of his friend Jack Bull (Skeet Ulrich). Pounding hoofbeats fill the soundtrack in the opening moments, signaling plenty of hard riding to come.

Head wrangler Rusty Hendrickson's horse Dollar, the gelding Matt Damon rode in *All the Pretty Horses,* is Skeet Ulrich's mount. Tobey Maguire rides a bald-faced sorrel gelding named Blaze for most of the film. A former falling horse, the Arab/Quarter Horse cross was reportedly a handful in his youth. A veteran of many films, Blaze has since mellowed into a good all-around horse. Hendrickson coached Maguire, who did all his own riding in the film. According to Hendrickson, the star proved to be an excellent student. He looks completely at home galloping Blaze. As the budget was tight, horses had to do double duty, and Blaze even did some falls in the battle scenes. He was deservedly retired after the movie.

Another falling horse used in the battle sequences was Paint That Ain't, a solid sorrel registered paint gelding owned by Mark Warrack, Hendrickson's longtime assistant wrangler. In addition to the veteran movie riders and stunt horses, Civil War reenactors and their horses were hired for the battle scenes. Filmmakers commonly use reenactors in historical movies, as they provide authentic knowledge and have their own period wardrobes—for themselves as well as their horses.

THE HOOFBEATS GO ON

Thirteen years after *Dances with Wolves,* Kevin Costner directed another critically acclaimed Western, *Open Range* (2003). Starring Costner, Robert Duvall, and Diego Luna, *Open Range* follows two cattlemen, pushing a herd westward in the 1880s, who encounter opposition from a land baron.

In *Open Range,* horses are relegated to typical supporting roles, mostly as vehicles for driving and rounding up cattle and as mounts in gunfights. They also pull wagons and provide colorful atmosphere just milling around in the background of dialogue scenes.

Costner, Duvall, and Luna rode the same horses throughout the film. Although Rusty Hendrickson did not work on the film, he provided Costner with his mount. The star called his buddy Hendrickson and asked if he could find a horse like Baby, the horse Costner had ridden in *Wyatt Earp.* Hendrickson suggested he just ride Baby, by then in his early teens but still in great shape. Hendrickson shipped Baby from his Montana ranch to the Canadian location, and Costner was happily reunited with his old costar. Duvall and Luna rode two other veteran movie mounts, Apache and Soldier.

The horse work in *Open Range* was carefully monitored by the AHA, and trained stunt horses were used throughout the film. In one scene, a horse appears to be struggling to get up after being shot. The horse, named Red, was a trained "lay down" horse. After Red was laid gently down on softened ground, he was cued to get up, then cued to lie back down so he would appear to be struggling.

REMEMBERING THE ALAMO

Back in 1960, John Wayne produced, directed, and starred as Davy Crockett in *The Alamo,* an epic Western about the historical battle for Texan independence that ends with the brutal massacre of the defenders of the Alamo fort by

Mexican soldiers. The film is best remembered for its action sequences, with plenty of stunt horses.

Forty-four years later, director John Lee Hancock's version of *The Alamo* (2004) was released. Starring Dennis Quaid as General Sam Houston, Billy Bob Thornton as Davy Crockett, and Jason Patric as James Bowie, the film had more than a million dollars budgeted for the horse unit. Wrangler Curtis Akin, a native Texan, was presented with the awesome challenge of finding all the main cast horses, stunt horses, and legions of army mounts. In all there were more than two hundred horses on the film, including more than fifty driving horses. Many were rodeo and ranch horses culled from spreads near the Texas location. Forty reenactors from the San Antonio Living History group were hired, along with their horses, as extras.

Curtis Akin had much of the period tack replicated for *The Alamo.* Carrico Leather in Kansas crafted thirty-two cavalry saddles, including a Santa Fe Hope saddle for General Huston (Quaid). Texas saddlemaker and reenactor Calvin Allen made a $12,000 replica of General Santa Anna's gorgeous saddle, complete with a carved lion's head saddle horn.

As General Houston, Dennis Quaid rode a white Andalusian named Paris. Trained to rear and fall, Paris is owned by the Anderson family of the Texas White Horse Ranch, which has more than thirty white horses. Ringo, an Arabian/Quarter Horse cross, doubled Paris. Jason Patric's mount was a dun ranch horse called Gunsmoke, owned by Robert Blanford and world-champion barrel racer Kay Blanford. Mexican actor Emilio Echevarria, who plays General Santa Anna, rode the black Quarter Horse stallion, Ima Bed of Cash. The grandson of the famous racing Quarter Horse, Dash for Cash, the stallion had a brief racing career before being purchased by the Bonita Ranch in Stephenville, Texas. Curtis Akin tried him out at a youth rodeo and was impressed by the beautiful stallion's quiet temperament. "He looks like a million dollars, and you can put your baby on him," said Akin in a 2003 interview. "You need that kind of men-

tality. You want something that if a bomb blows off next to him he's not going to go to pieces." Cash only had to get used to having a camera crane overhead; once he stopped looking and snorting at the strange beast, he was ready for "Action!"

All the horses used in the battle sequences were equipped with earplugs to deaden the noise of cannon shots and gunfire. Since the temperatures on location often soared into the mid-90s, wranglers made sure the horses were well watered and kept on shaded picket lines when not on camera. The horses were quartered at "Wranglerville," where Akin and his team of sixty, including several world champion rodeo stars, were housed during the filming. Akin and his crew ran what he calls a boot camp at Wranglerville, schooling the actors for two hours a day to fine-tune their riding skills.

A WOMAN'S PLACE IS IN A WESTERN

With some marvelous exceptions, such as Barbara Stanwyk as a lady rustler in 1955's *The Maverick Queen,* women have usually been relegated to background or, at best, supporting roles in big screen Westerns. However, Australian actress Cate Blanchett gives a tour-de-force lead performance as a stoic frontier doctor in *The Missing* (2003). Directed by Ron Howard, the film concerns the hunt for the kidnapped daughter of Maggie Gilkeson (Blanchett), who grudgingly joins forces with her long-estranged father, Samuel Jones, played by Tommy Lee Jones. The film is completely dependent on horses as Maggie and Jones saddle up to track her daughter's mounted abductors. Director Howard told head wrangler Tim Carroll that he wanted authentic-looking horses—not slickly groomed animals ready for the show ring. Carroll cast the lead mounts from his own movie horse ranch in Abiquiu, New Mexico. The trainer is a big believer in taking his colts on film sets, even before they are weaned, to

get them used to the commotion. By the time they are ready to be ridden, they are already movie horses.

Cate Blanchett—who had previously only ridden English, but proved to be an excellent western rider—was mounted on the brown gelding Magnum, a Quarter Horse type Carroll had raised from a colt. Magnum was doubled by his exact look-alike Jingles. The actress had difficulty telling them apart until she started riding: Magnum's gaits were smoother. As Maggie, Blanchett is required to pony a pack-horse. A mustang falling horse named Fred Red was used as he kept pace with the lead horse and would not put any stress on the actress's arm. "If the actors worry about their horses," reasons Carroll, "they can't do their job, which is acting."

Tommy Lee Jones rode the solid black eleven-year-old gelding Jamaica, a somewhat common-headed fellow Carroll calls simply a "good old horse." As Maggie's youngest daughter Dot, Jenna Boyd rode the bay Little Duke, a well-broke kids' horse doubled by Josh. As the kidnapped Lily, Evan Rachel Wood rode another solid movie mount named Joe.

Although horses are treated without sentiment by the film's characters, the filmmakers took great pains to ensure their safety in the many intense action scenes. In addition to trained stunt horses, many cinematic tricks were utilized to create suspense and drama. In one scene, a falling boulder spooks a horse during a flash flood. He rears and unseats his rider, a young girl, as the waters rise. Stunt double Julie Adair rode Carroll's stunt horse, Ninja. A fake rock made of Styrofoam was used, and tanker trucks pumping water regulated the "flood" level so it never rose above the horses' knees. In another scene, a flaming arrow hits a saddle during an Indian attack. The arrow, guided by a cable, never threatened the horse, and the computer-generated flame was added in the editing room: modern movie magic.

A CHILD'S DREAM OF HORSES

"Every night I pray to God to give me horses, wonderful horses."

—Velvet Brown, *National Velvet* (Screenplay by Theodore Reeves and Helen Deutsch)

Elizabeth Taylor's adoration of King Charles is obvious in this charming shot of the costars of *National Velvet* (1945).

IN THE CLASSIC FILM *NATIONAL VELVET* (1945), a dreamy-eyed young actress named Elizabeth Taylor, portraying Velvet Brown, looks heavenward and confesses her prayer for God-given horses. Countless children have shared Velvet's dream of owning a majestic animal who would not only be as loyal as the family dog but also have the power to transport them to magical lands. Many horse-themed films have capitalized on that dream, usually tossing in a strong moral about responsibility, perseverance, and compassion. Surprisingly modern in its outlook, *National Velvet* promoted the idea that a girl could excel in steeplechasing, a sport traditionally reserved for men. Of course, she needed the right coach, played in the film by a young Mickey Rooney and, most importantly, the perfect horse.

Based on the best-selling book by Enid Bagnold, *National Velvet* is set in the 1920s and revolves around working-class Velvet Brown and her horse, Pie, whom she enters in the most harrowing of races, the Grand National steeplechase, renowned for its formidable obstacles. In the novel, Pie stands for *piebald,* an English term for black-and-white pintos. Because piebalds were discriminated against in tradition-bound racing circles, Pie had an extra obstacle to overcome in the book. In the film, however, a blaze-faced chestnut Thoroughbred, King Charles, played Pie. His nickname was explained as a derivative of Pirate. King Charles was a spectacular jumper and had appeared in previous films performing his specialty, leaping over cars.

Taylor fell in love with King Charles, a seven-year-old grandson of Man O'War, at the Los Angeles riding school where she trained with Egon Mertz. At first rejected for the movie because she was small, Taylor campaigned aggressively for the part of Velvet Brown. She built her strength by riding an hour and a half every morning before school and began eating high-protein meals—including two giant farm breakfasts—and doing stretching exercises. After growing three inches, Taylor won the coveted role. She also convinced the producers to cast King Charles instead of a piebald horse.

A gifted equestrienne who started riding at age three, Taylor claimed she could jump King Charles over six-foot fences bareback. Like many star horses, however, King Charles had an ornery side, and when a trainer tried to teach him to play dead, he bit a chunk out of the man's shoulder. According to Taylor, only she and the jockey who doubled her in the race sequence could ride King Charles, but he followed the young actress around like a puppy, and she handled him with only a rope around his neck.

After the movie wrapped, producer Pandro S. Berman gave King Charles to Taylor for her thirteenth birthday. Taylor described that event as "one of THE moments of my life."

In 1961, *National Velvet,* the television series, debuted on NBC. Produced by MGM Studios, the series featured Lori Martin as Velvet Brown and a horse named Blaze King (King for short) as Pie. An American Saddlebred stallion, King was only three years old when the series producers saw him pulling a carriage. He had never been broken to ride but had the look the producers wanted. The script based Pie on King Charles: a blaze-faced chestnut with four white stockings. Wrangler Ken Lee was given six weeks to saddle-break King and teach Lori Martin to ride as well. Both pupils learned quickly and were ready on time.

Soldier and Chief were two horses from the Fat Jones Stables who doubled King. Wrangler Lee felt it was too risky to teach the main cast horse to rear, as sometimes a horse will use the trick offensively. When the script called for King to rear, Chief performed the trick instead. The gentle Chief, however, never harmed anyone. Soldier was a big horse who doubled King in all the jumping sequences. Although the series only ran for two years before it went into syndication, a number of *National Velvet* products were merchandised. One of the most unusual ones was a "King" horse seat, with a plastic horse head and yarn tail, for children to "ride" while watching the show.

After the series ended, Soldier was sold as a show jumper. A restaurateur in Cincinnati purchased King and Chief for his daughter. Eventually, they were donated to a farm for underprivileged children.

It wasn't until 1978 that a feature-length sequel to *National Velvet* was released. *International Velvet* starred a young Tatum O'Neal as Velvet Brown's niece, who trains for the British Olympic team aboard a horse named Arizona Pie. Olympic equestrian William Steinkraus served as a consultant on the film. Although the film

Wrangler Ken Lee was given six weeks to saddle-break Blaze King and teach Lori Martin to ride for the TV series *National Velvet* (1961–1963). Both pupils learned quickly, and Lori and King became the idols of millions of girls.

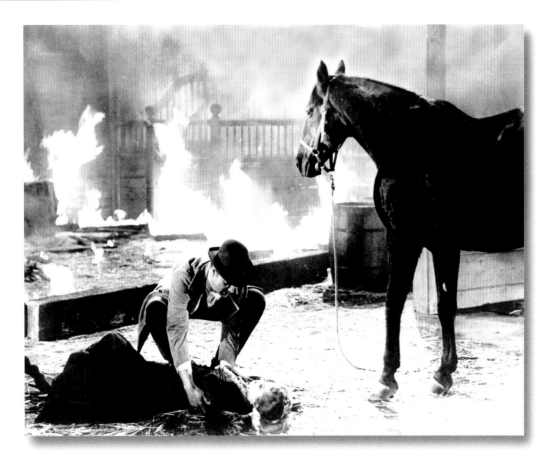

Above, Highland Dale as Beauty has his ears cocked for signals from trainer Ralph McCutcheon and ignores the fire as the human actors play out the drama in the 1946 *Black Beauty*. Opposite page, in a 1994 remake, Justin, Legs, and Hightower play Beauty, Merrylegs, and Ginger. For his role as the mare, Hightower's star had been extended into a stripe with make-up.

contains some excellent jumping sequences, it did not achieve the success of the beloved original.

BLACK BEAUTY

Anna Sewell's popular children's book *Black Beauty* was first published in 1877 and has remained in print ever since. The evergreen story is told from the perspective of a black stallion forced from a loving country home and subjected to cruelty as a saddle and carriage horse in Victorian London. The book's stark depiction of horse abuse is credited with starting the animal welfare movement in Britain.

Black Beauty's compelling story has inspired six films, the first in 1917, a silent film originally titled *Your Obedient Servant*. The title was later changed to *Black Beauty*, and the

film was rereleased in 1921. Vitagraph released its own silent version of *Black Beauty* in the same year. This version inspired the Swedish director Ingmar Bergman to become a filmmaker. Although Bergman was only six years old when he saw *Black Beauty*, the powerful emotions evoked by the film—particularly the dramatic burning barn sequence—ignited his own lifelong passion for cinema.

The next *Black Beauty* was a sound film released in 1933 by Monogram Studio. No record of the horses who starred in these early *Black Beauty* films has been found.

In 1946, Twentieth Century Fox released the third filmed version of *Black Beauty* to critical acclaim. A number of black horses were considered for the part of Beauty; the title role went to equine ingénue Highland Dale, who was only two years old at the time of his acting debut. Foaled in Missouri on March 4, 1943, the American Saddlebred stallion boasted an illustrious southern pedigree. Pedigree doesn't guarantee star quality, but Highland Dale had "it." Discovered when he was just eighteen months old by trainer Ralph McCutcheon, the beautiful Highland Dale proved to be a natural actor. Although only 15 hands high, he had such screen presence that he often stole the show from his human costars. After his impressive work as Beauty, Highland Dale was known around the McCutcheon barn as Beaut.

The year 1971 saw yet another remake of *Black Beauty*, a British production starring Mark Lester. The most recent version of *Black Beauty* is the 1994 Warner Brothers film directed by horse lover Caroline Thompson. Creating a heartwarming film that is true to Sewell's original tale, writer-director Thompson decided to use a narrator (Alan Cumming) to speak for Beauty. For the first time, the story was told from the horse's point of view. This clever device enables children especially to understand that horses have emotions similar to those of humans.

Caroline Thompson cast six-year-old black Quarter Horse stallion Doc's Keepin Time in the title role and made sure he received star billing. Owned by trainer Rex Peterson, Doc's Keepin Time came from a family of champion racing Quarter Horses. Despite his bloodlines, Doc's Keepin Time didn't shine on the racetrack, but Peterson saw his potential as a movie star. It began when he was searching for the star of the Family Channel's *The Black Stallion* television series. Peterson found Doc's Keepin Time just two weeks before production began. Cast as the title character, the stallion became known as Justin because Peterson found him for the series "just in time." The series ran from 1990 to 1993 and proved Justin's talent as a movie horse.

According to director Caroline Tompson, "Justin knew he was the star of *Black Beauty*." He could also be a prima donna and would sometimes pin his ears and bare his teeth at Thompson. Still, she loved working with Justin and Peterson. "Rex Peterson is my hero," said Thompson. "I couldn't have done *Black Beauty* without Rex. Rex Peterson is capable of looking at the world through the eyes of a horse, pure and simple."

Peterson used his wits to help create a realistic birthing scene for baby Beauty. Thompson was determined to capture the birth on film, so thirty pregnant mares were housed in foaling stalls on the English location. One of the mares finally gave birth to a black foal, but he was coming out crooked. When Peterson stepped in to turn the foal so he could be born normally, he noticed he did not have a white star like Beauty. Peterson quickly dabbed some white clown make up on the infant's forehead as he repositioned him, and baby Beauty was born with a star.

Justin's leading lady in *Black Beauty* was a chestnut Russian Thoroughbred mare named Rat, who played the part of Ginger. She was doubled in some scenes by Justin's

stablemate, Hightower, a gelding who had to be strategically filmed to pass as a mare. A dappled gray crossbred Shetland/Welsh pony aptly named Legs was imported from the States to play Merrylegs. In one of the film's more whimsical sequences, the clever pony uses his teeth to open all the stall doors to let his stablemates frolic at liberty.

After his star turn in *Black Beauty*, Justin received the American Quarter Horse Association's Silver Spur Award, an honor given to horses who exemplify the best of the breed. He went on to perform in commercials, music videos, and television, as well as in other films, including *The Horse Whisperer*. He played Gulliver, the horse who is killed early in the film. He also appeared in a music video for the British pop group Procol Harum (song: "Won't Fade Away"), in which he was completely buried and burst up out of the ground. Peterson consulted his mentor, Glenn Randall, for help with the next-to-impossible trick, but before Randall could respond, Peterson had figured out a way to train the stallion to accept being totally buried. He will never reveal how he accomplished this amazing feat, but it would not have been possible without the incredible bond of trust between Justin and his trainer— the kind of bond kids dream about when they imagine having a horse as a friend.

GYPSY COLT

A sentimental film about the bond between a horse and a little girl was 1954's *Gypsy Colt*, starring child actor Donna Corcoran and the then eleven-year old Highland Dale (playing a four-year-old) in the title role. Gypsy is a child's beloved pet who must be sold. The heartbroken horse escapes his new owners and travels 500 miles to return to his friend.

When he first read the script, trainer Ralph McCutcheon was concerned by the number of tricks

FURY

Beginning in October 1955, NBC drew children to the family television set on Saturday mornings to watch *Fury*, a show about a fiery black stallion and the boy who loved him. Fresh from his award-winning performance in *Gypsy Colt*, Highland Dale starred as Fury. His human costars were Bobby Diamond as Joey and Peter Graves as Joey's father. Set in the new West, the show ran from 1955 to 1960 and was later syndicated as *Brave Stallion*.

The series made Highland Dale a superstar, and he received volumes of fan mail, mostly from girls ages ten and eleven asking for a photo of "Fury," as he was forever after known to his public. His owner-trainer Ralph McCutcheon and insiders who worked with the horse continued to call him Beaut.

As Fury, Highland Dale commanded a then-whopping $1,500 per episode, out-earning seasoned actor Peter Graves, who gratefully acknowledged that "without that horse, I wouldn't have made the money I made." Working only four months a year, Highland Dale earned McCutcheon $500,000 in eight years.

In 1960 and 1961, Highland Dale added two more PATSY Awards to his collection for his work as Fury. In addition to his award for *Gypsy Colt*, he had also been given an Award of Excellence for *Outlaw Stallion* (1955). During a hiatus from the series in 1956, he had made his award-winning cameo in *Giant*. Highland Dale was to the movie horse world as famous and celebrated as some of his human costars, such as Joan Crawford (who rode him in 1954's *Johnny Guitar*), Elizabeth Taylor, and Clark Gable.

Highland Dale retired in the late 1960s at Ralph McCutcheon's ranch in Sand Canyon, north of Los Angeles. Although a stallion, he was never bred and lived to the ripe old age of twenty-nine.

Gypsy (Highland Dale) is determined to wake up his mistress Meg MacWade (Donna Cocoran) in one of the most charming scenes of 1954's *Gypsy Colt*.

demanded of Highland Dale. Beaut knew some of the tricks but needed to learn many more. Not only did the stallion have to perform largely at liberty, but he also had to feign near-death and stumble into a comatose state in the desert. At one point, four motorcyclists chase him through rocky terrain in a harrowing sequence that would terrify most horses. McCutcheon took three months to prepare Beaut for the film. Their hard work was recognized by the American Humane when Highland Dale won the first PATSY Award for his role.

Like many movie stars, Highland Dale continued to work for the film after shooting finished. He and Ralph McCutcheon went on a national publicity tour as *Gypsy Colt* premiered across America.

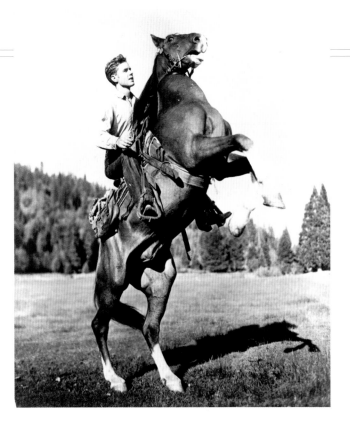

GALLANT BESS

The 1947 family film *Gallant Bess* told the story of an orphaned farmboy named Tex Barton (Marshall Tompson) on the cusp of manhood. Bonded to his mare Bess, with whom he hopes to build a horse ranch, Tex is forced to put his dreams on hold when America gets involved in World War II. Tex joins the U.S. Navy, but before he ships out to the South Pacific, he returns home to find Bess dying. After burying his beloved mare, Tex is stationed on an island where he finds a wounded mare in the jungle. The horse looks amazingly like Bess. Tex nurses this new Bess back to health, and she becomes the mascot of his navy unit. After returning the favor and saving Tex's life, Bess becomes despondent when he is shipped out for home without her. She breaks out of her corral and swims for the departing ship. The commanding officer's heart melts when he sees the mare's determination. He orders the ship's hold opened, and Bess manages to scramble aboard.

Although the horse gets billing as simply "Bess," the double role of the title character was actually played by a chestnut gelding named Silvernip. His white markings were altered slightly to distinguish the ranch Bess from the island Bess. Trained by Joe Atkinson, Silvernip displays some wonderful trick work in an early sequence in which Tex and the ranch Bess are camped out by a stream. While Tex sleeps, a parade of forest animals interacts with Bess, who reacts with amusing behaviors, such as turning "her" nose up at a skunk. Throughout the film, Silvernip works extensively at liberty and performs many standard tricks. While all of his work is outstanding, his final swimming scene is truly astonishing. Amazing as well is the revelation that according to the film's credits, the movie was based, at least in part, on a true story.

THE RED PONY

A less fanciful story was forged by author John Steinbeck from three of his classic short stories. The compelling 1949 family film *The Red Pony* concerns a young rancher's son, Tom Tiflin (Peter Miles), who learns about life's harsh realities. Alienated by his stern parents and tormented by his schoolmates, Tom bonds with his family's affable ranch hand, Billy Buck (Robert Mitchum). Trying to connect with his son, Tom's father gives him a beautiful dark chestnut pony to raise, but this only furthers the boy's dependence on Billy Buck. The clever pony, named Galiban after a mountain range, lets himself out of the barn one stormy night and contracts a deadly equine illness called strangles. In reality, there is no medical correlation between getting wet and getting strangles; but in the film it provides a pivotal plot point. Tom blames Billy for not keeping a closer eye on Galiban. Despite the ranch hand's best efforts to save him, the pony runs away to die. In a horrific scene, Tom discovers his beloved pet being devoured by buzzards.

The realism of this gruesome scene was accomplished with raw meat attached to the pony's sides. Trained to lie down, the pony amazingly tolerated trained buzzards picking at the meat.

Glenn Randall trained the flashy star pony, whose white blaze and flaxen mane and tail made him look like a miniature version of cowboy star Rex Allen's famous horse, Koko. In a wonderful fantasy sequence early in the film, Tom daydreams about being a circus ringmaster, and the flock of chickens he is feeding turns into a liberty act of eight white horses. These horses belonged to trainer Mark Smith, a friend of Randall's. Another fantasy sequence depicts Tom and Billy Buck as medieval knights leading a phalanx of mounted soldiers. Republic Pictures contracted all these horses and others incidental to the film from the Hudkins Brothers Stables.

The character of Billy Buck might very well have been patterned on Glenn Randall, as he possesses uncanny horse savvy. Raised in part on mare's milk, Billy tells Tom, "I'm half horse and horses know it." Ultimately, Tom realizes that the ranch hand had nothing to do with Galiban's death. In a gesture of sympathy, Billy softens the blow by giving the valuable foal of his champion mare Rosie to Tom.

THE FLICKA FLICKS

Mary O'Hara authored a trilogy of horse-themed books. The first, *My Friend Flicka*, was brought to the screen in 1943. Marketed as representing the American family values being fought for in World War II, the movie ironically starred a young British actor, Roddy McDowell, as Ken McLaughlin, the directionless son of a horse breeder. Ken dreams of bonding with a horse and comes into his own when he takes responsibility for a filly named Flicka.

Twentieth Century Fox originally attempted to economize by making the movie without specially trained

Country Delight with Roddy McDowell and Rita Johnson in *My Friend Flicka* (1943)

horses. The studio paid dearly for this decision, as the inexperienced horses caused costly delays in addition to close calls with stunt people. The studio then brought Jack "Swede" Lindell on to the film as equine supervisor, and the production took a two-week hiatus while he prepped experienced horses. Fox was so pleased with Lindell's work on *My Friend Flicka* that the studio created a special facility for him to train horses for its future films.

Country Delight, a seven-month-old sorrel American Saddlebred filly owned by Thomas H. Wright of Los Angeles, was cast as Flicka. Since Country Delight was not an experienced "actress," Lindell had to quickly put the necessary cues on the filly. She performed beautifully in the challenging role. Although it is always Country Delight in scenes in which the filly's sweet face with white star can be seen, she had several doubles for the stunts, such as one in which Flicka becomes tangled in barbed wire and badly injured. The scene was so realistic that

viewers responded with letters of outrage. In fact, the scene was an exquisitely staged piece of movie magic, using rubber bands with cork barbs for the wire and a skilled make-up artist to create Flicka's wounds.

Fat Jones's veteran horse Misty made a cameo appearance as Banner, Flicka's sire, in a scene in which he saves his herd from stampeding off a cliff. The Jones barn also supplied the myriad of other horses that populate the McLaughlins' Goose Bar Ranch.

My Friend Flicka was followed by a sequel, *Thunderhead, Son of Flicka*, released in 1945. The film featured the same major cast members as its predecessor. Swede Lindell was contracted as equine supervisor from the beginning, and the studio again rented horses from the Fat Jones Barn. The story begins with the birth of Thunderhead, supposedly a throwback to his "loco" great-grandsire, the Albino, who sired Flicka's crazy dam, Rocket. Faced with the challenge of finding a white colt to play Flicka's new baby, the studio gave contracts to dozens of mares likely to deliver such a foal. Shooting commenced when the perfect white colt was born. Ironically, according to genetic experts, it is highly unlikely that Thunderhead, whose movie dam and sire were both solid colors, would have been white.

One scene in the movie provoked audience concern even twenty years after the movie was filmed and shown on television. During a heavy rainstorm, young Thunderhead is trapped in a gully and struggles desperately as the water rises around him. Although the colt is eventually rescued in the film, the scenes of him panicking are extremely realistic. Actually, the entire sequence was filmed on a soundstage under very controlled—and safe—conditions.

The older Thunderhead in the movie was played by Blanco and nine other white horses from the Fat Jones Stable. Misty's character of Banner is killed off in the film,

by the old Albino stallion, but Thunderhead exacts revenge in a thrilling fight to the death with his great-grandsire. Now "King of the Herd," Thunderhead is released into the wilds by young Ken. Of course, the stallion's release symbolizes Ken's own rite of passage into young adulthood.

The television series *My Friend Flicka* debuted in 1956. It ran until 1957 on CBS and then moved to NBC for another year. A chestnut Arabian mare named Wahama played Flicka in the close work with the actors. Her double was Goldie, a chestnut Thoroughbred gelding featured in the action sequences. Because Goldie was such a handful, the young series star, Johnny Washbrook, an inexperienced equestrian, was not allowed on his back. A more accomplished rider, a ten-year-old girl, doubled Washbrook in the scenes with Goldie.

MISTY OF CHINCOTEAGUE

Another coming-of-age story that culminates with the release of a horse is *Misty* (1961), based on one of the most beloved children's books ever written, Marguerite Henry's *Misty of Chincoteague*. The story centers on a young brother and sister and the lessons they learn from wild ponies. At its heart is a real-life event that has been going on for centuries. Wild ponies that live on Virginia's Assateague Island are rounded up in late summer to swim across a narrow straight to nearby Chincoteague Island. There many of the weaned colts and yearlings are auctioned off to benefit the volunteer fire department that maintains the herd in good health. While historical evidence supports the legends that the ponies are descendants of Spanish horses from a shipwrecked galleon or descendants of pirate ponies, they are also likely kin of horses released on the island by Virginia settlers to avoid paying taxes on their livestock.

Starring David Ladd, the talented son of actor Alan Ladd, and ingénue Pam Smith as brother and sister, *Misty*

was filmed on location on the Chincoteague and Assateague Islands and features the pony swim and auction. The wild ponies were filmed for these scenes and are also shown galloping on the beach in beautiful sequences. The lead roles of Phantom and her foal, Misty, were played by real Chincoteague ponies tamed by local residents. As a foal, Misty was played by a pony named Emma, whose dark brown coat was bleached blond to match the coat of the pony in the book. Trainer Les Hilton spent several weeks working with the native ponies on location in advance of the shoot. Ladd, meanwhile, had no trouble with the film's riding scenes as he learned horsemanship with his father and sister Alana on the family's California horse ranch.

THE HORSE WITH THE FLYING TAIL

Another horse film based on real events was Disney's *The Horse with the Flying Tail*, released in 1960. The true story of a spectacular palomino jumper named Nautical, *The Horse with the Flying Tail* won an Academy Award for Best Documentary Feature Film and was a hit with horse-crazy kids who dreamed of finding such a diamond in the rough. Nautical's crowd-pleasing signature was his flamboyant flipping of his gorgeous white tail as he sailed over immense obstacles. The horse so aptly described in the film's title began life as Injun Joe in Roswell, New Mexico. He was given a western brand on his jaw, and when he was three, he was trained to be a cutting horse. He must not have liked his job because he reportedly escaped from every corral that tried to hold him. The palomino gelding was on the verge of being destroyed when he was rescued by an ex-cavalry officer. Sold as a foxhunter in Virginia, he had some exposure on the jumper show circuit, yet an explosive temperament kept Injun Joe from major success until world-class equestrian Hugh Wiley purchased him in 1955. Wiley, a U.S. Navy veteran, renamed him Nautical.

With the help of renowned U.S. Equestrian Team (USET) coach Bertalan de Nemethy, Wiley and Nautical formed a winning partnership. They represented the United States in major European competitions, winning England's coveted King George V Gold Cup in 1959. The former cow pony was awarded his trophy by none other than Her Majesty, Queen Elizabeth, the queen mother. Returning to the States, they helped the USET win the 1959 Pan American Games gold medal. Nautical's keen intelligence, great strength, and extreme speed combined with his flashy looks made him one of the most popular competitors of his era. According to Hugh Wiley, he loved to perform and went faster and jumped higher when he heard the roar of the crowd.

Although various horses portrayed the palomino in different stages of his life in the film, the real Nautical appeared in scenes documenting some of his career highlights. After the success of *The Horse with the Flying Tail*, Nautical suffered a bout with pneumonia and was retired. He received visitors for several years at the USET stables in New Jersey. Later he moved with Wiley to Maryland and occasionally made a public appearance at a horse show, where he tolerantly accepted the adulation of young fans. He eventually passed away on Wiley's farm.

THE BLACK STALLION

Mane and tail flying, a magnificent black stallion gallops down a deserted fairytale beach with a small boy astride. The child rides bareback, with no bridle, in perfect harmony with the glorious creature. This enduring poetic image is one of the reasons revered film reviewer Pauline Kael described *The Black Stallion* as "maybe the greatest children's movie ever made."

Based on Walter Farley's novel of the same name, 1979's *The Black Stallion* details the story of two shipwreck

orky Randall was assigned the task of training Cass Olé for his starring role as the Black Stallion. "He's the only horse I ever worked with that you could see had personality; you could see an expression on his face," said Randall. (Cass Olé shown here with Vincent Spano in *The Black Stallion Returns*.)

survivors, an American boy and the Arabian stallion who saves his life. Executive produced by Frances Ford Coppola, directed by Carroll Ballard, and gloriously photographed by Caleb Deschenal, *The Black Stallion* appealed to adults as well as children. Ballard had a strong vision that often challenged screenwriting convention. The heart of the film has an astonishing twenty-eight minutes of dialogue-free interaction between boy and horse as their bond of interdependency deepens to love.

Kelly Reno, an unknown rancher's son from Boulder, Colorado, starred as the boy, Alec Ramsey. The twelve-year old Kelly saw a notice in a horse magazine calling for boys with riding ability to audition for a new movie. Having learned to ride as a toddler, Kelly figured he qualified. Convincing his parents to drive him to the casting session in Denver, Kelly was chosen for the lead role over more experienced child actors. Except for the racing sequences, Kelly did all his own riding—and falling—in the film. *The Black Stallion* also marked the acting debut of Cass Olé, a purebred Arabian stallion foaled in 1969. As a show horse, Cass Olé enjoyed considerable success. In the mid-1970s, he was named American Horse Shows Association Horse of the Year for all breeds and won the national championship in Arabian western pleasure. His stellar record, superb temperament, and majestic presence won him the part of the Black. Although Cass Olé was not completely black, his four white socks and blaze were easily dyed.

Corky Randall was assigned the task of training Cass Olé for his starring role. Because the Black was required to work extensively at liberty, Corky taught the stallion to respond to off-camera whip cues. Cass Olé's exceptional talent wowed the veteran trainer. "He's the only horse I ever worked with that you could see had personality; you could see an expression on his face," said Randall.

"We didn't have that long to train Cass Olé; it just happened to be that he was a brilliant subject and trained out of this world."

Five horses doubled Cass Olé in fighting, running, and swimming scenes. Two were sorrel Quarter Horses belonging to Glenn Randall Jr. (brother of Corky) and were dyed black to resemble Cass. These horses worked in a sequence in which the Black bolts from Alec's backyard and runs through town. Two French Camargue ponies—known for their natural swimming abilities—were acquired for the water scenes. Seen swimming in the dimly lit shipwreck sequence and shot from underwater when Alec and the Black are rescued, the Camargues' coarse heads were not an issue, but since the ponies were white, they also required dye jobs. Another double, an Arabian named Fae-jur, a particular favorite of director Ballard, came from the Jack Tone Ranch in Stockton, California. All of Cass Olé's doubles were trained to respond to visual cues.

The Black Stallion made Cass Olé an international celebrity, and he delighted his fans with many personal appearances. He even participated in the 1981 Presidential Inauguration.

In 1983, a sequel, *The Black Stallion Returns*, was released. Directed by Robert Dalva, the Academy Award–nominated editor of *The Black Stallion*, the new film was based on Walter Farley's second book in *The Black Stallion* series. Kelly Reno reprised his role as Alec, and Cass Olé returned as the Black. The plot centers on Moroccan thieves who steal the stallion from his comfortable New York stable and take him back to North Africa to race.

Considered one of the most demanding films ever produced, *The Black Stallion Returns* began shooting in Zagora, Morocco, and wrapped up in Tunisia. Much of the film was shot in the Sahara Desert, where the Arabian

breed began. The film featured more than 20 horses in the lead roles (including doubles), and the production's stable housed 120 horses total. In Morocco, only the royal stable of the princess had more horses.

A chestnut stallion named SC Billy Rubin was the Black's racing rival. An Arabian gelding named Talishma (T-Bone) from Ginsburg Desert Wind Arabians played the Black's love interest, Johar, a gray Arabian mare. Black Midnight, a Polish Arabian from North Dakota, was used to double Cass Olé in the scenes with Talishma.

A stunning stallion named El Mokhtar also doubled Cass Olé. Foaled in Cairo, Egypt, in 1971, El Mokhtar was originally imported to the United States to be a breeding stallion. He was considered for the role of the Black in the first film, but his syndicate owners were not interested. At the urgings of Corky Randall, he was purchased for *The Black Stallion Returns* for $25,000. Since El Mokhtar

had never been ridden, Randall had to train him from scratch. According to the trainer, "He just never did anything wrong."

Much bigger than Cass Olé, El Mokhtar had a beautiful head and very expressive eyes, seen in some of the film's close-ups of the Black. He also possessed tremendous stamina and was used for the film's race sequences. Near the end of the movie, El Mokhtar, as the Black, appears to be running flat out, yet he suddenly surges ahead in an astonishing display of speed.

Just two weeks before shooting was set to wrap, El Mokhtar died tragically from complications of colic. A veterinarian was flown in from the States, but El Mokhtar could not be saved. An autopsy revealed a severely twisted intestine that even surgery, impossible on location, would likely not have remedied. The cast and crew were heartbroken. As the show must go on, Cass Olé performed the final race scene himself.

According to director Robert Dalva, Cass Olé was as enthusiastic about his work in *The Black Stallion Returns* as he had been in the original film. Cass came alive when he heard the sound of the slate (a wooden marker with a clapper used to identify scenes) slapping before each take and responded well to applause. To get the stallion revved up for the prerace sequence, Dalva directed the crowd to clap.

Although a born actor, Cass Olé did have his uncooperative moments. The most dramatic incident took place at one in the morning, on a remote location, miles from any village or highway. The moonless night was especially dark, and the crew was working in a small circle of light created by a generator. Dalva had been shooting a scene in which the villain, Kurr, kidnaps the Black. He had six takes in the can but wanted one more. Corky Randall noticed that Cass Olé was getting tired but told Dalva the horse could probably handle one last take. Kelly Reno was aboard Cass bareback with only a thin wire in the horse's mouth for control. Cass was asked to proceed to his mark, but as soon as he hit it, he spun left and galloped into the night. Kelly couldn't control Cass with just the wire and opted to bail off the runaway. To everyone's relief, Kelly came walking back into the light, unharmed—but he had no idea where Cass had gone.

The crew turned the lights out into the desert but could see no sign of the black horse. Corky Randall told Dalva he knew Cass was out there in the dark, "watching and laughing." Finally, the crew piled into Land Rovers and began searching for the stallion. Figuring Cass would be looking for food, they headed to the nearest village. "I was sitting on top of this Land Rover," says Dalva. "It was just starting to get light. I saw Cass appear from behind some bushes. He was hungry, he was tired and he was glad to see us." Turns out Cass had galloped about seven miles from the location.

Cass Olé died on July 22, 1993, at the age of twenty-four and was mourned by his many fans.

Ten years after Cass Olé's death, Disney Studios released *The Young Black Stallion*, a prequel to *The Black Stallion* made specifically for showing in IMAX. Based on a novel by Walter Farley and his son Steven Farley, produced by Fred Roos, and directed by Australian Simon Wincer, the film is set in the North African desert at the end of World War II. The movie begins with the birth of the Black and follows his adventures with a young girl named Neera.

Neera is played by Biana Tamimi, a native Texan who began riding at age five. Tamimi's excellent skills on horseback enabled her to perform much of the riding in the film, although stunt doubles spared the young actress unnecessary risk.

During the making of *The Young Black Stallion*, forty horses were employed, including twenty-one Arabians leased from Jack Maritz, a South African breeder. His mare, Jara, was filmed giving birth to a foal meant to be Shetan, as the Black is known by the Arabian people in the film. The baby Shetan was played by a long-legged colt named Cricket. Including Cricket, nine horses were required to play Shetan. For the lead horse, Australian horse master Heath Harris chose the three-time South African National Champion Stallion Thee Cyclone. Originally bred in Michigan by Frank and Pat Bradish, the pure Egyptian Arabian was just six months old in 1994 when he was imported to South Africa. In addition to his breeding class championships, he had many under saddle wins, including National Champion Country English Pleasure. Conditioned by ranch work, Cyclone was physically fit for the demanding role of Shetan. There was only one problem with the classically beautiful stallion: he was bay. Like so many movie stars, Cyclone had to change his hair color for his star turn. Thee Cyclone's main double, a mare

named AE Juliette, was also bay and required a dye job to match the stallion in racing scenes.

Two other mares, Isabella and Madonna, stood in for Cyclone during trekking scenes across the desert with Neera and scenes in which the horses interact with the young girl. A young stallion named Exclusive worked with Biana Tamimi in some of these scenes as well. According to the actress, Exclusive was a bit wild and made her nervous. Her favorite was a stallion named Rambo, whom she rode in some of the racing scenes. She also rode a mare named Nyala in many of the racing shots. The only nonpurebred Arabian horse used was an Arabian/Thoroughbred cross named Jibber Jabber, who did most of the rearing stunts. In one of his scenes, Shetan is visible from Neera's window, rearing dramatically on a mountaintop, and her grandfather realizes the horse she has been talking about is not a dream. The oldest horse in the movie was Bint Fore, a twenty-nine-year-old former broodmare who came out of retirement for a bit part pulling a cart. She limped a little, but her age-related lameness fit the character, and the mare enjoyed the attention.

CONTINUING THE TRADITION

Riding on the success of the first two *Black Stallion* movies came 1984's *Sylvester*, about a sixteen-year-old orphan who becomes a successful three-day-eventing Olympic rider after falling in love with a rodeo bronc she calls Sylvester.

Starring Melissa Gilbert and Richard Farnsworth, the film was shot in part at the Kentucky Horse Park in Lexington and includes footage of the 1984 Rolex Kentucky three-day event. The horse who played Sylvester, Tis No Trouble, was a dapple gray grand prix jumper discovered by screenwriter Carol Sobieski at the Foxfield Riding Club in Thousand Oaks, California. Nicknamed Sylvester after his character, the gelding was well loved by those who worked with him on the film, including trainers Corky Randall and Rex Peterson. In 1986, Tis No Trouble picked up the last PATSY ever given by the AHA at the thirty-second annual awards.

Continuing the tradition of turning books into film, Columbia produced *The New Adventures of Pippi Longstocking* (1988), adapted from the Swedish children's book by Astrid Lindgren. The film features the antics of a sea captain's daughter, Pippi Longstocking, her pet monkey, and her horse, Alphonso. In the Pippi Longstocking books, Alphonso is a Knapstrupper, a Danish breed similar in color to American Appaloosas. In the movie, Alphonso is played by a leopard Appaloosa owned by Hollywild Park in South Carolina. Alphonso was trained to sit, walk up and down stairs, pull a motorized sidecar, and allow several children to ride him at once. The film was not successful and proves that even the most talented horse actors have the unfortunate disadvantage of not being able to read the script before committing to their roles.

In 1992, Miramax released an exceptional film about the mystical bond between children and horses. Filmed in Ireland by British director Mike Newell, with an international cast starring Gabriel Byrne and Ellen Barkin, *Into the West* focuses on two young brothers, Ossie and Tito. They connect with a mysterious gray horse who follows their gypsy grandfather from the seashore to Dublin. Stuck in a miserable existence with their alcoholic father (Byrne), who is still grieving the death of their mother, the boys are fascinated by their grandfather's tale of the horse, Tír na nÓg, Celtic for "the Land of Eternal Youth," and the magical undersea kingdom whence he came.

Ossie and Tito try to keep Tír na nÓg in their tenement apartment but are forced to give him up. A wealthy horse dealer illegally buys the gray and discovers his preternatural jumping ability. The boys reclaim the gray in a dramatic scene at a horse show and go on the run— to the West, a place they have imagined from watching American Westerns.

Tír na nÓg takes the boys on a journey that not only connects them with their mother's spirit but also heals their father's broken heart and reunites him with his gypsy soul. The many haunting close-ups of Tír na nÓg's kind eye, as well as amusing shots of him in the tenement and beautiful scenes of him running, make lasting impressions.

Tír na nÓg was portrayed by three different light gray horses belonging to French stunt and trick trainer Mario Luraschi. For the romantic image of the lone horse running on the beach, a Lippizan liberty horse was cued to run 200 meters from a distant mark to the camera. The memorable shot was accomplished in one take. Two Andalusians played Tír na nÓg in all the other scenes. The talented horses were handled by Mr. Luraschi's protégé, Joelle Baland.

The Black Stallion screenwriter Jeanne Rosenberg penned the family film *Running Free* (2001), directed by the Russian Sergie Bodrov. A fictionalized story about how a group of real wild horses came to live in the Garub Desert of Namibia, South Africa, the tale begins in 1914 with a group of German horses being loaded onto a ship bound for South Africa, where they will toil in the mines. Among them is a pregnant gray mare who gives birth en route to the hero of the film, a chestnut colt. Like 1994's *Black Beauty*, the story is told from the colt's point of view through narration, added by a studio writer after the film was cut. Actor Lukas Haas provided his voice.

As the ship finds shore, the colt is separated from his mother. He is rescued by Richard (Chase Moore), an orphan boy who works at the stable of the German mine boss. Richard names the colt Lucky and does his best to nurture him. Despite Richard's efforts, Lucky finds the going rough at the fancy stable. His nemesis is a majestic black stallion named Caesar, who disapproves of the attraction between Lucky and his daughter, Beauty.

Aladdin, as Lucky in *Running Free* (2001), plays tag with a long-horned onyx.

Lucky is separated from Richard at the onset of World War I and finds himself alone. Searching for companionship in the desert, Lucky discovers two baby lion cubs resting under a tree. By now fully grown (and portrayed by a horse named Aladdin), Lucky lies down in the shade and plays with the cubs in an incredible sequence of animals-only acting. When the mother lion challenges Lucky, he is helped by a friendly onyx. The horse interacts with the long-horned African antelope in some fascinating scenes, made even more incredible by the fact that onyx are wild animals that have never been domesticated. The film culminates with Lucky returning to the old mining encampment for a showdown with Caesar. Victorious, he takes the former workhorses to live wild in the desert. All grown up, Beauty becomes his companion. In a tag scene, the adult Richard returns for a brief, touching reunion with Lucky.

While some reviewers criticized the narration's rather treacly anthropomorphizing of animals, it does help children identify with their four-legged friends as feeling beings. For older adult horse lovers, the cinematography and equine action make the movie more than worthwhile.

For much of the film, Lucky is a weanling. Amazing sequences depict the colt struggling in the ocean. According to Heath Harris, the ocean work proved very difficult as the water temperature was quite cold. As soon as a foal—in reality an at least six-months-old colt— would hit the beach, he would be wrapped in blankets and warmed by portable heat lamps. Several colts were used to create the swimming sequence to minimize exposure. In fact, it took ten horses to play Lucky in his younger years, including Jibber Jabber of *The Black Stallion Returns*. Trainers Harris and Bob Lovgren worked with all the horses. Head trainer Sled Reynolds supervised the animal action and worked with the exotics. Tommy Hall, an expert on the wild

horses of Namibia, was involved in the shooting of real wild herds. A team of thirteen assistant trainers was employed to marshal the extensive equine and exotic animal cast.

One of the most dramatic scenes in the film depicts a fight between Lucky's dam and Caesar, a fight that results in the mare's demise. The fight looks frighteningly real, but according to the American Humane Association, trainers cued the horses off camera to perform each behavior throughout the choreographed action. American Huimane did not monitor the production directly but relied on the reports of the Animal Anti-Cruelty League of Johannesburg, South Africa.

When the final credits roll, the horse stars are given billing just after the human actors, with a freeze frame of each horse superimposed behind the credit. Lucky's dam was played by a noble Polish Arabian named Kateefa. His filly friend, Beauty, was played by Noodle, and a weanling named Nisha is given credit for playing Lucky as a young horse. Although Caesar is referred to as a Thoroughbred, he was played by a jet-black Friesian stallion named Fat Albert.

ANIMATED EQUINES

Animated equines have enchanted children of all ages for decades. In Disney's first full-length animated feature, 1937's *Snow White and the Seven Dwarfs*, Prince Charming rides a beautiful white steed. This horse was modeled on King John, an Arabian stallion owned by the illustrious Kellogg Arabians of California. Short cartoons such as Disney's *How to Ride a Horse* from 1941, starring the loveable Goofy as a ridiculous cowboy, warmed up audiences for the feature attractions. In more recent times, a horse named Kahn provided transportation and companionship to Mulan, the heroine in *Mulan* (1998). In *Toy Story 2* (1999), the horse Bullseye saves the day in the film's

climactic sequence, helping cowboy star Woody make an improbable transfer to his back from the landing gear of an airplane.

It wasn't until 2002 that a full-length animated feature focused primarily on a horse. DreamWorks' *Spirit, Stallion of the Cimarron* tells the story of a wild stallion and his adventures with humans both good and evil. Told from the stallion's point of view through narration, *Spirit* includes the voices of stars Matt Damon (Spirit) and James Cromwell.

Spirit's animators sought to create the most realistic horses possible for the film. Horses are difficult creatures to animate because of their long, inflexible spines, range of gaits, well-defined musculature, and vibrant body language. Anatomy and locomotion expert Stuart Sumida, who teaches at California State University San Bernadino, was recruited to instruct the animators at the Los Angeles Equestrian Center, where he could illustrate his lectures with live examples. "My job," said Sumida, "is to teach animators about natural movement and shape so that when these characters are moving on-screen the audiences are so comfortable with what they do, they lose themselves in the story."

The horses in *Spirit* do not speak, so their emotions had to be conveyed on their faces. To create more expression, artists gave the horses eyebrows and white around the irises of their eyes. Of course, real horses have neither characteristic.

A handsome Kiger Mustang stallion served as the model for *Spirit*. Named for Oregon's Kiger Gorge, where Bureau of Land Management officials discovered the breed in 1977, Kigers are thought to be purebred descendants of the Spanish Barbs first brought to America in the 1600s. Prized for their beauty and dispositions, they are now bred in captivity. Originally called Donner, Spirit, as he was

renamed after the movie, was foaled on a ranch in Bend, Oregon, on May 8, 1995. A dun with a dorsal stripe, he stands 14.3 hands high. He was chosen for Spirit because of his great personality, his lovely gaits, and his willingness to pose for hours while the animators copied his conformation. After making his contribution to the film, Spirit was permanently retired to the Return to Freedom wild horse sanctuary in Lompoc, California, for an idyllic life among others of his kind.

A blue-eyed bay overo pinto mare named Wakaya (registered with the American Paint Horse Association as Maide Of Smoke) was screenwriter John Fusco's special inspiration for Spirit's companion, Rain. Wakaya lives in Vermont with many equine friends on Fusco's farm where he maintains a conservancy for rare Spanish Mustangs, as well as a retirement colony for movie horses.

A wooly Spirit surveys his winter pasture at the Return to Freedom wild horse sanctuary.

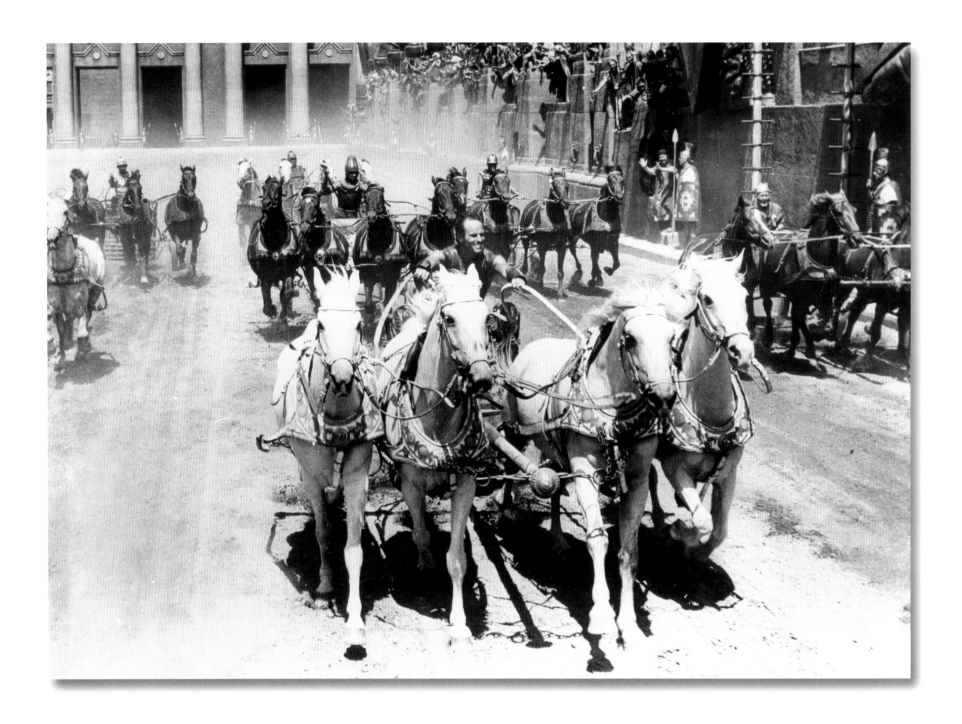

EPICS AND ADVENTURES

"A horse! A horse! My Kingdom for a horse!"

—William Shakespeare, *Richard III*, Act. V, Scene 4

Ben Hur's heavenly horses spirit Charlton Heston to victory in the 1959 release.

IN THE FINAL ACT OF Shakespeare's play *Richard III*, the murderous King Richard loses his mount in battle and cries out for a horse to spirit him away from certain death. Alas, no steed materializes to save the maniacal monarch, and Richard perishes. The great British actor Sir Laurence Olivier starred in a self-produced and directed film of the play in 1955. Film, of course, permitted the staging of the climactic battle with scores of horses, including the beautiful gray, felled by an arrow, who brought graphic realism to Richard's desperate plea. Sir Lawrence gallantly credited the two "Masters of Horse," Jeremy Taylor and Jack Curran, who furnished the many equines that appear throughout the film, at court and on the battlefield.

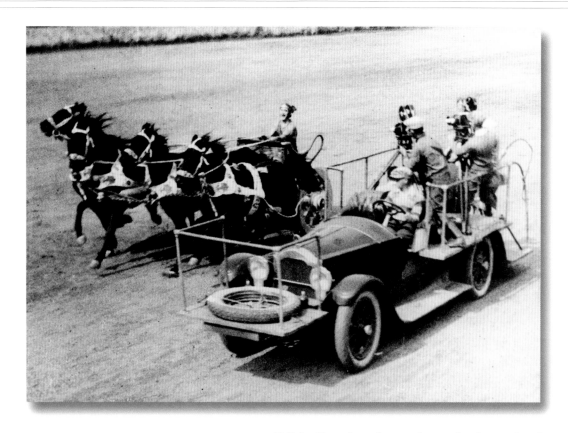

Celluloid kingdoms from widespread realms, real and imagined, have been won and lost by armies on horseback. Meanwhile, soldiers of fortune and avengers of all sorts have dashed across the screen on equally dashing steeds. Historical dramas have costumed equines in elaborate trappings—which have sometimes presented unforeseen productions problems. From the silent era to the twenty-first century, the intrepid movie horse has had many adventures in some of the greatest extravaganzas ever filmed.

BEN-HUR

Winner of a record-making eleven Academy Awards, including Best Picture, Ben-Hur (1959), the tale of a Jew's persecution by the Romans in the time of Christ, was based on a novel by Civil War hero Gen. Lew Wallace. The film's best-remembered sequence is a thrilling chariot race between hero Judah Ben-Hur and his nemesis, Messala. Ben-Hur was first staged as a play in 1880; it used live horses in the chariot race scene. In the most lavish productions, as many as five horse-driven chariots appeared on treadmills, against a rolling canvas backdrop. The first film version of Ben-Hur appeared in 1907. The chintzy production grabbed footage of a mock chariot race—all the rage since the success of the play—being staged by the Brooklyn New York fire department as part of a fireworks celebration. This fifteen-minute one-reeler marked the first time a chariot race had been filmed. William S. Hart played the role of Messala, Ben-Hur's treacherous friend. Hart, of course, became the first cowboy movie star to share billing with his horse, Fritz. The play Ben-Hur continued its twenty-year run, featuring one constant cast member, an Arabian horse belonging to Lew Wallace.

Goldwyn Pictures secured the motion picture rights in 1923. The resultant film cost $4 million and was Hollywood's most expensive silent epic. Photography began in Rome in early 1924, but problems plagued the film from the start and brought shooting to a temporary halt. It resumed in June 1924, after the director and many of the cast had been replaced. A disastrous fire during the great sea battle claimed the lives of several Italian extras and prompted the newly formed Metro-Goldwyn-Mayer Studios to bring the production home to California. The climactic chariot race had yet to be filmed.

The coliseum set was built on a vacant lot, and preparations for the great race were made. Unfortunately, the man in charge of the sequence, second unit director B. Reeves "Breezy" Eason, had little regard for safety in staging the action. He even offered a $5,000 bonus to the winning driver, ratcheting up the competition to add realism at a deadly cost to horses. Estimates place the number of equines who paid with

their lives at as few as two and as many as one hundred. It was clearly much more than two. From the get-go, the sequence is nerve-wracking to watch as the horses rear and fight, waiting for the start. Finally, the signal is given; the horses fly off their marks. As forty-two cameras whirred, a wreck instigated by Messala, played by Francis X. Bushman, leaves four horses crumpled on the ground. An accidental crash on a turn had several more chariots smashing into the wreck, resulting in a huge pile of chariots, stuntmen, and horses. Publicity stills actually featured these unfortunate horses, some dead on the spot. Horses that didn't die right away were not given the benefit of veterinary care. According to Bushman, "If it limped, they shot it."

Fortunately, the men in charge of the chariot race in William Wyler's 1959 remake of *Ben-Hur* were consummate professionals who put safety first. Wyler himself had been an assistant director on the 1925 film and presumably had learned what *not* to do. Legendary trainer Glenn Randall worked with the teams of horses while another legend, Yakima Canutt, directed the action. The arena, built in Rome, covered eighteen acres, and was, at the time, the largest single film set ever built. Forty thousand tons of white beach sand were used to make the track, ensuring safe footing. Eight thousand extras packed into the five-story stands watched as Charlton Heston, playing Judah Ben-Hur, drove a team of four white horses and Stephen Boyd, playing Messala, drove a team of blacks. The horses' contrasting colors not only obviously symbolized good and evil but also made it easy to identify the hero and villain as they tore around the track. Yakima Canutt's son Joe doubled Heston for a stunt in which the horses jump over a wreck. Joe was accidentally thrown onto the tongue of the chariot but managed to scramble back into the vehicle and regain control of the team. The

mishap was included in the film, with an insert of Heston climbing into the chariot. Joe Canutt suffered the only injury in the whole race, a cut on his chin. The twenty-minute chariot race still stands as one of the most breathtaking sequences ever committed to celluloid.

Glenn Randall was especially proud of his work in an earlier scene, in which Ben-Hur is the guest of Sheik Ilderim (Hugh Griffith). After a sumptuous dinner in his tent, Ilderim summons his "beloveds." Ben-Hur, thinking the sheik is summoning the many wives he has been boasting about, tries to take his leave. Then an attendant parts the tent flaps, and there the sheik's four white chariot horses stand together, with no bridles or halters. Ilderim adores the animals, whom he has named after heavenly stars: Antares, Aldebaran, Rigel, and Atair. On command, they come to their master to offer their goodnights. Nuzzling and nodding, nudging Ilderim, whinnying, and yawning, each horse performs to the delight of Ben-Hur. Randall lay on the ground out of frame, cuing each horse to do his bit.

ROMANS RIDE

Since Ben-Hur, the gladiators and games of ancient Rome have continued to fascinate filmmakers and audiences alike. Director Stanley Kubrick threw his hat into the arena with 1960's *Spartacus*. The story of a slave who becomes a gladiator and leads a revolt against the decadent empire, the film starring Kirk Douglas and Sir Laurence Olivier picked up four Academy Awards. Although the production filmed in Europe, the most intense scenes involving horses were battle sequences directed by Yakima Canutt on the back lot of Universal Pictures. A who's who of Hollywood stuntmen performed numerous horse falls, including Cliff Lyons, Jack Williams, and Canutt's sons, Joe and Tap. Tap Canutt used his mare Gypsy on the show, Jack Williams rode his mare Coco, and Chuck Roberson used his famous horse Cocaine.

At the 2001 Academy Awards ceremonies, the Best Picture Oscar went to *Gladiator* (2000), directed by Englishman Ridley Scott and starring Australian actor Russell Crowe as Maximus, a victorious general who is enslaved and forced to perform as a gladiator, circa AD 180. The first "voice" in the film is that of a whinnying horse, heralding the arrival of Maximus and his army. As Maximus, Crowe rides a spirited black steed from Seville, Spain, known by his barn name, George. During one scene, he was spooked by fire used in the bloody battle sequence and backed downhill into some trees. Russell Crowe's cheek was lacerated by a branch, but despite being scared, the star kept his cool. "A horse can sense when you're not totally in control of what you're doing," he said later. "If he senses fear, he's likely to respond, 'Well, if you're scared, get off my back, 'cause I can do this stunt just fine and dandy without you.' " No attempt was made to cover up Crowe's wound, which fit his character. Owned by *Gladiator* horse master Steve Dent of England's Field Way Farms, the magnificent George is a veteran of many films. He was originally purchased to portray Daredevil, the fearsome mount of the Headless Horseman in *Sleepy Hollow* (2000)—and served as the model for the animatronic horse used to double him.

A headless horseman of a different sort, a decapitated corpse, rides another of Dent's Spanish horses in *Gladiator's* opening battle sequence, the beautiful gray Andalusian, Conyo. Dent prefers these Spanish breeds for their fiery yet tractable temperaments. "Spanish horses are the best," he has stated. "You just have to work with them for ten minutes, and they've revved up like a Ferrari."

Gladiator is resplendent with fabulous horses, from the little white pony that belongs to Maximus's son to a host of wagon and chariot horses. A white horse is used symbolically in a vision when Maximus is wounded, and close-ups of thundering hooves portend the murder of his family. In one of the brutal games in the Roman coliseum, warriors in chariots, each pulled by teams

of two horses, attack the gladiators. Maximus commandeers a gray steed, a beautiful Andalusian stallion named Jabonero, from a wrecked chariot and emerges victorious.

GREEK MYTHOLOGY

The myths and legendary stories of ancient Greece have also attracted filmmakers. Based on the myth of Perseus and Andromeda, MGM's 1981 spectacular *Clash of the Titans* featured a winged Pegasus, courtesy of special effects, along with an all-star cast headed by Sir Laurence Olivier.

Homer's poem *The Illiad* has spawned at least two films about the Trojan War, circa 1193 BC. *Helen of Troy* (1956), a Warner Brothers production, featured an international cast directed by Robert Wise. Second unit directors Yakima Canutt and Sergio Leone coordinated stunts, including chariot horses.

A more recent film about the Trojan War, *Troy* (2004), was also produced by Warner Brothers. Directed by Wolfgang Petersen, the film stars Brad Pitt, Eric Bana, Orlando Bloom, and Diane Kruger. Wrangler Raleigh Wilson had the job of import-

Above, one of Steve Dent's Andalusians and his rider negotiate the flaming battlefield in 2000's Roman epic *Gladiator*. Opposite page, the mighty Spanish steed George carries the film's title character, Maximus (Russell Crowe), past his soldiers before battle.

ing fifteen Andalusians from Madrid to Malta, where the walled city of Troy was created for the film. About thirty Thoroughbred types from Malta were also used for battle sequences. Local polo players worked as extras, and their experience riding while wielding a polo mallet made it easy for them to ride carrying a large shield. Four chariot teams were trained with specially designed vehicles made of aluminum alloy, which would flip more easily in stunt sequences. To ensure clean getaways, the horses were equipped with breakaway harnesses.

For one stunt, Wilson trained liberty horses to jump through a ring of carefully controlled propane-powered flames. Special fire-retardant gel was used to protect the horses from head to tail. Both Brad Pitt and Orlando Bloom were experienced riders but needed to learn how to drive chariots for the film. The actors also had to get used to riding without stirrups; saddles as we know them now did not exist in ancient Greece. Determined to be historically accurate, the producers insisted on all custom-made tack, with no shiny buckles. To ensure the actors' safety, emergency handholds were attached to surcingles, hidden under the blankets that served as saddles.

From Malta, production moved to Baja California, Mexico, where Wilson had to acquire new horses. He was allotted one cleared acre for the horse camp and had 12-by-12-foot shaded pens constructed in rows of twenty. A 120-by-60-foot arena was built for training and exercising the horses, four 750-liter water tanks provided clean drinking and bathing water, and four generators powered the water pumps and floodlights. Because algae formed quickly in the tropical climate, the tank containing drinking water was scrubbed twice weekly. Electrolytes were added to the horses' drinking water. Thirty grooms were employed to attend to the animals in shifts, twenty-four hours a day. As the camp was being set up, Wilson and his

team scoured the country for horses to match those used on Malta. Fifty horses and riders came from Durango, in addition to twenty Canadian draft-type horses from a Mennonite community in the same region. Accustomed to hauling heavy milk wagons, the Mennonite horses knew how to drive, but they had to get used to hauling cattle hides piled with "corpses" in scenes depicting the aftermath of battle. Nineteen horses were purchased for falls, rears, and cast horses. Among them were a handful of Andalusians dyed to match the horses used on Malta.

It took weeks to get the horses into top physical shape. Proper diet, excellent care, and a rigorous conditioning schedule resulted in a fit and healthy herd of movie horses ready for "Action!" By the time the production wrapped and the horses were returned to their original owners—or placed in new homes—they were in the best conditions of their lives.

BROTHERS IN ARMOR

The legend of Britain's King Arthur has been recreated on film for decades. In 1953, MGM released *Knights of the Roundtable*, the studios' first feature shot in Cinemascope. The paint-by-numbers version of the medieval legend starred Mel Ferrer as King Arthur, Robert Taylor as his devoted knight Sir Lancelot, and the sultry Ava Gardner as Queen Guinevere. Lancelot's steed, Berik, was a trained Hollywood horse who performed classic tricks such as pulling the hero out of quicksand, laughing, and coming to a whistle. Throughout the picture, Berik is obscured by a medieval costume called a bard, which includes a hood and body skirt, so it is difficult to even determine his color. He most likely came from the Fat Jones Stable, which supplied cast horses to MGM in the 1950s. Yakima Canutt was the second unit director, in charge of the stunt and equine action, which included the requisite jousting match.

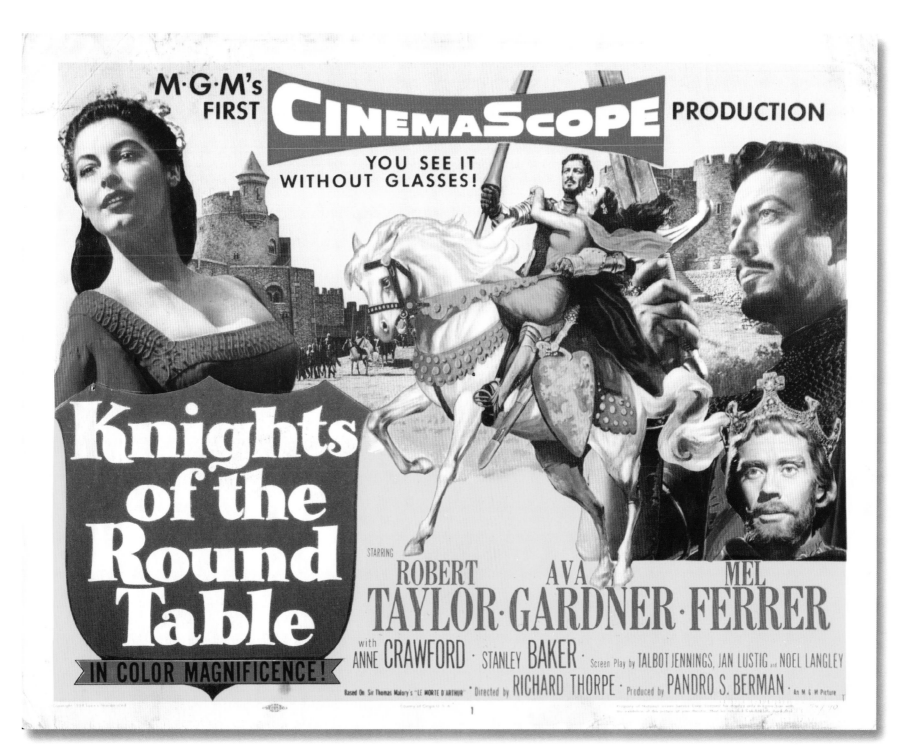

Jousting stuntmen
demonstrate breakaway rubber-tipped lances for *Camelot* (1967) in front of a castle set built on what is now Forest Lawn Cemetery in the Hollywood hills. Opposite page left, *A Knight's Tale's* star stunt horse Emilio takes a fall in a Paris exhibition with his owner-trainer, Mario Luraschi. Opposite page, knights of *King Arthur*, (2004) left to right, Ioan Gruffudd, Hugh Dancy, Joel Edgerton, Mads Mikkelsen, and Ray Stevenson, are led in a gallop by Clive Owen as Arthur, aboard the regal Bohemia.

In 1967, Warner Brothers released *Camelot*, a musical version of the legend based on Alan Jay Lerner's stage play. Yakima Canutt's son Tap ran the horse action. On some night shoots on Warner's Burbank back lot, Tap had more than thirty-five stuntmen and fifty riding extras working.

The whimsical headgear worn by the horses in the jousting sequence initially caused problems. The costume designers had created helmets with attached horns and other fanciful embellishments. When the helmets were placed on the horses, all hell broke loose. According to Tap Canutt, "It took us a couple of hours to figure out why our cast horses suddenly turned into rodeo stock, bucking and kicking like doubles for Rex, the Devil Horse." What the designers didn't take into consideration was the sensitive spot on the top of a horse's head, the poll. The helmets were putting too much pressure on the poll. "Once the inside of the helmet was redesigned to relieve that pressure," the stunt coordinator remembered in 2004, "the horses' natures went back to what I like: gentle."

A veteran of many major epic pictures, Tap Canutt has worn all kinds of armor. Real armor, of course, was heavy; but even though it is lightweight, especially for stuntmen—and horses—motion picture armor is rigorously designed and tested before its use. It must be both comfortable and protective. Leather replaces steel, woven cord replaces chain mail, and plastic copies of headgear are fitted around padded football type helmets. In fact, Canutt has stated, "I preferred working in leather armor because I felt like I was wearing an 'all-over pad,' which beats hitting the ground as a naked Apache."

In 2001's comedic romantic adventure *A Knight's Tale*, shot in Czechoslovakia, Australian heartthrob Heath Ledger starred as a peasant squire named William who assumes the identity of a knight. Disguised as Sir Ulrich Von Lichtenstein, William seeks glory in a series of jousting matches. After being knighted by Edward, prince of Wales, who recognizes his pure heart, Sir William finally bests his

devious rival, Count Adhemar of Anjou (Rufus Sewell), and wins the Lady Jocelyn (Shannyn Sossamon).

Playing fast and loose with history, American writer-director-producer Brian Helgeland staged the multiple jousting tournaments as medieval rock concerts, with contemporary music and jokes. The horse work in the film is quite serious, however, and Helgeland was fortunate to have the assistance of French trainer Mario Luraschi, who specializes in spectacular stunt horses. While many of the production horses came from the Czech National Stud, including Heath Ledger's bay roan mount, Mr. Luraschi provided all of the stunt horses, including El Noche, Count Ademar's black steed, whose signature move in the film is a rear before galloping into the joust. A half Andalusian/half Thoroughbred, El Noche is a veteran of many European films and live shows.

The horses trained rigorously for two months before production and practiced daily during the four-month shooting schedule. While the lead actors did some riding, they were easily doubled for the jousting runs because of their armor.

The horses were well protected by armor of their own, including full faceplates with eye shields to protect against splinters from the knights' lances, which were primarily made of balsa wood. To create a dramatic splintering effect when the knights made contact with an opponent, the hollowed out tips of the lances were filled with dry spaghetti.

The most stunning horse work in *A Knight's Tale* was performed by Mario Luraschi's chestnut Spanish/Anglo Arab crossbred gelding, Emilio, who was tuned on set by Pascal Madura. As the knight he is carrying (stuntman Thomas Dupont) is felled by a lance, Emilio flips up and over backward, falling through the lisse, or rail, that separates the jousters. The stunt required extensive planning and was perfectly executed by Emilio and Dupont.

The stunt team received the "Best Work with an Animal" prize at the 2002 Taurus World Stunt Awards. Founded in 2000 by Red Bull soft drink scion Dietrich Mateschitz, the Taurus Awards are given annually in Hollywood and have revived the tradition of recognizing animals for their contributions to film.

Written and executive produced by *Gladiator* writer-producer David Franzoni, *King Arthur* (2004) is a departure from the fanciful films of yore. The more historically accurate film contends that Arthur was a half-Roman officer and his Knights of the Roundtable were Sarmatian warriors, from eastern Europe. The Sarmatians reportedly had the finest cavalry in the ancient world.

Set in the Dark Ages, *King Arthur* features no jousting costumes and, in fact, no jousting as the sport did not yet exist. What the film does feature are scores of splendid horses on which much

of the action depends. The very first image of *King Arthur* is of the mounted knights' riding straight toward the camera in a swirl of smoky mist, looking mighty and mythical.

The knights' mounts were mostly Spanish Andalusians from Steve Dent's Field Way Farm, which provided a total of sixty horses for the production. Dent worked closely with director Antoine Fuqua, who took a particular interest in matching the human actors with their equine partners.

As Arthur, Clive Owen rides Bohemia, a regal light gray Andalusian gelding. Owen learned to ride for *King Arthur* in an intensive "boot camp," taking lessons from Steve Dent five days a week for seven weeks. "Arthur is supposed to be a good horseman," Owen has said, "so a big part of the acting challenge is how you feel and look and present yourself on horseback." Owen met his challenge with aplomb and appears quite regal aboard the beautiful Bohemia. Like many horse stars, Bohemia had his own stunt double. In this case, Conyo, one of Steve Dent's most accomplished specialty horses, executed rears and lay downs for Bohemia on the battlefield.

Sir Lancelot (Ioan Gruffudd) was matched with an eight-year-old black Andalusian stallion named Aroma. Gruffudd thoroughly enjoyed the adventure of boot camp and became an accomplished rider.

As the fearsome but garrulous Bors, Ray Winstone is mounted on George, the splendid equine actor from *Gladiator* and *The Headless Horseman*. Truly one of the most sought-after horses in modern movies, George is also the mount of British star Orlando Bloom, who portrays the heroic blacksmith Balian of Ibelin in 2005's *Kingdom of Heaven*.

Danish heartthrob Mads Mikkelsen had never ridden before *King Arthur*. For his role as the knight Tristan, Mikkelsen immersed himself in the boot camp experience. "It was like going out to this great playground every day and getting paid for it," he stated. "It was useful in terms of bonding with the actors and with the horses." Mikkelsen forged his bond with a dappled gray Andalusian gelding called Oscar.

A gray Andalusian stallion named Jabonero carries Hugh Darcy, as Sir Galahad, into battle. Jabonero had previously worked in *Gladiator* with Russell Crowe. As Gawain, Joel Edgerton was mounted aboard a gray Andalusian gelding named Rusty. The Australian Edgerton had learned to ride as a child and brushed up his skills for his role in *Ned Kelly* (2003). According to Edgerton, however, the *King Arthur* riding boot camp "took everything to another level." The only non-Spanish mount was Goliath, a big-boned French three-quarter crossbred black gelding with a white star. The handsome, husky horse was the perfect complement to actor Ray Stevenson's character Dagonet, an awesome warrior with a tender side.

For stunt coordinator Dent, the weeks of preparation paid off during the battle scenes, which often comprise many controlled shots. Surprisingly, according to Dent: "The hardest shot in the movie was when all seven of them [the knights] were galloping across a field with about five cameras on them. Of course, when they ride like this, all the horses are competing, and it is dangerous. But it worked, and it worked brilliantly."

Thematically, *King Arthur* pays great homage to the noble horse. When young Lancelot is brutally recruited into the Sarmatian cavalry at the beginning of the film, his father consoles him with the legend that every fallen knight returns as a great horse. It is implied that young Lancelot's handsome black steed—an impressive Belgian named Hendrix—is one of these. At the end of the film, when Lancelot and two of his fellow knights have been slain by the Saxons, three magnificent riderless horses cavort together, symbolizing their fallen masters. It is a profoundly poetic image that adds the absolute importance of the horse to the Arthurian legend.

FAR AND AWAY

Beginning in Ireland and ending up in America's west, 1992's *Far and Away*, directed by Ron Howard and starring Tom Cruise and Nicole Kidman, revisits the Oklahoma land rush depicted in the early Western *Cimarron*. Head wrangler Rudy Ugland and wrangler Rusty Hendrickson gathered 750 horses for the sequence, which was monitored by American Humane Association representatives every step of the way. The filmmakers employed an army of stuntmen to ride and drive breakaway wagons in carefully staged wrecks.

Ugland furnished many of his own horses, including the veteran falling horse Twister, who performed his specialty, a spectacular combination rear and fall. Nicole Kidman was assigned to Ugland's reliable movie horse 101. A more accomplished rider, Tom Cruise rode Whiskey, a beautiful black Quarter Horse with a white star. Like the Appaloosa Dear John, Whiskey was trained to buck on cue. When Cruise's character, Joseph, arrives at the race site, the only available mounts are a placid old creature and a frisky young animal bucking in a corral. This was Whiskey, responding to Ugland's off-screen whip cues. Joseph chooses the calm horse, who dies almost immediately on the blacksmith's hitching rail. The real horse was tranquilized for close shots (a practice acceptable at the time but no longer condoned by the American Humane), and a fake horse was used for wider shots. Joseph is obliged to ride the fractious black, who promptly dumps his reluctant rider. Joseph is so fed up with the skittish horse that he punches him in the nose so he can mount. The punch was an illusion, of course, achieved by pulling Whiskey's head away with a wire when the punch "connects."

Since working with them in his films, Tom Cruise has become hooked on horses and went home with two from the *Far and Away* production: not Whiskey though, who in 2005 was still enjoying life at Mr. Ugland's retirement ranch in Atascadero, California.

THE CIVIL WAR

MGM and producer David O. Selznick conspired to create the sweeping Civil War–era romantic drama *Gone with the Wind* (1939), another winner of multiple Academy Awards, including Best Picture. Equines are everywhere in the movie, from the opening credit sequence over a pastoral scene to laboring mules, fancy mounts, and carriage and battle horses. A white horse introduces Scarlett O'Hara's father, Gerald, as a zestful man, who makes his entrance jumping a series of fences. Diamond, an American Saddlebred jumping horse that Elizabeth Taylor trained on as a child, and another Saddlebred, Anacacho Revel, also appeared.

Yakima Canutt, doubling Clark Gable, drives Tracy Lane's stunt horse through the flaming city of Atlanta (part of an old set for *King Kong* on a studio back lot in Culver City) in 1939's *Gone with the Wind.*

This was the era of Charlie Flores's stable, so many of the horses must have belonged to him. Others were specialty horses supplied by individual trainers.

Second unit director Breezy Eason handled the dramatic burning of Atlanta. Fortunately, no equine casualties occurred during the recreation of this horrific event—nor during any other part of movie—to tarnish the production. That is probably because the expert Yakima Canutt was on task. Canutt staged a sequence in which he drives a one-horse hack at a full run through the burning set and up an alley, where, as he is attacked by several ruffians, the horse rears and paws the air. Cowboy Tracy Lane owned the horse and had trained him to execute the action. The horse was cued to perform at the right moment by a small "hot shot" placed under the breast collar. According to Canutt: "The 'hot shot,' similar to the battery-powered electric prods used to herd cattle, had been weakened as it only takes a small shock to cue a horse into action and not hurt him." As the camera rolled, the horse was cued to rear twice, but as he pawed the air, Canutt remembered, "his hind feet must have slipped because he sat down and came over on his back with all four legs sticking straight up between the shafts. I jumped out of the way and hollered, 'Cut!' We got the horse up just as Breezy walked over and asked me if I knew what picture I was working on. 'Gone with the Wind,' I said. Breezy snorted, 'Oh yeah, looks more like a Mack Sennett comedy to me.'" After the laughter died down, the scene was reshot without a mishap.

When Scarlett O'Hara (Vivien Leigh) escapes from Atlanta, it is aboard a cart pulled by Woebegone, an old nag on his last legs. A horse in poor condition was procured for the scene, but by the time the sequence was filmed, he had gained weight on the pro-

duction's steady rations and had to be made up to look like he was starving. He supposedly collapses from fatigue, but this gruesome action is implied rather than depicted.

Scarlett O'Hara loses two of her closest loved ones to horse-jumping accidents. Her father, demented since the death of his wife, is killed jumping a horse over a pasture fence. Scarlett and Rhett Butler's only child, Bonnie (Cammie King), meets her untimely demise when her little pony refuses a jump as her horrified parents watch. The beautiful black pony was a registered Shetland named Bobby. Mark Smith of Burbank, California, taught the pony to balk at a jump and hurl his rider over his head. Smith displayed tremendous confidence in Bobby when he cast his own six-year-old son, Richard, as Cammie King's stunt double. Young Richard learned to project himself into the fall and roll on impact.

A modern look at the romantic trials of the Civil War hit movie screens in 2003 with the release of *Cold Mountain*, which, like *Gone with the Wind*, was based on a popular book. Steve Dent coordinated the horse unit and cast his veteran Spanish animals, George and Conyo, in key roles.

The gray liberty-trained Andalusian Conyo is featured in an early battlefield scene. Having fallen when his rider was shot, he gets up riderless and trots off the field. The result is an eerie image of the symbolic "good" white horse leaving the field of death.

Ray Winstone plays the self-serving Captain Teague, leader of a unit that shoots Confederate deserters and their supporters. He is mounted on George, the handsome black who has supported so many stars. With his silver-studded bridle and breastplate, George, often shot from low angles to look even more imposing, adds menace to Teague's villainous persona.

THE LAST SAMURAI'S HONORABLE HORSES

Tom Cruise mounted up again for his role as Nathan Algren, a disillusioned Civil War hero who joins forces with Samurai warriors in *The Last Samurai* (2003). Director Ed Zwick is especially proud of the fact that no stuntmen or horses were injured in the stunning battle sequences and Samurai equestrian drills. "These were remarkable animals," Zwick has stated of his equine actors, "so well trained and loved by everyone." Horse master Peter White supervised the acquisition and training of the fifty horses in New Zealand, where the film was shot. None of the equines had previously done film work, and the seventy-five Japanese extras recruited from Auckland had never ridden. Amazingly, they were able to gallop downhill firing arrows, with no hands on the reins, after just two weeks of intensive training.

Animal lover Tom Cruise made sure that the film crew took the most sophisticated safety precautions and that American Humane monitors approved all the action. "American Humane wishes that every celebrity would be as proactive as Tom Cruise was regarding the treatment of the animals," said the organization's Film and Television Unit's director Karen Rosa in a 2004 interview. "He was amazing." At the end of production, the film's trainers and wranglers had become so attached to the horses that they purchased about half of them. The remaining horses were returned to their original owners with acting added to their resumes. Tom Cruise, meanwhile, went home with his movie mount, Felix, a chestnut gelding with a star.

FANTASY STEEDS

Middle-earth. Mordor. Gondor. The realms of the *Lord of the Rings* trilogy exist only in the imagination of its creator—J. R. R. Tolkien—and millions of devoted fans, yet

the films contain some very realistic, riveting horse action. *The Fellowship of the Ring* (2001), *The Two Towers* (2002), and *Return of the King* (2003) were shot simultaneously in New Zealand over a period of nearly two years. A main unit and two separate second units, all under the masterful watch of director Peter Jackson, had the task of assembling, caring for, and training the equine cast.

THE FELLOWSHIP OF THE RING

The Fellowship of the Ring begins the trilogy and introduces the hobbit hero Frodo and his pals, Samwise, Merry, and Pippin (Elijah Wood, Sean Austin, Dominic Monaghan, and Billy Boyd), as well as the wizard Gandalf the Grey (Ian McKellen), the elf prince Legolas (Orlando Bloom),

Above, the scarily costumed horses help create the frightening images of the evil Ringwraiths in *The Fellowship of the Ring* (2001), the first installment in the *Lord of the Rings* trilogy. Opposite page, Brego (Uraeus) and Aragorn (Viggo Mortensen) forged a bond that carried them beyond the battlefields.

and the human warrior Aragorn (Viggo Mortensen). Frodo, who has inherited the evil Lord Sauron's dangerous magic ring, is aided by all these characters in his quest to dispose of the ring at Mount Doom.

Head wrangler Dave Johnson handled the more than two hundred horses used in the various battle and chase scenes. Stuntman Casey O'Neill coordinated the horse stunts.

One of the most exciting scenes is a chase scene in which the elvish princess Arwen (Liv Tyler), mounted on her white horse Asfaloth, flees from the villainous Black Riders, or Ringwraiths. Asfaloth was played by a thirteen-year-old light gray Andalusian named Florian. He was used for beauty shots and stunt work and was doubled by two other grays, Hero and Odie. Hero did the running scenes. The well-behaved Odie was Liv Tyler's riding mount.

New Zealand horsewoman Jane Abbott doubled Liv Tyler in the galloping and rearing sequences. For close-ups in these action sequences, Tyler was astride a barrel rig mounted on a tracking vehicle. Covered with horsehide and mane purchased from a tanner, the horse-barrel looked surprisingly real. Devices such as these have been used for decades. In early Westerns, the hero was often filmed in tight shots on a horse-barrel in front of a screen showing the major action, a process known as rear projection.

The carefully choreographed chase sequence featured five rearing horses, twenty-plus jumping horses, three falling horses, and five lay-down horses. The main horse actors playing the Ringwraiths' mounts were Bob, Chico, and Zee, who had been trained in polo, cross-country, and dressage, respectively. The Ringwraith horses were dramatically decked in elaborate dark armor. This tack, though appearing to be metal, was actually leather specially fit to each horse. The riders rehearsed with the horses for months to acclimate the animals to the armor and the riders' flapping black robes before shooting commenced. The final scene, in which a tidal wave sweeps away

the Ringwraiths and their horses, was computer generated. In the course of filming the difficult sequence, Florian so endeared himself to Jane Abbott that she acquired him from the production company after they wrapped.

Another equine character in the film is Bill the Pony, a Hobbit-size horse adopted by Sam. Bill accompanies the Hobbitts to the Moria Mines gate, where Aragorn releases him to return home, as the mines are no place for a pony. Played by a horse named Shane, Bill helps carry the hobbits' supplies. His pack, which appears heavy, was actually made from lightweight foam.

As they climb treacherous mountain terrain, an avalanche besieges the heroes. Despite how it looks on film, Shane did not come into contact with actual snow. A pony costume worn by two human dancers replaced Shane in a scene shot in a mountain location accessible only by helicopter. Other scenes in the snow sequence were filmed on a set covered with processed potato flakes. Still others were shot against a blue screen in a studio. The snow and terrain were added in the editing room.

Director Peter Jackson maintains that his crews worked hard to ensure that no horses were harmed during the making of *The Lord of the Rings*. Except for some reshoots in the second and third episodes, American Humane was not contracted to monitor the animal action in the trilogy. Representatives of the Animal Welfare Institute of New Zealand, AWINZ, were charged with overseeing most of the action.

THE TWO TOWERS

Horses are even more prominent in *The Two Towers* than they were in *The Fellowship of the Ring*. The men who join the fight to save Middle-earth are the Rohans, known for their expert horsemanship. Throughout the film, these humans battle Lord Sauron's monstrous Orc armies, who are mounted on hyena-like creatures called Wargs.

While horses are generally important in *The Two Towers*, two equine characters stand out with critical roles. The first is Shadowfax, the alabaster mount of the wizard Gandalf. Gandalf summons Shadowfax, Lord of the Horses, and the magnificent stallion comes running to him from over the hills. Gandalf mounts him without a bridle or saddle and gallops off to give warning of an impending attack on the remaining human stronghold, Gondor.

Shadowfax was played by a fourteen-year-old Andalusian named Domero. He had one main double for the many galloping scenes, Blanco, an eight-year-old Andalusian stallion. Blanco was slightly smaller than Domero and had a skimpier mane so he required hair extensions to match the Andalusian's luxurious locks. Domero was taught to work at liberty and come to a mark by head trainer Don Reynolds. It took seven takes to get the shot of Shadowfax responding to Gandalf's whistle. The first time the horse cracked up the crew when he came flying up to Ian McKellan, put his nose on the actor's shoulder, and looked directly into the camera. As Gandalf, McKellen rode Shadowfax using a loose white loop—undetectable on screen—around his neck. Since he was difficult to stop, Domero was controlled by a "V" of mounted wranglers who kept him from running past his designated stopping point at the end of a scene.

Blanco was trained for liberty work by Graham Ware Jr. and was used extensively in the film as well. Domero and Blanco became fast friends, and according to producer Barrie Osborne, "We quickly learned that the best way to get Domero to run to any spot was to station Blanco there. Without fail, Domero would run to greet his buddy."

The other horse character in *The Two Towers* with a major scene is Brego, the mount of Aragorn. Brego was mainly played by Uraeus, a bay warmblood stallion from Wellington, New Zealand. His trick-trained double,

Brownie, a Thoroughbred gelding, was a former polo pony. Uraeus was Viggo Mortensen's main mount for the film, and the star developed a strong bond with the stallion, even riding him on his days off for fun. In the crucial scene, Brego awakens Aragorn after he is thrown into a river and washed ashore unconscious. Once Aragorn is revived, Brego kneels so the wounded warrior can mount him.

The brief scene, which shows the horse nuzzling Aragorn, rolling him over, and then kneeling at his side, took three weeks for training and was filmed during reshoots with trainer Graham Ware Jr., working under the supervision of an American Humane monitor. The complex series of behaviors were performed individually by the two horses and then edited together to appear as one action. Brownie did the kneel and was trained to be ridden without a saddle and bridle for the end of the scene. For the wake-up nuzzle, Mortensen wanted to use Uraeus. At first, Ware was concerned about training him to nuzzle as stallions are prone to nipping. Mortensen, however, felt the stallion could learn the trick safely. "I had known Uraeus for a couple of years," he later reflected, "and felt he was more than smart enough to pick it up in short order." He was right: it took Graham just six days to teach Uraeus to nuzzle gently. In the end, he agreed it was worth it as the bond between actor and stallion is visible on screen. "I knew Viggo had the utmost faith in the horse," the trainer said later. The result is a heartwarming moment that relieves some of the film's relentless tension.

The most difficult task in *The Two Towers* for Graham Ware Jr. was training a horse to rear and land his front feet on a sheet of Plexiglas over a buried camera. The camera gives us the point of view of two hobbits, Merry and Pippin, hiding from the hideous Orcs. A jet black New Zealand Station Horse named Bobby was painstakingly taught to rear, walk forward while striking the air with his front

hooves, and on cue, plant his feet squarely on the Plexiglas. On screen, the rearing horse seen from the perspective of the tiny hobbits is breathtaking.

Many other equines participated in the production of *The Two Towers*. Owned by local residents who worked as extras, approximately 350 horses were used for the battle charges. The breeds were varied. They included Thoroughbreds, Irish Cobs, Kaimanawa (New Zealand wild horses), Clydesdales, and Station Horses (Clydesdale/Kaimanawa crosses).

For the main battle sequence between the Orcs and the Rohans, wrangler John Scott arranged the extras in four rows of one hundred horses each, with the quicker Thoroughbreds in the rear so they wouldn't outdistance the other horses. The horses had been accustomed to the sights and sounds of battle prior to the shoot so they wouldn't spook at such novelties as raised weapons and fallen bodies. Some horses were also trained to slide stop on voice command, allowing them to hit their marks with a flourish.

At the climax of the charge, the audience sees horses running into the spears of the advancing Orcs. Though the galloping horses are real, the gruesome impalement images were computer generated—a technological advance since the use of animatronics for similar scenes in films such as *Braveheart* and *The Patriot*.

At the end of the great battle, the scene is littered with the bodies of dead men and horses. Most of the equine bodies were prosthetics, with stuffed horses used for the close-up shots.

THE RETURN OF THE KING

The final installment of Peter Jackson's momentous undertaking, *The Return of the King*, swept the 2004 Academy Awards with eleven Oscars. *The Return of the King* features most of the characters from the prior films, including the swift Shadowfax, who continues to provide service to the wizard Gandalf. Again, Shadowfax (played by Domero and Blanco) performs without a bridle. In one scene, he runs up a set of stairs when he and Gandalf enter the fortress city of Minas Tirith. At first, Domero balked at taking the steps so the wranglers placed Blanco at the top of the stairs, out of frame. Sure enough, Domero eagerly raced up to his buddy and stopped when he saw his mark.

Near the climax of the film, scores of horses carry the Rohan warriors into battle, against frightening creatures such as the monstrous multitusked Mûmakil and the flying dragonlike Nazguls. Thanks to the magic of CGI, the horses dodge the massive feet of the Mûmakil in a breathtaking sequence. With their hideous claws, ferocious shrieking Nazguls swoop down to pick up horses and riders, then drop them hundreds of feet to their deaths. Of course, all such action is computer generated. Not computer generated was the stunt action of twelve falling horses and five rearing horses trained by Graham Ware Jr. for the sequence. Doubling Shadowfax, Blanco does a spectacular rear as Gandolf, with Pippin riding double, is confronted by the Witchking on a Nazgul.

Sadly, Domero, who portrayed Shadowfax, was retired from show business as his preexisting condition of melanoma worsened. He was placed with caretakers in New Zealand to live out the rest of his life in comfort with ongoing veterinary care, instigated during production. He has since passed away from natural causes.

Blanco and Brownie both found homes with wranglers who had bonded with the horses during the making of the trilogy. After working so closely with Uraeus during the long production of *Lord of the Rings*, Viggo

Mortensen could not walk away from his equine buddy. He purchased the big bay stallion. "Uraeus is my friend," the actor has stated, "and I am happy to ensure his well-being to the best of my abilities." When asked what he planned to do with Uraeus off screen, Mortenson humbly replied, "Hopefully continue to learn from him." To keep Uraeus company, he also purchased Kenny, a highly intelligent, unflappable chestnut gelding who worked as the actor's mount in some of the battle scenes in *The Two Towers*.

ADVENTURERS AND AVENGERS

Horses have added adrenaline-pumping excitement to the exploits of adventurers and avengers who have entertained generations of popcorn-munching audiences. Whether they are dashing across the desert in elaborate regalia or galloping through the moonlight with a masked swordsman astride, movie horses have been integral to the heroics of our heroes. In fact, if it weren't for a horse, there would have been no Indiana Jones.

INDIANA JONES

The image of a rugged hero jumping from his horse to a truck inspired George Lucas to write *Raiders of the Lost Ark* (1981). That bit of action kicks off one of the film's most memorable sequences, in which Indiana Jones (Harrison Ford) commandeers a Nazi truck containing the legendary Ark of the Covenant. The scene, shot in Tunisia, was coordinated by Glenn Randall Jr., who worked closely with director Steven Spielberg. Jones rides a beautiful dappled gray through a desert encampment and down a steep hill to intercept the truck. Once alongside the vehicle, he leaps from the saddle to the truck. Veteran stuntman Terry Leonard doubled Harrison Ford from the top of the hill. Glenn Randall drove the truck as that stuntman made his leap from horse to truck, a maneuver known as a transfer in stunt parlance. The transfer went smoothly, and the image that inspired George Lucas was recreated in one of the most loved adventure films of our time.

THE SHEIK AND THE KELLOGG ARABIANS

Long before Indiana Jones made his famous transfer, another adventurer, played by silent star Rudolph Valentino, displayed his horsemanship in the 1921 hit film *The Sheik*. As the seductive Arabian chieftain Ahmed Ben Hassan, Valentino rode a voluptuous gray mare named Anna. Anna also appeared in the Marion Davies vehicle *When Knighthood Was in Flower* (1922). Produced at the staggering cost—for a silent film—of $1.5 million, the extravagant drama centers on the love life of King Henry VIII's sister, Mary Tudor (Davies). Costumed in medieval bard, Anna carries an admirer of Mary Tudor's to victory in a jousting tournament. The unflappable, sturdy mare went on to star on Broadway, pulling a chariot in the opera *Aida* for twenty-five years. A starry-eyed fan, when asked what he thought of the opera, said, "That's the swellest looking horse I've ever seen." Appearing with famous tenors, including the illustrious Enrico Caruso, Anna achieved such fame that when she died at age thirty-nine in March 1940, the *New York Times* reported her obituary.

Catapulted to superstardom by *The Sheik*, Valentino appeared in its even more popular sequel, *The Son of the Sheik*, released in 1926. Playing dual roles as an older Skeik Ahmed Ben Hassan and his handsome namesake son, Ahmed, Valentino was outfitted in extravagant costumes. As the young Ahmed, Valentino rode an outstanding black trick horse with white hind socks. The black, elaborately costumed in Arabian regalia, was trained to rear and spin on command and was used for leaping mounts and galloping scenes across sand dunes. For the older sheik, Valentino wanted a special Arabian steed. He lobbied cereal king W. K. Kellogg, who had recently estab-

ment of his success was sadly short lived as he died of a ruptured ulcer while touring to promote the film.

Jadaan's film career continued, with appearances in *The Desert Song* (1929), *Beau Ideal* (1931), *The Scarlet Empress* (1934), *The Garden of Allah* (1936), and *Under Two Flags* (1936). As Jadaan aged, his steel gray dapples faded, and he turned white. In 1945, at age twenty-nine, Jadaan was euthanized at the University of California College of Agriculture at Davis. His skeleton is still used for classroom instruction at UC Davis, and his saddle from *The Sheik* is on display at the Arabian Horse Center—the former Kellogg ranch—on the California State Polytechnic University campus in Pomona.

Another Kellogg Arabian, the gray racing stallion King John, also became a movie star. Imported from Egypt by Herman W. Frank in 1929, King John was a champion show horse before W. K. Kellogg purchased him. After many public appearances as one of the renowned Kellogg Arabians, the stallion joined his stablemate Jadaan in the 1934 film *The Scarlet Empress*, a romanticized biography of Russia's Catherine the Great, starring Marlene Dietrich. King John appears in the finale when the triumphant Catherine leads her mounted supporters into the royal palace. Riding King John, Dietrich runs him up a marble staircase and strikes a regal pose. Later that year, the stallion appeared with Gary Cooper in the swashbuckler *Lives of a Bengal Lancer*, and the following spring he again worked with Jadaan in *Garden of Allah*. He can also be seen in effigy in the animated Disney classic, *Snow White and the Seven Dwarfs* (1937), as King John served as the model for Prince Charming's archetypal white steed. The real stallion lived to be twenty-four years old.

Above, Rudolph Valentino had to have W. K. Kellogg's Arabian stallion Jadaan as his mount in *The Son of the Sheik*. Opposite page, Marlene Dietrich as Catherine the Great with King John as they appeared in *The Scarlet Empress* (1934).

lished his Arabian Horse Ranch in Pomona, California, for the use of his fine dappled gray stallion Jadaan. In writing to Kellogg, Valentino praised Jadaan as "the finest Arab from every standpoint." He vowed to pay all of Jadaan's expenses during filming and insure him for $25,000. After some negotiation, Kellogg acquiesced, and Jadaan was shipped to the desert location near Yuma, Arizona. Reportedly incensed when Valentino kept the stallion four days longer than promised, Kellogg eventually calmed down and enjoyed the fame Jadaan's movie appearance brought to his ranch. Valentino's own enjoy-

Above, Corky Randall trained Diamond, the Quarter Horse who portrayed Tornado in the Disney series *Zorro* (1957–1959), starring Guy William. Opposite page, Roman riding stuntman Tad Griffith, doubling Antonio Banderas, leaps over a fallen tree branch and back onto sisters Black and Blue in this spectacular stunt for 1998's *The Mask of Zorro*.

Z FOR ZORRO

The character of Diego de la Vega, the Spanish educated Mexican-Californian nobleman who pretended to be a fop to protect his alter ego, the masked avenger Zorro, first appeared in the 1919 novel *The Curse of Capistrano*, by Johnston McCulley. The cinematic potential of the Hispanic Robin Hood character and his exploits was not lost on silent star Douglas Fairbanks Sr., who snapped up the movie rights for a 1922 silent film, *The Mark of Zorro*. Thus began a long franchise of the character, who defended his turf against Spanish invaders in two American remakes of *The Mark of Zorro* (1940 and 1974), thirty-some other features produced both domestically and internationally, several serials, a long-running television series, comic books, and most recently, spectacular films starring Antonio Banderas and some stunning Friesian horses.

Horse trainer Corky Randall came out of semi-retirement to coordinate the livestock for *The Mask of Zorro*

(1998), starring Antonio Banderas. Three black Friesians and one Mexican Mustang played the part of Zorro's horse, Tornado. Trainers Gordon Spencer and Bob Lovgren, a protégé of the late Glenn Randall, were assigned to work with the actors and the four Tornados. The main Tornado was a Friesian stallion named Casey, owned by Sled Reynolds, whose company, Gentle Jungle, supplies horses and exotic animals for film. Reynolds taught Casey to rear, but Lovgren worked with the stallion to perfect the near vertical rear that was his mentor's trademark. The athletic Banderas was able to sit the rearing Friesian after lessons with Gordon Spencer. The star particularly liked the spirited Casey, who did 90 percent of the work as Tornado in the film. His main double, a young Friesian named Duke, went on to become a dressage show horse while Casey remained in "the biz."

The star's leading lady, Catherine Zeta-Jones, as Elena Montero, was a novice equestrienne. Fortunately, her dance background helped her find her horse's rhythm in daily riding lessons during preproduction. Her mount in the film is a Mexican palomino owned by Chico Hernandez. A former kid's horse, the palomino had the perfect qualities for a leading lady's cast horse: beauty and a quiet temperament.

Stuntmen Casey O'Neill and Tad Griffith doubled Antonio Banderas for the most demanding and dangerous scenes. In the movie's wildest sequence, Zorro makes a transfer from the galloping Tornado onto the back of a villain's horse. After disposing of another villain, Zorro straddles the two horses in a fabulous display of Roman riding, which climaxes in a jump over a fallen tree branch. Zorro's black mask and wardrobe made it easy for Tad Griffith to double the star.

Born into a family of champion trick riders, Griffith learned the art of Roman riding at an early age. The compatibility of the horses' gaits and temperaments is of paramount importance in mastering the trick. The other crucial

ingredient is trust. As Tad Griffith stated in a 2002 interview about trick riding horses, "They have to almost work with you like a dance partner." For *The Mask of Zorro*, he used his own horses, a matched pair of black Morgan/Thoroughbred sisters named Black and Blue. Originally from Montana, the 15.2-hand mares were three and four years old when Tad Griffith acquired them. Having grown up wild in a pasture, they were not even halter broken. He worked them as a team from the beginning. Years of training and many trick-riding exhibitions later, the mares had become the perfect dance partners.

Like the folkloric tales of the American west, the world's great stories and legends bear retelling, again and again. Technological advances such as CGI make the many facets of movies safer for horses, but still, Tad Griffith has a point when he says, "What made *The Mask Of Zorro* is the fact that people know that they're getting the real thing. This is real men, riding real horses."

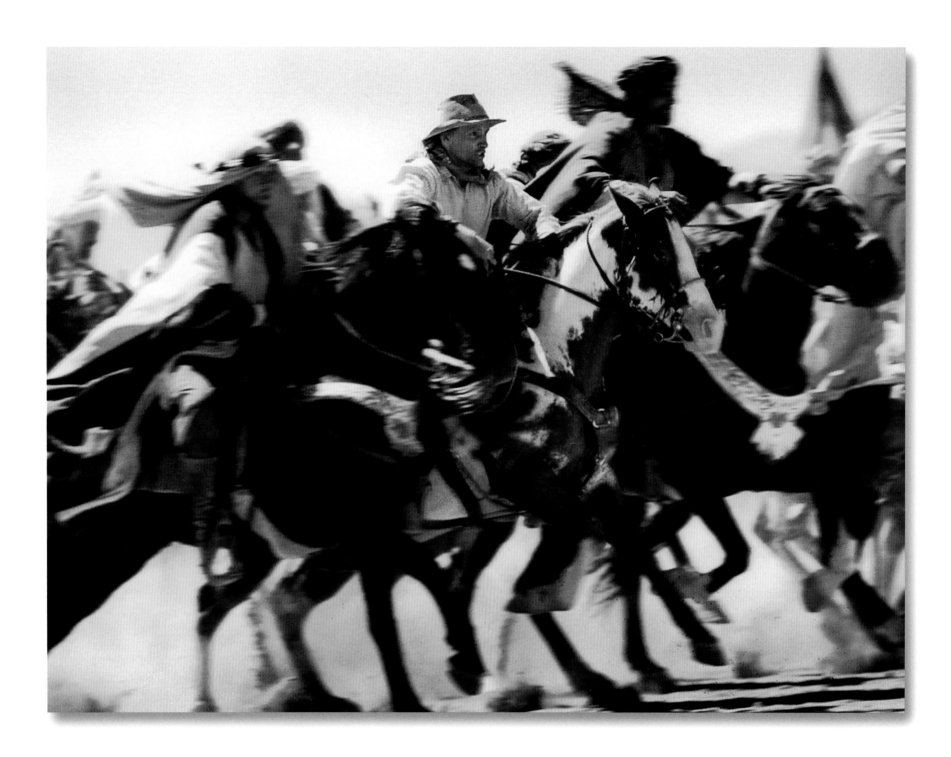

OFF TO THE RACES

"You know, everybody thinks we found this broken down horse and fixed him, but we didn't. He fixed us."

—Red Pollard, voiceover, *Seabiscuit,*
(Screenplay by Gary Ross, based on the book by Laura Hillenbrand)

Riders battle for the lead in the 3,000-mile endurance race portrayed in 2004's *Hidalgo*. The sorrel and white overo playing the title character is easy to spot amid the solid-colored horses.

BEFORE HOLLYWOOD OPENED THE STARTING GATE on its long run of horse racing films, motion picture pioneer Thomas Edison turned his camera on a race at Sheepshead Bay, New York. The year was 1897. In 1904, *Great Train Robbery* director Edwin S. Porter made *Two Rubes at a Country Fair*, featuring a horse race with female jockeys. Director Reginald Barker established a soon-to-be-clichéd plotline in *The Thoroughbred* (1916), a comedic tale of a man struggling to get out of debt by entering his horse in a big race. A New York Times critic praised *The Thoroughbred* and commented, "It is a wonder horse racing has not been used oftener for movie purposes." Yet Hollywood was still slow to place its bets on a winner.

Blue Bloods
of the
Blue Grass

WILLIAM FOX Presents

KENTUCKY PRIDE

A romance of the Kings and Queens of the Turf
with
J. Farrell MacDonald ~ Gertrude Astor ~ Henry B. Walthall
and a cast of the world's greatest race horses ——
Man O'War ~ Negofol ~ Morvich ~ Fair Play ~
The Finn ~ Virginia's Future ~ Confederacy

Story by Dorothy Yost ~ A JOHN FORD production

Although the pageantry, win/lose suspense, and hoof-pounding excitement of a good horse race inspired dozens of British films in the early 1900s, Hollywood lagged behind until a big red Thoroughbred stallion named Man O'War brought "the sport of kings" to the common American. Beaten only once in his career—and that by a nose in a race he began by facing the wrong way—Man O'War was a national sports hero by 1919. Fans who couldn't make it to the track at Saratoga or Belmont could cheer Man O'War while listening to his races on the radio. America's fervor for horse racing had been ignited, and the motion picture industry jumped on the bandwagon.

From the 1920s to the present, the colorful characters of the racetrack milieu—from wealthy owners, gifted trainers, weight battling jockeys, unscrupulous competitors, and touts to low-heelers hoping to hit the jackpot—have provided inspiration for screenwriters. Common themes, the winning racehorse bailing out a desperate owner, a long shot coming from behind, a former champion making a comeback after an injury, have all been worked and reworked over the decades.

Kentucky, the home state of Thoroughbred racing, became a popular setting for films such as *Kentucky Derby* (1922), *My Old Kentucky Home* (1922), *Kentucky Pride* (1925), and *Kentucky Handicap* (1926). These were followed in the 1930s and '40s by movies such as *Old Kentucky* (1936), which featured Will Rogers, *Pride of the Bluegrass* (1939), and *Bluegrass of Kentucky* (1944).

Many stars have wagered on racehorse movies, from Clark Gable in *Sporting Blood* (1931) and *Saratoga* (1937), Judy Garland and Mickey Rooney in *Thoroughbreds Don't Cry* (1937), the Marx Brothers in *A Day at the Races* (1937), Abbott and Costello in *It Ain't Hay* (1943), and Bob Hope and Lucille Ball in *Sorrowful Jones* (1949) to Sharon Stone, Nick Nolte, and Jeff Bridges in *Simpatico* (1999). Jeff Bridges made a better bet with Tobey Maguire and Chris Cooper in the Oscar-nominated *Seabiscuit* (2003). The gamble hasn't always been successful, but the track continues to lure filmmakers. Movies about Thoroughbred racing are the most common, but Standardbred harness racing, Quarter Horse racing, and endurance racing with a variety of breeds have also provided fodder for a number of features.

CASEY'S SHADOW

Set in the world of Quarter Horse racing, *Casey's Shadow* (1978) starred Walter Matthau as Cajun horse trainer Lloyd Bourdelle. The film, directed by Martin Ritt, was inspired by the success of a small-time trainer, Lloyd

Romero, who made it big when his long shot won the million-dollar purse at the All-American Futurity, at Ruidoso Downs, New Mexico. A *Time* magazine review said the film "accurately recreates the arduous rituals of training, the sweaty romance of jockeying, and the cracker-barrel humor of the eccentrics who build their lives around long shots."

The film concerns an orphaned colt sired by a champion named Sure Hit. One of Bourdelle's three sons acquires his dam in foal, and she dies soon after giving birth. Bourdelle is disappointed because the blaze-faced sorrel colt has white stockings and therefore white hooves, which are supposedly weaker than black ones. His youngest son, Casey (Marshall Hershewe), refuses to let the colt die and coaxes him to suckle his lactating pony who has a weanling foal. The colt, named Casey's Shadow for the way he bonds to his rescuer, grows into a strong, incredibly fast horse, and Bourdelle sees his chance at winning the coveted All-American. After the horse is injured, the usually principled Bourdelle is faced with the moral dilemma of realizing a lifelong dream at the risk of destroying the stallion. The tale of human frailty and greed ends on a redemptive note, but not before driving home the point that incredible stress is put on racehorses who as two-year-olds are pushed to perform before their leg bones have fully matured.

Several horses played the young Casey's Shadow, and although they embodied the right spirit of a developing racehorse, an astute observer can see that their blazes don't always match. The lead horse playing the two-year-old was a flashy bald-faced sorrel with four white socks. Although he was supposed to be a registered Quarter Horse, Casey, as he was named for the production, was actually a Morgan/Quarter cross. He did 90 percent of the work but was doubled by Baldy Socks, who, according to

Walter Matthau and Alexis Smith pose with their equine costar of *Casey's Shadow* (1978).

wrangler Phil Cowling, required make-up applications of "Streaks and Tips" to match Casey. Cowling taught Baldy Socks to lie down for a scene in which Casey is ill. He worked under the supervision of his boss wrangler, the late Al Janks, who supplied all the horses for the film.

RACEHORSE BIOGRAPHIES

Several biographical stories of famous racehorses have made it to the screen. Ironically, the more fictionalized scenarios have not usually been as compelling as the scripts that stick closer to the truth.

THE GREAT DAN PATCH

The life of Dan Patch, an unbeaten Standardbred harness racer who became a household name in the early twentieth century, was perfect movie material. Sired by Joe Patchen, a renowned pacer from Illinois, the exceptional colt from Indiana was foaled in 1896. He was owned by

his breeder, dry goods merchant Dan Messner Jr. Trained by Johnny Wattles, Dan Patch (named for his owner and his sire) did not race until he was a four-year-old. After cleaning up on the county fair circuit in Indiana, the fabulous pacer went on the national Grand Circuit and won fifty-two consecutive races.

After his mare Lady Patch was poisoned, presumably by gamblers, Messner feared for Dan Patch's life. He sold the colt to M. E. Sturgis of Buffalo, New York, for $20,000. Dan Patch continued his undefeated career, touring the country in a private white railroad car emblazoned with his picture and name. Wherever he stopped to race, the locals proclaimed a Dan Patch Day. Pampered by four grooms, the horse reportedly loved the attention, including the band music that usually heralded his arrival.

By the end of 1903, no horse in America dared to challenge the remarkable stallion. Sturgis sold him for $60,000 to Marion W. Savage, owner of International Stock Food Company of Hamilton, Minnesota. A marketing genius, Savage used the Dan Patch name to promote a variety of products, including horse feed, cigars, silk scarves, and pillows. Dan Patch raced only in special exhibitions against the clock, pulling his trademark white sulky. The other horses in these races were there purely to give Dan the incentive to strut his stuff. He commanded a stud fee of $300, a fortune at the time. Breeders were enticed by Savage's assurance that "a colt by Dan Patch is just like a government bond." Dan Patch made millions for Savage, who reportedly loved the great pacing horse. In 1916, at age twenty, Dan Patch collapsed and died. Savage died thirty-two hours later, from complications after a heart attack. Dan Patch and his devoted owner were buried at the same hour.

The 1949 equine "bio-pic" *The Great Dan Patch* left out most of the dramatic details of the horse's career in favor of a sappy fictionalized love triangle between a fictional owner, David Palmer (Dennis O'Keefe), his socially ambitious wife Ruth (Ruth Warrick), and Cissy Lathrop (Gail Russell), the pure-hearted, horse savvy daughter of Dan Patch's equally fictitious trainer, Ben Lathrop (John Hoyt). While the gorgeous black horse with a white star who played Dan Patch was cited by the Hollywood trade publication *Variety* for his beauty and performance, no credit is given in the film to either the horse or his trainer.

PHAR LAP

Many believe a New Zealand bred gelding named Phar Lap ("lightning" in Siamese) was the greatest galloper the world has ever seen. Director Simon Wincer's 1983 film *Phar Lap* is a valentine to the remarkable horse, whose astonishing career was cut shockingly short by a mysterious death.

In the movie, trainer Harry Telford (Martin Vaughan), betting on the colt's ancestral bloodlines, buys the horse in New Zealand for an Australia-based American owner, Dave Davis (Ron Leibman), in 1928. The ungainly fifteen-month-old red chestnut arrives in Australia, and Davis is so unimpressed, he agrees to let Telford lease the gelding for three years. Convinced Phar Lap has a lazy streak, Telford is hard on the colt on which he has staked his economic future. Slow-motion scenes depicting the trainer legging up Phar Lap by galloping him in sand dunes reveal just how arduous this is for a horse. Despite the rigors of training, Phar Lap doesn't show much speed until he reaches the age of four. Topping out at 17 hands, he finally hits his gargantuan stride—with the help of his strapper (Australian for "groom") Tommy Woodcock (Tom Burlinson), who figured out the key to unlocking his competitive spirit. Phar Lap simply needed to be held back and then allowed to run from behind. His jockey, Jim Pike (James Steele), never even has to use the whip.

With James Steel as jockey Jim Pike aboard, Towering Inferno, in white bridle as Phar Lap, towers over the competition at the start of a turf race.

Phar Lap wins the 1930 Melbourne Cup and the Futurity Stakes, races of greatly varying distances. After winning thirty-six races, "the Red Terror" as he was known by his many fans in his adopted country, is handicapped so heavily it is impossible for him to continue racing in Australia. Greedy for more winnings, Davis and Telford decide to send him to America to run in the Aqua Caliente Handicap on the California-Mexican border. Woodcock is promoted to Phar Lap's trainer and nurses him though a badly cracked hoof to win the $100,000 purse on March 20, 1932.

Seventeen days later, Phar Lap suddenly becomes gravely ill on the northern California farm where he is resting up for his next big race. Woodcock, sleeping in a

nearby stall, is awakened by the horse's pitiful groans. Despite the desperate ministering of Woodcock and a veterinarian, Phar Lap drops dead. Gamblers' henchmen are suspected of poisoning the big red horse. Although a postmortem showed evidence of poisoning, the tragic mystery was never solved.

In preparing *Phar Lap* (1983), producer John Sexton was so concerned about historical accuracy that he sent

master of horse Heath Harris and head trainer Evanne Chesson on a months' long search for a red chestnut horse big enough to portray the 17-hand wonder. They looked at horse after horse, but none had the size and rich red color of Phar Lap. Then one day, lunching with friend Shirley Pye McMillian at Branca Plains, her sheep and cattle station at Walcha, Heath and Evanne spotted a big red horse in a paddock. McMillian had been traveling and was

totally unaware of the search for Phar Lap's double. Her horse, the 17-hand Thoroughbred/Whaler cross Towering Inferno, was a ranch mount that the stockmen didn't like. "He was just too big for the men to keep getting on and off," said Shirley McMillan. "Even so, I kept him as I though he might one day do something worthwhile." According to Harris, it was kismet. He knew he had found his star horse as soon as he walked toward the gelding. "It moved just like Phar Lap," he later recalled. "Its color was exactly right, even its hind fetlocks were white." He also had a white star and, most surprisingly, a distinctive pattern of black spots on his thigh in the shape of a Southern Cross, like Phar Lap.

Towering Inferno was nicknamed Bobby after Phar Lap's own stable name. The script required him to rear, strike, paw the ground, look in both directions, nod his head, and play dead. He had to tear a shirt off the back of a stableboy—like the real Phar lap used to do. In addition to all these tricks, he had to learn to gallop with a camera car right beside him. Heath and Evanne quickly discovered that Bobby had the smarts to go with his movie star looks and the trick for them was staying one step ahead of the clever horse. Their patience and hard work with Bobby paid off as the horse turned into a fabulous performer who never spooked at the camera. In fact, he became something of a ham and reveled in the attention of the film crew. Those who remembered the real Phar Lap were astonished by the resemblance. When Bobby was presented to the press, veteran racing journalist Johnny Tapp turned to producer John Sexton and said, "It's a reincarnation."

Tom Burlinson, the handsome young star of *The Man from Snowy River*, is wonderful in the role of Tommy Woodcock. Fortunately, the late Woodcock was, at seventy-eight, still very much alive when *Phar Lap* was being made, and the actor was able to glean a great deal from

him. Woodcock even lent a custom-made horse blanket that had belonged to Phar Lap for a scene depicting the gelding's trip to America. Amazingly, it fit the movie Phar Lap as if it were made for *him*.

Tommy Woodcock was with Phar Lap almost constantly during his short-lived career. When Phar Lap died, Woodcock could not control his tears for the horse he had loved greatly. Under the direction of Simon Wincer, Burlinson and Towering Inferno recreated this heartbreaking scene so convincingly that it's difficult to keep a dry eye while watching the sad finale to the beautifully crafted *Phar Lap*.

Towering Inferno, aka Bobby, was purchased by Heath Harris after production. He was retired from movie work but raised more than $300,000 for charities in Australia and New Zealand making personal appearances as the horse from *Phar Lap*. At age twenty-six, a bizarre turn of events claimed his life. Bobby was struck by lightning—the very thing Phar Lap was named for—while taking shelter from a thunderstorm under a tree on the Harris ranch. Since the veterinarian was too far away to euthanize the fatally injured gelding, Harris—who felt about Bobby the way Tommy Woodcock had felt about Phar Lap—was obliged to put his suffering old friend out of his misery. He has said it was the hardest day of his life.

Two Seabiscuits

A horse that could have given Phar Lap a run for the money was Seabiscuit, an underdog who bucked the odds to become America's sweetheart during the Depression. The two biographical films about Seabiscuit, made more than fifty years apart, couldn't be more different. *The Story of Seabiscuit* (1949) starred Shirley Temple and suffered the same type of truth tinkering that had plagued *The Great Dan Patch*. Not only were the lives of the real people surround-

ing Seabiscuit altered to ill effect, but in this case the equine actors also were uncooperative. When the horse portraying War Admiral kept beating the movie's Seabiscuit, director David Butler resorted to archival footage of the famous match between the two rivals.

The true story of Seabiscuit, a crooked-legged horse who went from loser to champion with the help of a half-blind jockey and a washed-up trainer, was magnificently told in Laura Hillenbrand's marvelous book Seabiscuit, An American Legend, published in 2001. Ripe for a remake, Seabiscuit's incredible rags-to-riches story was given topflight treatment by the A-list producing team of Kathleen Kennedy and Frank Marshall and director Gary Ross. For the 2003 Universal Pictures movie Seabiscuit, Ross cast Tobey Maguire as Seabiscuit's jockey Red Pollard, Chris Cooper as trainer "Silent" Tom Smith, and Jeff Bridges as owner C. S. Howard. Elizabeth Banks was cast as Marcella (Mrs. C. S.) Howard, and William H. Macy as racing wag "Tick Tock" McGlaughlin. With the human stars set, the awesome task of casting the equine hero of the movie was next. Enter the wrangler from Montana Rusty Hendrickson.

The forty horses initially selected for the film were between three and seven years old. Culled from all over America, most were Thoroughbreds, but a few Quarter Horses and solid color Appaloosas made the grade. None of the horses was a big winner at the track. As Rusty points out, "A good movie horse is different from a great racehorse." Six weeks before the cameras rolled, Rusty and his crew began prepping the equine cast, gaining their trust and exposing them to new experiences. They learned to follow the camera car by working alongside a pickup truck. They learned to stand for long minutes in the starting gate while microphones on rods hovered overhead. As the weeks went by, one small Thoroughbred gelding from

Kentucky, Fighting Furrari, emerged as the star. A slight wind problem had kept the athletic little bay from being a top racehorse, but Hendrickson saw his potential as an "actor." He resembled the real Seabiscuit, Hendrickson said, and "he has a cute personality." His nice temperament made him an ideal cast horse, one that the star, Tobey Maguire, could handle with confidence. Having taught Maguire to ride on the Western Ride with the Devil, Hendrickson knew the actor could sit a horse. Riding a racehorse, of course, is a whole different proposition.

Hall of Fame jockey Chris McCarron coached Maguire on the finer points of balancing on a horse galloping 40 miles per hour. "I started going to Tobey's house in late July [2002] and put him on the Equicizer [a mechanical horse jockeys use to condition themselves]. He learned his lessons extremely quickly." Although for safety reasons, during most of the race close-ups, Maguire is aboard the "S.S. Seabiscuit," a customized Equicizer mounted on a flatbed truck, the star does quite a bit of riding in the film. According to McCarron, who videotaped the young actor's progress, Maguire easily earned the respect of the professional riders on the film. "After four lessons, I showed the video to the jockeys, and they were very impressed. I think it all worked out very well."

Once the lead horse was chosen, nine more were selected to play Seabiscuit's doubles. Some are seen only from a distance. All are Thoroughbreds except one, a Quarter Horse, Triple Digit Cash, owned by Hendrickson and nicknamed "Biscuit" for the production. A trick horse, Biscuit specialized in "mouth work" and had his moment when Seabiscuit rips the silks off a rival jockey. Because the real Seabiscuit was a complex character, it took more than one horse to duplicate his quirks. Another, nicknamed Gravy, was taught to rear for his role as the angry

Red Pollard (Tobey Maguire) works out with Seabiscuit (Fighting Furrari).

Seabiscuit. Muffin, however, had the cushiest role as the lazy Seabiscuit, who lies down in his stall. The horses were all made up to match Seabiscuit's plain bay color, with socks and stars carefully painted brown.

In addition to Triple Digit Cash, Hendrickson brought four more of his own Quarter Horses to the production: Cutter Bailey Ford, Go Benny Dial, Keepin Doc's Memory, and Doc's Keepin Gossip. The latter two horses were sired by Rex Peterson's movie horse Doc's Keepin Time. Used to pony the racehorses to the starting gate and

for mounts as outriders (the ones who help pony particularly fractious racehorses and capture runaways), the quiet-tempered Quarter Horses were the supporting actors to the Thoroughbred stars.

Director Ross, who grew up riding western on family vacations and spent a fair amount of time at the track in his youth, readily admits that recreating *Seabiscuit's* famous races with historical accuracy was the film's biggest challenge. From Lexington to Los Angeles, the action was carefully choreographed by the film's con-

sultant, jockey Chris McCarron, who planned every shot with the director and cinematographer John Schwartzman. With the help of graphic designers, the team created "race books," huge maps laid out on the clubhouse floor that the jockeys could walk around to learn their moves. The meticulous planning proved invaluable, but there were still problems. Horses are not always the most cooperative actors. "It's very hard to control nuances of speed," said Ross after filming, "if a horse wants to go, you can only contain him so much." McCarron readily agreed. "The most difficult challenge was dealing with horses not necessarily ready or willing to do what it is the director is looking for."

Although professional jockeys were hired to make the races look as realistic as possible, they sometimes had trouble rating their mounts. Even McCarron, cast as War Admiral's jockey Charley Kurtsinger, had trouble holding on to the big black gelding Cobra Flight in a scene of the legendary match race between War Admiral and Seabiscuit. "That was a very embarrassing moment for me," McCarron recalled after the fact. "I pretty much picked Cobra Flight to be one of the ones that would let Seabiscuit pull away from him. He showed me no speed in the morning workout. But when the cameras were rolling, he moved up head to head with Seabiscuit and then won by a nose." In the end, another horse, Made to Space Jam, played the losing War Admiral.

The horses were tested by long hours of shooting, but American Humane monitors made sure the Thoroughbreds were not galloped longer than three furlongs three times a day and were given rest days in between races. The jockeys were even required to carry bats of foam rubber. Another concern was the stress of travel between far-flung locations. Weight was carefully maintained with a high-calorie diet of alfalfa hay supple-

mented with beet pulp. Keeping the horses healthy and sound was ensured by a top-notch team of veterinarians and farriers. The diligence paid off: no horses were harmed during the making of *Seabiscuit*.

After making the film, director Ross said that he has "a different understanding of the process of horse racing. It's much less controllable than I thought." He also came away from the film with a renewed admiration for horses and the people who ride them. "It's an amazing fusion between man and animal. When you think that thousands of years ago man climbed on the back of an animal and became mobile in a way he had never known … you're reconnected to that very elemental thing."

ENDURANCE RACES

Nothing could be more elemental than the intense bond between a man—or woman—and a horse required by the demands of an endurance race. Covering hundreds, even thousands, of miles together over all kinds of terrain in variable weather conditions, these partners are totally reliant upon one another to make it to the finish line.

RUN APPALOOSA, RUN

The controversial Omak Stampede Suicide Race in northeastern Washington State was the setting for the Disney theatrical featurette *Run Appaloosa, Run*. It is unlikely that Disney would make a film about this race today as the Omak Stampede has received much bad publicity because thirteen horses have been killed in the race since 1983. Although not long like most endurance races, the Omak Stampede is treacherous, with a 120-foot running start, a 210-foot downhill plunge into a river of varying depths, and for the survivors, a final sprint of 500 feet. Animal rights' organizations have been working since the mid-1980s to abolish the race.

In 1966, however, no such controversy surrounded *Run Appaloosa, Run*. The fictitious story concerns an orphaned Appaloosa and a young Nez Perce woman who rescued him as a colt. Adele Placios played Mary Blackfeather, the young woman who is obligated to sell the colt, Holy Smoke, to help her tribe. After Holy Smoke has been abused and passed from owner to owner, Mary discovers him working with a rodeo clown, outfitted in humiliating donkey ears and baggy pants for the amusement of the crowd. When an enraged Brahma bull charges the stallion, Mary's dog, Silver, a highly trained Australian Shepherd, comes to the rescue. Once again, Mary saves the Appaloosa, this time by purchasing him. She trains him for the suicide race even though she knows that as a woman she will not be permitted by her tribe to enter. Inspecting his tribal herds in his 1926 classic convertible, Chief Greystone (Walter Cloud) is impressed when Mary and Holy Smoke come thundering out of the blue to jump the stalled car. He tacitly gives his consent for Mary to enter the race.

A charismatic sorrel stallion, with a spotted hip blanket, named Baldy's Holy Smoke played the lead equine role. Formerly owned by Ross Worthington of Spokane, Washington, the stallion was purchased by Disney and trained by the late Jimmy Williams, renowned for producing international show jumpers. Holy Smoke did all his own stunts in the film, including the car jump and the climactic 210-foot downhill charge into the Okanogan River during the race's grand finale. Filming took place during the actual race, and director Larry Lansburgh, an experienced horseman and camera operator, got into the act and handheld an 85mm camera while galloping down a 250-foot sand track into the river. The rider's eye view gives the film an extra dose of realism. *Run Appaloosa, Run* of course, has the requisite Disney happy ending, with Mary and

Holy Smoke winning the grueling race after some suspenseful moments. It's interesting to note that former singing cowboy star Rex Allen narrated the film and sang the title song.

BITE THE BULLET

A much darker movie, *Bite the Bullet* (1975), also featured an orphaned Appaloosa. Directed by the veteran Richard Brooks, the gritty film dramatized a 700-mile endurance race across mountains and desert in the American west at the turn of the century. Shot in Nevada and New Mexico, the movie stars Gene Hackman as Sam Clayton, a cowboy hired to escort a fancy Thoroughbred racehorse to the start of the race. Clayton's intrinsic goodness is revealed at the outset when he interrupts his mission to rescue an Appaloosa colt from an abandoned glue wagon. The colt's plight is unflinchingly depicted with graphic shots of his deceased mother, who had been tethered by a metal ring through her nose. Clayton hoists the little fellow onto his saddle and cradles him with his free arm until he finds a young boy tending horses on a ranch. Satisfied he has found a good home for the orphan, he gives the colt to the boy.

Hackman's mount, a buckskin Quarter Horse gelding named—you guessed it—Buck, belonged to the movie's wrangler Rudy Ugland, who has said he was "probably the best horse I ever owned in my life. The horse I started my business with, my own personal horse." Buck was bred by Bronc Curry in Montana and was a roping ranch horse. He was eight years old when Ugland purchased him and began taking him on film sets to get him used to the frenetic atmosphere. Four years later, the horse appeared in *Bite the Bullet*, his first film. His movie career lasted two decades, and he died of natural causes at age thirty-six. The little Appaloosa colt was out of a mustang

mare owned by the wrangler as well, but after working with him for a year, Rudy decided he wasn't movie material, and he was sold as a pleasure horse. The colt's dead movie mama was a very realistic-looking stuffed horse.

After delivering the Thoroughbred mare to her owner in time for the start of the race, Hackman's Clayton enters the competition, pitting himself and Buck against his old friend Luke Matthews (James Coburn), Miss Jones (Candice Bergen), a whore who needs the purse, and Carbo (Jan-Michael Vincent), a brash young man who misdirects his need for attention by abusing women and animals. In the field also are Ben Johnson, in a brief cameo as Mister, Ian Bannen as a British sportsman foolish enough to attempt the race in an English saddle, and Mario Arteaga as a poor Mexican. Robert Hoy portrays Lee Christie, rider of the fancy mare, who was actually not a Thoroughbred at all but an Arabian. James Coburn rode a Quarter Horse called Brownie, and Candice Bergen was mounted on a big beautiful dappled gray named Dude. Both horses belonged to Rudy Ugland, as did Jan-Michael Vincent's mount, Cricket, who has the most excruciating scene in the entire film.

The script called for the horse to be literally ridden to death. He had to look as if he just dropped dead so could not be pulled into a fall. Drugs, still permitted by American Humane at the time, would have to be used. A week in advance of shooting, a test was made with a veterinarian to determine how long it would take Cricket to fall after being administered a nonlethal shot of Phenobarbital. Six seconds was all it took. Then Ugland and the filmmakers figured out how far the little bay horse could travel in those six seconds and planned the shot accordingly. The sequence was staged in sand dunes, and a softened landing spot was prepared. Covered with shaving cream sweat, Cricket really looks awful as Jan-Michael Vincent pushes him those terrible six seconds before he collapses. The

Rudy Ugland's prized horse Buck served Gene Hackman well during the arduous filming of *Bite the Bullet*.

sequence was shot in agonizingly slow motion, and the sound of the horse struggling for breath was amplified for effect. After his horse was down, Carbo began to beat him. While this action was simulated, the drug caused Cricket's tongue to loll out, making the scene all the more gut wrenching. Once Cricket revived, he was sponged off and given his oats for a good day's work. He went on to do many more films for Rudy Ugland.

The realism of the equine action in *Bite the Bullet* and the unsentimental depiction of the human qualities that drive such intense competition combined to make a compelling film that, as Clayton helps his buckskin to the finish line, ultimately celebrates that elemental connection between a man and a horse.

HIDALGO

"Nobody hurts my horse," says cowboy Frank T. Hopkins in a soft growl before sending his nemesis to his doom in the old-fashioned epic adventure *Hidalgo* (2004), which centers on a 3,000-mile endurance race across the Arabian desert. Playing Hopkins, actor Viggo Mortensen became so bonded with his pinto costar RH Tecontender, or TJ, that the words could have been his. They were penned by American Paint Horse aficionado John Fusco, who spent years researching his screenplay, based on the writings of Hopkins, a half–Native American cowboy who, on his red-and-white mustang Hidalgo, is credited with winning four hundred endurance races. There has been much controversy about the veracity of Hopkins's claims, especially the existence of the pivotal race of *Hidalgo*. In the film, set in 1890, Hopkins and his eight-year old mustang, Hidalgo, are challenged by Sheik Riyadh to compete in the Arabian Desert Challenge, across 3,000 miles of brutal terrain known as the Ocean of Fire. At stake for the sheik (Omar Shariff) is his family honor, symbolized by his prized black Arabian stallion, Al-Hattal. At stake for Hopkins is his own personal honor, shattered when, as a U.S. Calvary dispatch rider, he unwittingly delivered the orders that instigated the Indian massacre at Wounded Knee. More than that, Hopkins rides for the honor of his horse—a lowly mustang in the eyes of the sheik, one unfit for breeding or his claim to fame as the world's greatest endurance horse. After debasing himself by performing drunk in Buffalo Bill Cody's Wild West Show in New York, Hopkins rises to the occasion, and he and Hidalgo board a ship for Morocco to face the greatest challenge of their lives.

Horse trainer Rex Peterson faced his own challenge, finding the five sorrel and white overo Paints who would play Hidalgo. Combing corrals and barns from Oregon to Missouri, Texas to Michigan, Peterson considered and

rejected close to a hundred horses before finding TJ, who would become the main Hidalgo. The distinctively marked, bald-faced Paint stallion became the model for Hidalgo's four doubles.

RJ Masterbug, or RJ, was an untrained three-year-old stallion when Peterson acquired him, but after five minutes with the horse, Rex knew he had the perfect personality for a trick horse. RJ can be seen rearing, grabbing objects, and dragging them in the film. His cute and clever tricks are a refreshing throwback to the days when a cowboy's best friend was his horse. The toughest trick to train was for a dragging scene, in which Hidalgo pulls his drunken master out of the Wild West Show exhibition arena. Since horses are herbivores, they simply do not have the jaw strength to pull much weight with their mouths. RJ, however, was able to master the task, and the scene is truly charming. TJ was no slouch either when it came to a dif-

Above, Viggo
Mortensen and TJ take a break between takes with trainer Rex Peterson and Doc, whose face paint needs some touching up. Opposite page, Frank Hopkins (Viggo Mortensen) and Hidalgo, played here by Doc, attempt to outrun a raging sandstorm in *Hidalgo*.

ficult lay-down scene in which Hopkins and Hidalgo endure a locust invasion. To protect himself and his horse from the swarming insects, Mortensen lies down with TJ and covers them both with a blanket. Rex Peterson taught Mortensen to lay TJ down, as the trainer could not be close enough to cue him. The scene required multiple takes, and Mr. Mortensen later said this about his costar's performance: "To get a horse to lie down like that 30 times in a row is not easy. To get him to hit the same spot over and over again, then to throw a blanket over him and blind him that way, well, most horses, especially stallions, are not going to put up with that. But TJ did."

TJ also proved to be a quick study for another scene in which Hidalgo is supposed to pick up Hopkins's hat and bring it to him. RJ was trained for the sequence, but director Joe Johnson decided he needed a close up and TJ would have to be trained to do the scene. According to Mortensen, "TJ had been standing there the whole time, quietly, just watching Rex work with RJ. So, when they wanted this close-up, Rex said, 'Well, let's just try it,' and we brought TJ in. The first time, TJ picks up the hat, gently holds it, and looks me right in the eye. Every take! I mean that was amazing!"

Director Johnson was also amused by TJ's voracious appetite. "He was different from the other horses. He was smaller, and all he wanted to do was eat. At times, you'd look over and it looked like he was eating sand. He'd eat a candied locust [used as props in the film], a regular locust—he'd eat anything."

For the jumping scenes, a 1991 gelding named Oscar, who had competed as a show hunter, got the job done. "He's an incredible jumper," said Mortensen. "The part where I'm racing the guy in the beginning of the movie and we're jumping those fences: That was Oscar. He could sail over them." Honkey Tonkin Tuff, a 1996

gelding nicknamed DC, was a daring horse, except when it came to another species on the set—camels, of which he was decidedly not fond. Bigger than the other Hidalgos, DC was used for longer running shots, in which his size would be an advantage. Ima Stage Mount Two, known on the set as Doc, was tough and willing. His bravery enabled him to be trained for the film's most treacherous stunt, a slide into a pit trap. The frightening scene took over three months of training to achieve. Doc gradually learned to gallop to a slide-stop onto a platform that eventually lowered him into a pit almost ten feet deep. Rex Peterson's most oft-stressed training tool, patience, was the key to getting this spectacular stunt on film.

Equine makeup artist Garrett Immel skillfully painted the Paints to match. For the larger areas, he used an airbrush, but for the more intricate markings and facial areas, he used a variety of paintbrushes. He had no trouble with the horses standing still. In fact, Immel has joked that horses are much easier to work on than humans.

Viggo Mortensen, who had honed his riding skills on *The Lord of the Rings* trilogy, still needed some brush up lessons with Peterson. Mortensen did nearly all his own riding in Hidalgo; he was doubled only for difficult stunts, by Mike Watson. Peterson couldn't say enough good things about the star's ability and horse-friendly attitude. Careful to dismount to rest the horses' backs between takes, Mortensen had the utmost respect for his equine costars. Rex has said, "The show would not have been possible without Viggo." The actor in turn had this high praise for Peterson's ability and his choice of Paints: "Rex has a good eye and he picked well." He enjoyed working with all the Hidalgo horses, but at the end of filming, the bond he had forged with TJ was too tough to break so Mortensen decided to give him a permanent role as stablemate to his *Lord of the Rings* costars, Uraeus and Kenny. About TJ,

Mortensen has said, "He is a good friend that I went through hard challenges with. I feel a loyalty to him."

Screenwriter-producer John Fusco also added a *Hidalgo* horse to his stable, the talented Oscar. "I had to have a 'Hidalgo,' and Oscar is the one I rode initially," said Fusco. "I had checked on all their backgrounds and knew that he was good with children. I thought he would be great for my son." Rex Peterson kept RJ, while DC and Doc found happy homes as pleasure horses.

For the impressive black Arabian stallion Al-Hattal, director Joe Johnston wanted an animal that would tower over Hidalgo. This was a tall order for Rex Peterson as most Arabs are not that big. After much research, the trainer found the 16-hand black TC Bey Cedar, born in 1994, at a Kentucky breeding farm. According to Peterson, the stallion struck him immediately as "an exceptionally nice horse that had an 'OK, what do you want me to do?' attitude." He decided to buy the stallion for the production after working with him for only a few minutes. Peterson's instincts proved to be correct: the stallion trained beautifully, and although he had plenty of presence to play the prancing Al-Hattal, TC was easy going on the set around the other equine cast members. Peterson purchased the black at the end of filming and retired him from show business to resume enjoying life as a breeding stallion.

Hidalgo's climactic release of 572 wild horses presented Peterson and his team with another unique challenge. Finding that many wild horses was the first obstacle, and it took seven different Native American herds to fulfill the casting call. No stallions, who might have disrupted the herds by fighting, and no foals, who could have been hurt with so many horses running, were used. A number of additional professional wranglers were hired to marshal the action, which took four days to shoot in Montana.

Hidalgo screenwriter
John Fusco with Hidalgo double Oscar (left) and Wakaya—who worked in *Young Guns 2* and inspired Fusco to create the character of Rain in his screenplay for *Spirit, Stallion of the Cimarron*—at home on their Vermont farm.

The horses first had to be acclimated to the sound of a helicopter for the breathtaking panoramic aerial shots. Peterson and his team worked with wild horse experts to prevent a real stampede, all the while making sure American Humane guidelines were followed—as they were throughout *Hidalgo's* production. The result is an unforgettable finale to one of the finest horse movies in modern times.

For actors, the work often continues on a film long after the cameras have stopped rolling. Big stars are obliged to show up at movie premieres to greet their adoring fans and members of the press. TJ was no exception and made a crowd-pleasing appearance with Viggo Mortensen on the red carpet when *Hidalgo* premiered on March 1, 2004, at Hollywood's famed El Capitan Theater. Several days after the premiere, the actor left for a European publicity tour for *Hidalgo* while, like a cowboy's true partner, TJ stayed behind in Hollywood to greet admirers at the El Capitan during the movie's opening weekend.

HORSE LAUGHS AND BITS

"I think half of this belongs to a horse somewhere out in the valley."

—Lee Marvin on accepting his Best Actor Oscar for *Cat Ballou*

The classic: Smokey and Lee Marvin in *Cat Ballou.*

WHEN WARNED ABOUT BEING UPSTAGED by a powerful male costar, Marilyn Monroe famously quipped, "It's not him I'm worried about, it's those hammy horses." Marilyn was only half-kidding. Movie horses have been known to hog the limelight, sometimes drawing attention to themselves through sheer presence. It's difficult to ignore someone who weighs at least a thousand pounds, even when he's just cavorting in the background, much less when he's performing clever tricks or wisecracking like a four-legged stand-up comedian. Whether clowning around in a comedy, running away with the leading lady in a romance, or popping up for a cameo in a psychological thriller, the charismatic movie horse has stolen more than a few scenes.

FOUR-LEGGED FUN

In 1965's *Cat Ballou*, a gray horse named Smokey posed, leaning against a building with his front legs crossed, emulating the hung-over appearance of his snoozing rider, Kid Shelleen (Lee Marvin). When the actor accepted his Oscar at the 1966 Academy Awards ceremony for his performance as the drunken gunfighter, he got a big laugh for mentioning his equine costar. Director Elliot Silverstein knew that the "stoned" Smokey would make the shot memorable. To achieve that hilarious image, however, Smokey was forced to resort to method acting: he was drugged. Owned by the Fat Jones Stable and trained by Al Janks, Smokey was recognized for his work with a Craven Award from the American Humane Association, which was probably unaware of the training "method" used for the famous scene. Overlooked was his stunt double, who was featured in a comic sequence in which the drunken

Shelleen does some fancy trick riding. Lee Marvin was doubled by Tap Canutt in that sequence.

The makers of *Cat Ballou* weren't the first to exploit the horse's comedic potential. In the 1920s and '30s, Lionel Comport specialized in renting extremely sway-backed nags to the studios, which paid fifteen to thirty dollars a day for these walking sight gags. In 1929, the comedy team of Laurel and Hardy starred in *Wrong Again*, in which a horse, instead of a painting, is mistakenly delivered to a rich man by the bunglers. In this comedy of errors, the horse winds up on top of a piano. The Marx Brothers got laughs in *A Day at the Races* (1937) as veterinarian Groucho dispenses advice to an ailing horse, and jockey Harpo motivates his mount to run by showing him a picture of a man he hates. Abbot and Costello's *It Ain't Hay* (1943) features a ridiculously "disguised" horse—named Teabiscuit, in parody of Seabiscuit—wearing dark glasses and slippers, being sneaked into a hotel room. Bob Hope looks as if he is getting racing tips straight from the horse's mouth in *The Lemon Drop Kid* (1951), but really the nag is just nibbling a lemon drop placed behind Hope's ear.

COLORFUL CHARACTERS

Paints, palominos, an ornery red roan, and a pure white stallion were among the equine comedians who added spice to a variety of humorous roles.

DICE

Roy Rogers's Little Trigger, who had the famous cover-stealing scene with bedmate Bob Hope in *Son of Paleface*, wasn't the only cowboy horse to kick up his hooves in a comedy. Dice, Ralph McCutcheon's black-and-white pinto, guest starred in 1943's *It's a Great Life*, one of a series of movies based on the comic strip characters of Blondie

and Dagwood Bumstead. In the film, Dagwood (Arthur Lake) is sent by his boss, Dithers (Jonathan Hale), to buy a house. In typical bumbling fashion, Dagwood mistakenly buys a horse, named Reggie (Dice), instead.

Dice proves to be quite the comedian, displaying his full repertoire of tricks, which include lying down and hiding behind a sofa; and entering an elevator, changing his mind, backing out, and taking the stairs. In addition to providing lots of physical gags, his deadpan looks make him a perfect foil for the mugging actors.

KING COTTON

A whole galaxy of Hollywood stars made cameo appearances in the 1960 comedy *Pepe*, but Ralph McCutcheon's trick horse King Cotton stole the show. A big white American Saddlebred-Morab cross, the stallion had incredible screen presence. The Mexican comedian Cantinflas

stars as Pepe, a poor stable boy who loves a stallion named Don Juan, whom he has raised from a colt. When the horse is put up for auction, Pepe gets Don Juan to feign illness so he won't be sold. Ted Holt (Dan Dailey), a washed-up film director desperate for cash, sees through the ruse and buys the "sick" stallion at a bargain price, hoping to make a fortune from stud fees. Pepe winds up in Hollywood caring for Don Juan at Holt's dilapidated estate. Since there is no green pasture or stable, Don Juan beds down on the closest thing resembling a lawn: a billiard table. Throughout the film, Pepe calls Don Juan his son, causing silly misunderstandings. This tiresome running gag is forgiven every time King Cotton, as Don Juan, appears on screen.

For the beginning scenes of Don Juan playing sick, King Cotton was trained to limp, as was McCutcheon's Highland Dale for *Giant*. He had all the same tricks as Dice, including going up and down stairs. One of the most

Above left, Reggie (Dice) puts up with the typical Dagwood (Arthur Lake) incompetence while Blondie (Penny Singleton) and the kids look on in *It's a Great Life*. Above right, wearing a sensible sun hat, King Cotton, as *Pepe's* Don Juan, practices horse paddling much to the amusement of costars Cantinflas and Shirley Jones.

outrageous scenes has Don Juan swimming in Holt's pool. The sequence begins with a quick shot of Don Juan surfacing from underwater, then cuts to the actors and back to the swimming horse. A fake horse head was used for the surfacing shot. King Cotton deservedly won a PATSY Award from American Humane for his efforts.

The stallion continued his acting career through the sixties. Charleton Heston rode him in 1962's *Diamond Head*, and he appeared in *The Virginian* television series. His last known film was *Viva Max* (1969), in which he was ridden by Peter Ustinov. Despite these appearances, King Cotton never again got the chance to shine quite as brightly on the screen as he had in *Pepe*.

OLD FOOLER

The Rounders (1965) prominently featured a cantankerous blaze-faced red roan horse named Old Fooler, who gives cowboys Ben Jones (Glenn Ford) and Howdy Lewis (Henry Fonda) a bad time. After corralling stray cattle and breaking wild horses for Jim Ed Love (Chill Wills), the two cowboys take the roan to the Sedona, Arizona, rodeo and challenge all comers to ride the unbreakable bronc. Old Fooler, who has repeatedly bucked off Ben, foils the cowboys by sitting down instead of bucking for money.

Old Fooler was destined for stardom. V. J. Spacey bought a chocolate roan Quarter Horse–type mare at auction in Lancaster, California, and she turned out to be in foal with Old Fooler, a distinctive red roan colt. Fat Jones acquired him when he was three and, according to trainer Ken Lee, "half-spoiled and half-broke." Director Burt Kennedy was scouting horses for *The Rounders* at the Jones stable and spotted Old Fooler alone in a corral. He liked the horse's looks and cast him on the spot. Lee was skeptical that the roan, as ornery as his movie character, would learn the tricks required by the script, but eight weeks later, he

was camera ready. Lee had taught Old Fooler to sit, bite on command, drag a man through mud, and untie knots. In one silly scene in *The Rounders*, Old Fooler spots an attractive mare's rump, unties the mare from a hitching rail, and leads her out of the barn. Old Fooler also learned how to drink from a bottle for his role in another movie, *Flap* (1973), in which he played a drunken horse named H-Bomb.

ALBORADO

In 1968, the beautiful dappled steel gray gelding Alborado won the PATSY for his role as the title character in Disney's *The Horse in a Grey Flannel Suit*. Dean Jones starred as Fred Bolton, an advertising executive who convinces his boss to buy a horse for his daughter, Helen (Ellen Janov), to campaign in prestigious competitions. The idea is for the horse to attract publicity for an antacid. The horse, named Aspercel after the medicine, runs away after Fred

SAM

A most memorable sight gag in Mel Brooks's *Blazing Saddles* (1973) involves a stunt horse who takes a fall from a standstill when the hulking Mongo (Alex Karras) punches him out of sheer meanness on his way into a bar. The perfectly timed bit is brief but packed a visual wallop. A subtler running gag is in the appearance of Sheriff Bart's steed. Bart (Cleavon Little), the first black sheriff in the West, was mounted on a flashy palomino, a visual reference to Trigger, the sidekick of Roy Rogers. The slick and urban Bart couldn't be more different from the squeaky clean cowboy.

The palomino Sam fell on hard times after his movie career ended, when his owner of eight years had a stroke. He was rescued by a wonderful southern California organization called HorseAid and lived out the rest of his days at pasture, surrounded by fellow retirees.

FIDO

Fifty-seven years after Dice tickled moviegoers with his antics, another pinto charmed audiences with his physical comedy in the Western spoof *Shanghai Noon* (2000). The movie concerns a member of China's Imperial Guard, Chon Wang (mispronounced as "John Wayne"), who comes to Nevada to rescue the kidnapped Princess Pei Pei (Lucy Liu). Chon (Jackie Chan) rescues a young Native American girl and is honored by the chief with a wife and a trick pinto pony named Fido. Chon hooks up with a goofy train robber, Roy O'Bannon (Owen Wilson), and together they save the princess. Since it's a Jackie Chan movie, there is plenty of fighting action, much of it comic, but the charming red-and-white pinto steals all his scenes.

Fido was just four when head wrangler John Scott picked him and two doubles to try out for the role as Chon's

Albarado, escorted by Jimmy Williams's assistant trainer Karlie Anderson, picks up his award for *The Horse in the Gray Flannel Suit* from Denver Pyle at the 19th Annual PATSY ceremony.

insults him. Comically clad in boxer shorts and bedroom slippers, Fred frantically chases the gray. Finally catching him, Fred makes several futile attempts to mount bareback. After playing hard to get, "Aspy" gives in and sticks his head between Fred's legs while the hapless human is standing on a wall. Fred slides down Aspy's neck and off they go on a wild ride, pursued by the police, who think the horse has been stolen. Apsy redeems himself by winning the championship in the open-jumping division at the Washington International Horse Show.

Albarado, the big gray Thoroughbred who played the jumping Aspercel, was trained by Jimmy Williams. His double, appearing in the comedic sequence with Jones, performed a number of tricks, including drinking beer from a cup. Both horses were immensely talented, but Albarado picked up the PATSY. As with *Cat Ballou's* Smokey, the star got all the credit.

Clowning around on the set of *Shanghai Noon*, Fido sits while his costar Jackie Chan makes like a reptile.

ACTION-PACKED LAUGHS

Arnold Schwarzenegger and director James Cameron used a horse for comic relief in the 1994 action thriller *True Lies*. Secret agent Harry Tasker (Schwarzenegger) commandeers a policeman's mount for an outrageous chase scene that includes a gallop through a luxury hotel and a ride in its glass elevator. The action culminates in a humorous rooftop tete à tete between man and horse, whose wisdom prevailed in not following the villain, on a motorcycle, over the edge. The sequence was spoofed by Leslie Neilsen in *Spy Hard* (1996), right down to the same formally clad stunt performers from *True Lies*, Loren Janes and May Boss, in the elevator. The *Spy Hard* sequence, however, culminates in horse and rider crashing through a wall and going over the building's edge after the bad guy, who is absurdly riding a lawn mower.

For *True Lies*, head wrangler James Halty found six different horses for various aspects of the sequence. Director Cameron wanted a big Thoroughbred for the equine cameo. With the old Hollywood stables no longer in existence and the smaller rental outfits having mostly Quarter Horse types, Halty, a former jumper rider himself, turned to Los Angeles–area show barns for help. He found the handsome lead horse, Ernie, at Foxfield Riding School in Westlake Village. A beautiful 16.2-hand chestnut Thoroughbred with a white stripe and two white socks, Ernie had previously found fame as a successful show horse named Tommy Tucker. Retired from competition, Ernie was being used for lessons. A gentle giant, he suited Arnold Schwarzenegger perfectly and performed in all the close-up scenes with the actor.

Since Ernie was leased to the production with the stipulation that he not be jumped, two jumping doubles were required for the wild chase through the hotel lobby, during which the horse leaps over furniture. Two more

horse. Trainer Claude Chaussé, whom Scott recruited from Montreal after seeing his accordion-playing horse during a live show, spent only a few minutes with the three pintos before declaring Fido to be the smartest. The wrangler was amazed by Chaussé's keen perception and his noncoercive training methods. "He works strictly out of kindness," Scott has observed.

An excellent study, Fido was trained to lie down, sit, kiss, come to a whistle, and most difficult of all, drink a bottle of "whiskey." The bottle, of course, was plastic, but the shots of Fido chugging from it are real, not computer generated. One of Fido's cutest scenes, in which he repeatedly reaches around and removes his saddle blanket with his teeth as Chon tries to saddle him, is an homage to his movie-horse role model, Dear John, the Appaloosa who pulled the same trick on Gregory Peck in *The Big Country*. After the movie, the young pinto remained as part of John Scott's movie herd in Alberta, Canada.

horses were used for the outdoor portion of the chase. A sixth horse performed a bowing trick, but that scene wound up on the cutting-room floor. A set was built for the elevator interior scenes with the star and stunt performers, who were not required to do anything but react to the horse. However, Loren Janes and May Boss were deliberately cast to handle any safety issues that might arise working on such a small set with a large animal. Fortunately, the scene went smoothly, and the dressed-up couple's response to sharing an elevator with a horse is priceless. For an exterior long shot of the horse and actors going up in the glass elevator, an animatronic horse was used for two reasons: first for safety, and second because the real horse, at more than a thousand pounds, was simply too heavy for the elevator.

The special effects house of M.E.L (Makeup & Effects Laboratories, Inc.) was contracted to build Ernie's replica. Starting with a life-size fiberglass horse, the effects team crafted a new head and mechanical neck from metal and latex foam. Working from photographs of Ernie, Jeremy Aiello sculpted the animatronic parts. M.E.L. partner Paul Elliot had the job of operating the animatronic horse from inside, with foot pedals and hand levers. Equipped with a radio earpiece so he could take direction and cooled by fans and cold packs, Elliot spent four long hours inside the fake Ernie while the elevator sequence was shot. Who says show business isn't glamorous?

In addition to the exterior elevator shot, the animatronic Ernie was used for a quick insert in the rooftop sequence in which Schwarzenegger appears to be hanging by the horse's reins. The animatronic took three months to build at a cost of $150,000. After the movie, he was "retired" to an exhibit in a Planet Hollywood restaurant, since closed.

The real Ernie returned to his job at Foxfield Riding School after *True Lies* and continued to work with young students. He was also a member of Foxfield's famous drill

team, which performs without the benefit of saddles or bridles. Later, an adult student, Sue Lawrence, fell in love with the handsome chestnut gelding. Joanne Postell, who owns Foxfield, gave Ernie to her. He moved to Flagstaff, Arizona, with his new owner and spent the rest of his days enjoying a quiet life.

The producers of *Spy Hard* commissioned another animatronic from M.E.L. for their spoof sequence. In Leslie Neilsen's rooftop scene, the horse slides on his haunches. This animatronic was modified to sit and slide on wheels. When the horse goes over the edge, the "stunt horse" is shown to be an obvious dummy, with computer-enhanced lips, as it mugs and curses on descent.

THE TALKERS

Loquacious equines have gotten laughs since 1949, when Francis, the Talking Mule, debuted in *Francis*, the first of seven films featuring the wildly popular novelty.

M.E.L.'s Paul Elliott and the animatronic Ernie from *True Lies*

FRANCIS

In the kickoff film of the *Francis* series, Donald O'Connor plays Peter Sterling, a bungling army private who makes friends with a talking mule. O'Connor costarred with Francis in the next five films, *Francis Goes to the Races* (1951), *Francis Goes to West Point* (1952), *Francis Covers Big Town* (1953), *Francis Joins the WACS* (1954) and *Francis in the Navy* (1955). By 1956, O'Connor had tired of playing second fiddle to a mule, and Mickey Rooney took over to costar in *Francis in the Haunted House*. The chemistry between Rooney and Francis just wasn't right, and the movie flopped, ending the popular feature series. In all the films, cowboy star Chill Wills provided the gravelly voice of Francis, who was actually a female mule named Molly.

Gambling on the concept put forth in a novel by David Stern, Universal Pictures had purchased the untrained but tractable Molly for $350 in 1948. While Stern busied himself writing the screenplay for *Francis*, trainer Les Hilton went to work teaching Molly a number of tricks. By the time the cameras rolled, Molly could climb stairs, untie a rope with her teeth, and wink on cue. She flatly refused to sit, however, and was doubled by another trick mule for any sitting scenes. To make Molly "talk," Hilton reportedly tried chewing gum and chewing tobacco. When neither worked, he crafted a bridle with a heavy thread running under her top lip. When the thread was pulled, Molly wiggled her lips. An overnight sensation, Molly, known to her adoring public forever after as Francis, won the first ever PATSY Award for *Francis*. She would win two more PATSYs in her career, for *Francis Goes to West Point* and *Frances Joins the WACS*. Francis was also immortalized in Dell comic books.

The fruits, or in this case, grains, of success brought an actress's familiar problem to the equine leading lady: the struggle to maintain a perfect figure. Molly gained so much weight between her first and second picture that she was ordered by the studio to shed two hundred pounds. Her hay ration was reduced and like many a weight conscious star, she took up jogging. When diet and enforced trots up and down the Hollywood hills behind a station wagon only resulted in a hundred-pound loss, Molly sweated off the next hundred in a steam room custom built for her.

MISTER ED

The wisecracking equine who embarrasses a human confidant by refusing to talk in front of other humans was a surefire formula. It fueled the premise of the beloved CBS television series *Mister Ed*. Conceived by Arthur Lubin,

Mister Ed was played by the gelding Bamboo Harvester, foaled in El Monte, California, in 1949. His grandsire, the Harvester, was an American saddlebred and his sire, Chief Tonganoizie, was out of an Arabian mare. His dam, Zetna, was pure Arabian. A show and parade horse in his early years, Bamboo Harvester was eleven when Filmways Television Productions purchased him for $1,500. Because of his experience with Francis, Les Hilton was contracted to transform the palomino into Mister Ed. Hilton stabled the horse in his own backyard in the Burbank Rancho residential area near Los Angeles' Griffith Park. Living in such close proximity enabled Hilton to develop a strong bond with the palomino, who turned out to be a remarkable actor. He easily learned whatever tricks were needed for the week's episode, and scripts were written to showcase his talents. Ed learned to open doors, untie knots, answer the phone, and wield a large pencil to write notes. In one episode, he authored the memoir "Love and the Single Horse." He was often dressed up in silly costumes for stints as an artist, a surfer, a Beatles fan, a baseball player, a pilot, a playboy, a dancer, and a scholar, but no matter what the equine chameleon was up to each week, he remained a loyal friend to Wilbur. One trick Mister Ed could not master without artificial aid was talking. Hilton employed the same technique he had used with Francis and threaded an invisible nylon filament through Ed's halter and under his top lip. When the off-screen trainer tugged on the line, Mister Ed "talked." This is why Mister Ed was never seen in talking scenes without his handsome leather halter. His deep masculine voice was provided by former cowboy star Alan "Rocky" Lane. The actor's identity was kept secret, and the credits simply read: "Mister Ed … Himself."

Mister Ed had one double, Pumpkin, who looked almost exactly like him, except for a slightly darker nose

Mister Ed looks over his lines with costar Alan Young.

who directed all the *Francis* films, the series was based on twenty-eight short stories by Walter Brooks. In the series, Alan Young starred as architect Wilbur Post, a befuddled sort who was the perfect foil for the dry-witted Mister Ed. In the pilot episode, Wilbur and his scatterbrained wife Carol (Connie Hines) move into a new house that comes with a palomino horse in the backyard stable. Much to Wilbur's surprise, the palomino, Mister Ed, begins to talk—but only to him. In the memorable first episode, Ed proves his elocution skills to Wilbur by quipping drolly, "How now, brown cow." An instant success, the series ran on CBS from 1961 to 1966, before going into syndication. It was revived in the 1980s by the cable network Nickelodeon's popular Nick at Nite series.

and a pumpkin shaped spot at the top of his white blaze, easily disguised with clown make-up. Pumpkin was used mostly as a stand-in for Ed, so the star would not get tired during lighting set-ups. Pumpkin was reportedly used only twice in the series, in episodes "TV or Not TV" and "Ed the Hero." Pumpkin also appeared with Eddie Albert and Eva Gabor on *Green Acres* in the late 1960s and was featured in some pudding commercials.

Alan Young has fond memories of working with Mister Ed. In his book *Mister Ed and Me*, Young remembers following Mister Ed's horse trailer to work and watching his snowy tail. "If his tail was tucked down behind the tailgate, it meant he wasn't quite awake yet. But if it was outside the gate, flowing in the breeze, he was ready and eager. On those days, when we pulled onto the lot, he would begin stamping on the trailer floor, impatient to start acting."

Bamboo Harvester really did seem to enjoy his work and was a consummate professional who rarely required more than one take of a scene. Famous guest stars such as Clint Eastwood, Zsa Zsa Gabor, and Mae West got a kick out of working with the palomino, who won PATSY Awards as Mister Ed four times in a row, from 1962 to 1965. Kids hooked on the series could have their own Mister Ed talking puppet made by the Mattel Toy Company.

After the *Mister Ed* series ended, Les Hilton continued to care for Bamboo Harvester at his Burbank home. Alan Young frequently visited his former costar and always got a thrill when he saw his handsome blaze face poking out of his stall. One day in 1968, however, Les Hilton greeted Young with sad news. At age nineteen, Ed had died after being given a tranquilizer by a well-meaning caretaker who thought he was having a seizure. What the caretaker didn't know was that because of his rather top-heavy conformation, Ed always thrashed about trying to get on his feet after lying down. Ed's tragic demise was withheld from the public so as not to upset fans still enjoying the series in syndication.

Trainer Les Hilton passed away in 1976, after a long career training some of the most beloved equines of television and movies. Wrangler Rudy Ugland, who received his basic training from Hilton, remembered him fondly in a 2004 interview. In describing Hilton's incredible rapport with horses, Ugland said that while he was wrangling for Hilton, the trainer "would never let me catch a horse, feed a horse, or put him away. He wanted his horses totally dependent on him." The carefully created bond between trainer and horse resulted in some of the most exceptional horse work ever captured on film. With Mister Ed, Les Hilton helped create an enduring icon of American popular culture.

DON

When Warner Brothers studios contracted Corky Randall to train a talking horse for its comedy *Hot to Trot* (1988), he was determined not to resort to the filament routine that prompted Mister Ed. Corky and his brother, Glenn Randall Jr., worked with the star horse, Don, and taught him to open his mouth and curl his lips to "speak" by using whip cues. The film stars Bob Golthwaite as Fred P. Chaney, a dim wit who inherits half of a successful broker-age firm and a talking horse, who makes him look like a genius by giving him stock tips. For his role as the clever tipster, Don, a five-year-old bay Thoroughbred from Hemet, California, was also trained by the Randalls to sit, lie down, operate a telephone, flip a light switch, and bring Chaney his newspaper and slippers. Special foam furniture enabled Don to sit comfortably on a chair or sofa for several takes at a time.

The film was not a big success, but Don and the Randalls' excellent work is worth looking at because of the amazing training breakthrough. Don continued his movie career, and had small roles in *Heat* (1995) and *That Thing You Do* (1996) as well as numerous television series and commercials.

STRIPES

A talking horse of a very different color is featured in *Racing Stripes* (2005). This time, the equine star is a zebra who longs to be a racehorse. The film combines live action with computer animation that creates talkers out of a whole menagerie à la *Babe*, the 1995 comedy hit about a talking pig.

Widower and single dad Nolan Walsh (Bruce Greenwood) finds a baby zebra abandoned by the side of a road by a traveling circus. He takes him home to his farm, where the little fellow grows up among a barnyard

Don shows off his talking technique as trained by Corky Randall for *Hot To Trot.*

of talking animals. Named Stripes, the zebra finds a friend in Nolan's fourteen-year old daughter, Channing (Hayden Panettiere), who helps him realize his dream.

Trainers Heath Harris and Bob Lovgren headed a huge team who worked with the horses and zebras on location in South Africa for *Racing Stripes*. For one sequence, when Stripes is entered in the Blue Moon Race, a sort of equine drag race held by kids, the trainers had the awesome task of directing forty liberty horses. Months of preparation went into this one scene.

Stripes was played by six different zebras. Since zebras are essentially wild and aggressive, they simply could not be expected to be trained to behave like hors-es and could not be taught to race. For certain racing scenes, Stripes was doubled by white ponies, painted with zebra stripes by equine make-up artist Tara Lawrence and her team.

Horse Bits

Filmmakers have long known that horses are powerful symbols and useful plot facilitators. In addition to amusing us with clever tricks, horses have made cameo appearances in thrillers, dramas, and fluffy romantic movies. Director Stanley Kramer cast Ralph McCutcheon's palomino Sunny in a small but crucial role in the romantic drama *Not as a Stranger* (1955). The gorgeous palomino is part of a seduction sequence, as a sultry horse breeder (Gloria Graham) teases a married doctor (Robert Mitchum) by jumping Sunny over a fence, inviting the doctor for a drink, and galloping away. The doctor's sexual frustration is obviously symbolized in a later sequence as California, a palomino stallion doubling Sunny, rears and whinnies in his stall, pining for a nearby mare. The horse's urgent whinnies are background music for a scene that culminates with Graham and Mitchum locked in a passionate embrace.

Director Alfred Hitchcock particularly appreciated the dramatic qualities of horses and used them to terrific advantage in *Notorius* (1946), in which Ingrid Bergman's runaway mount facilitates a rendezvous with Cary Grant and later in the psychological thriller *Marnie* (1964), in which the troubled title character's independent nature is emphasized by her relationship with a big black hunter, Forio.

In one unforgettable scene, Marnie's husband (Sean Connery) surprises Marnie (Tippi Hedren) by giving her the horse she had previously just rented. The horse is delivered to their front door, and although she is wearing a yellow chiffon cocktail dress, Marnie impulsively jumps aboard Forio and gallops off over a fence. The unusual image says more about Marnie's nature than reams of dialogue could possibly convey.

Jennifer Lopez steps into Ingrid Bergman's stirrups for *The Wedding Planner* (2001), when she goes riding with clients and her horse runs away, leaving Matthew McConaughey no choice but to rescue her. It's a plot device as old as the hills, yet the runaway horse sequence adds glamour and excitement to this modern romance. In 28 *Days* (2000), Sandra Bullock's character is introduced to equine-assisted therapy as a means of overcoming substance abuse. In reality, horses are used in a number of therapeutic situations. Through special riding programs throughout America, horses help handicapped kids to develop physically, mentally, and emotionally. Inner city kids find self-esteem caring for and riding horses. In addition to working with the disadvantaged, horses teach prisoners work ethics and compassion in rehabilitation programs, which utilize former racehorses. *Big Spender* (2003), starring Casper Van Dien and a number of Canadian Thoroughbreds, was a television movie made for the Animal Planet cable network that featured such a program. From movies such as these, modern audiences are coming to understand Winston Churchill's wise words, "There's something about the outside of a horse that's good for the inside of a man."

The Last Laugh...

The horse may have had his heyday in Hollywood, but he keeps making a comeback. His presence was strongly felt at the 2004 Academy Awards Ceremony.

In a filmed spoof of the Oscar-nominated movies, host Billy Crystal galloped one of the racing stars of *Seabiscuit* and rode Shadowfax up the staircase in *Lord of the Rings, The Return of the King*. To create the illusions, the actor's head was placed on the bodies of Tobey Maguire and Ian McKellan through the magic of CGI, but the horses were the real thing. The bits got the biggest laugh of the night.

On Valentine's Day, 2004, just a few weeks before completing the first draft of *Hollywood Hoofbeats*, I took a break from writing to go hiking with my dog, Buster.

It was a beautiful Saturday afternoon, and as we began the climb up Rattlesnake Trail in Griffith Park I noticed a pile of video equipment on the ground at the first bend. Just beyond, a young filmmaker (who looked no older than twelve) was manning a camera on a tripod, surrounded by his crew of three adults. A young actress, dressed in a period ensemble of a white ruffled shirt, blouse and bonnet stood at the side of the trail as a messenger in a tri-cornered hat trotted down the hill on a gorgeous buckskin gelding. The messenger, who on closer inspection was also a young woman, handed the actress in white a rolled up letter. Cut!

Under the guise of waiting for the dust to settle, I led Buster slowly past the filmmakers, obviously students and some supportive relatives. They were deciding to re-shoot the scene so I continued up the hill and around the next bend where I waited for the buckskin to return to his mark. The horse was impeccably groomed, his black points offsetting his golden brown coat, which glistened in the afternoon sun. He had a lovely head with a white star and an intelligent eye. He did not appear nervous, but alert and eager as he waited for his cue. It came after a minute or so, and his rider kicked him into a smart trot down the hill. I had just watched *The Man From Snowy River* (again) the night before and was reminded of the steep downhill descent on another buckskin. I watched them until they were out of sight and continued my uphill march.

Forty-five minutes later, Buster and I were headed back down the hill. The filmmakers were still at it, shooting a scene with the girl in white. I thought about approaching them but figured that—like countless aspiring filmmakers who, for many decades, have used Griffith Park as a location while building their reels—they didn't have permits and might be reluctant to talk. I looked around for the buckskin, hoping to discover his name, but he was gone, probably back to his nearby barn. I wondered if he would ever "act" again, if he'd find his way into a feature film. I was comforted by the thought that if he did, he would never be trip-wired or overworked. If he didn't continue his acting career, he had nevertheless left his faint hoof prints in the long history of the movie horse.

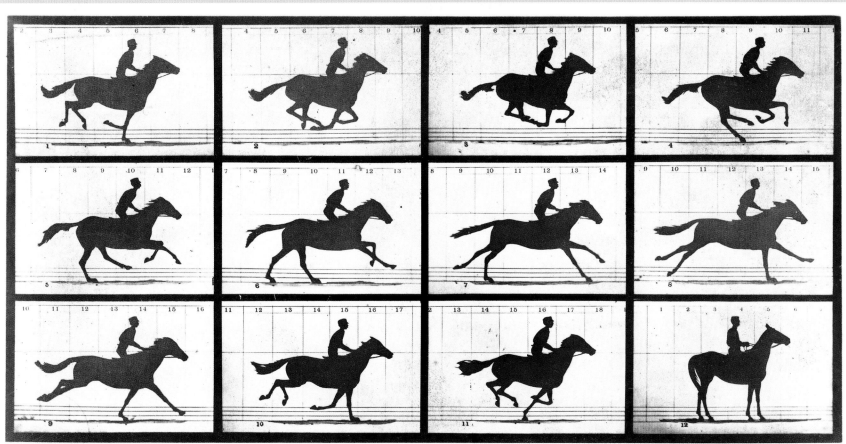

Copyright, 1878, by MUYBRIDGE.

MORSE'S Gallery, 417 Montgomery St., San Francisco.

THE HORSE IN MOTION.

Illustrated by
MUYBRIDGE.

AUTOMATIC ELECTRO-PHOTOGRAPH.

"SALLIE GARDNER," owned by LELAND STANFORD; running at a 1.40 gait over the Palo Alto track, 19th June, 1878.

The negatives of these photographs were made at intervals of twenty-seven inches of distance, and about the twenty-fifth part of a second of time; they illustrate consecutive positions assumed in each twenty-seven inches of progress during a single stride of the mare. The vertical lines were twenty-seven inches apart; the horizontal lines represent elevations of four inches each. The exposure of each negative was less than the two-thousandth part of a second.

Sallie Gardner, The Horse in Motion *by Eadweard Muybridge.*

Acknowledgments

The authors wish to thank the following individuals for their generosity and invaluable contributions to *Hollywood Hoofbeats:*

Gini Barrett
Robert S. Birchard
Laurent Bouzereau
Shelley Boyle
Clair Brandt
Lisa Brown
Karla Buhlman
Polly Burson
Tap Canutt
Harry Carey, Jr.,
Marilyn Carey
Diana Serra Cary
Russ Case
Barbara Casey
Bernadine Cheviron
Victoria Countner
Robert Dalva
Neda Demayo
Steve Dent
Tim Farley
Marva Felchlin
Jay Fishburn
Rory Flynn
John Fusco
Alex Green
Douglas Green
Howard Green
Tad Griffith
Wendy Griffith
John Hagner
Donna Hall
Maxine Hansen

Heath Harris
Rusty Hendrickson
Walter Hill
Laura Hilllenbrand
Jeff Ikemiya
Suzy Jarratt
Herb Jeffries
Elizabeth Kaye-McCall
David Kiehn
Christine Kruger
Bruce Larsen
Kenneth Lee
Tim Lilley
Daryle Ann Lindley
Mario Luraschi
Manola Madrid
Frank Marshall
Michael McClean
Salome Milstead
Dorothy S. Mitchum
Georgia Morris
Len Morris
Viggo Mortensen
Selina Nelson
Barrie Osborne
Leo A. Pando
Mary Jane Parkinson
Melissa Paul
Rex Peterson
Mary Radford
Jacqueline Ramirez
Chuck Rand

Corky Randall
Glenn Randall Jr.
Joan Randall
Lynn Rawlins
V. Lynn Reynolds
Dusty Rogers
Cheryl Rogers-Barnett
Karen Rosa
Joy Rose-Larsen
Gary Ross
Wilma Russell
John Scott
Brooke Shannon
James Sherwood
Nancy Sherwood
James Gregory Simcoe
Packy Smith
Caroline Thompson
Faye Thompson
Lillian Turner
Polly Ugland
Rudy Ugland
David Vidad
Marc Wanamaker
Graham Ware Jr.
Bruce Weber
Ray White
Jack Williams
Alan Young

Silent star Baby Peggy (Diana Serra Cary) parodied the cowboy/horse partnership on her miniature horse, Tim, in Peg O' the Mounties, 1924.

Bibliography

Amaral, Anthony. *Movie Horses: Their Treatment and Training.* Indianapolis: Bobbs-Merrill, 1967.

Baxter, John. *Stunt: The Story of the Great Movie Stuntmen.* Garden City, N.Y.: Doubleday, 1974.

Birchard, Robert S. *King Cowboy: Tom Mix and the Movies.* Burbank, Calif.: Riverwood Press, 1993.

Canutt, Yakima, with Oliver Drake. *Stunt Man.* Norman: University of Oklahoma Press, 1997.

Carey, Harry Jr. *Company of Heroes.* Metuchen, N.J.: Scarecrow Press, 1994.

Cary, Diana Serra. *The Hollywood Posse.* Norman: University of Oklahoma Press, 1996.

Christeson, Helen Mae, and Frances Mary Christeson. *Tony and His Pals.* Chicago: Whitman, 1934..

Conley, Kevin. "Hollywood Postcard: Doppelgängers," The Talk of the Town. *New Yorker,* May 31, 2004.

Fenin, George N., and William K. Everson. *The Western: From Silents to the Seventies.* New York: Grossman, 1973.

George-Warren, Holly. *Cowboy: How Hollywood Invented the Wild West.* Pleasantville, N.Y.: Reader's Digest; London: Ivy Press, 2002.

Green, Douglas B. *Singing in the Saddle: The History of the Singing Cowboy.* Nashville: Country Music

Foundation Press/Vanderbilt University Press, 2002.

Griffith, R., and A. Mayer. *The Movies.* New York: Simon and Schuster, 1975.

Gunning, Tom. *D. W. Griffith and the Origins of American Narrative Film.* Urbana: University of Illinois Press, 1994.

Hart, William S. *My Life—East and West.* Boston: Houghton Mifflin, 1929; North Stratford: Ayer, 2000.

Hintz, H. F. *Horses in the Movies.* Cranbury, N.J.: A. S. Barnes, 1979.

King, Susan. "He Brings Out the Animal in Animated Film." *Los Angeles Times,* Jan. 2, 2004, sec. E.

Kurz, Shelly M. "All the Pretty Horses." *Western Horseman,* Dec. 2000.

Jarratt, Suzy. *Heath Harris: Movie Horses Down Under.* Arcadia, NSW, Australia: Horse Talk Enterprises, 1985.

Lahue, K. C. *Winners of the West: The Sagebrush Heroes of the Silent Screen.* South Brunswick: A. S. Barnes, 1971.

Lee, Raymond. *Not So Dumb.* South Brunswick: A. S. Barnes, 1970.

Montana, Montie. *Not Without My Horse.* Aqua Dulce, Calif.: Double M Press, 1993.

Parkinson, Mary Jane. *The Kellogg Arabian Ranch: The First Sixty Years.* Pomona, Calif.: Cal Poly Kellogg

Unit Foundation, 1984.

Pattie, Jane. *John Wayne: There Rode a Legend.* Fort Worth, Texas: Wilma Russell's Western Classics, 2003.

Price, Steven D., ed. *The Quotable Horse Lover.* Guilford, Conn.: Lyons Press, 1999 Western Classics, 2003.

Rainey, Buck. *The Life and Films of Buck Jones: The Silent Era.* Waynesville, N.C.: World of Yesterday, 1988.

———. *The Life and Films of Buck Jones: The Sound Era.* Waynesville, N.C.: World of Yesterday, 1991.

Roberson, "Bad Chuck," with Bodie Thorne. *The Fall Guy: 30 Years as the Duke's Double.* Vancouver, B.C.: Hancock House, 1980.

Rogers-Barnett, Cheryl, and Frank Thompson. *Cowboy Princess: Life with My Parents, Roy Rogers and Dale Evans.* Lanham, Md.: Taylor Trade Publishing, 2003.

Rothel, David. *The Great Show Business Animals.* San Diego: A. S. Barnes, 1980.

Sellnow, Les. *The Journey of the Western Horse: From the Spanish Conquest to the Silver Screen.* Lexington, Ky.: Blood Horse Publications, 2003.

Solnit, Rebecca. *River of Shadows: Eadweard Muybridge and the Technological Wild West.* New York: Penguin Books, 2004.

Turner, Lillian. "The Golden Horse on the Silver Screen." *Montana: The*

Magazine of Western History (Autumn/Winter, 1995).

White, Raymond E. "B-Western Horses." *Western Horseman* (June 2001).

Wyatt, Edgar M. *The Hoxie Boys: The Lives and Films of Jack and Al Hoxie.* Raleigh, N.C.: Wyatt Classics, 1992.

———. *More Than a Cowboy: The Life and Films of Fred Thomson and Silver King.* Raleigh, N.C.: Wyatt Classics, 1988.

Young, Alan, with Bill Burt. *Mister Ed and Me.* New York: St. Martin's Press, 1994.

James Stewart's beloved co-star "Pie" by Henry Fonda

The images in this volume are provided courtesy of the following:

FRONT COVER

Filmstrip Images (left to right):
Roy Rogers, *South of Caliente* (1951)—Marc Wanamaker, Bison Archives. Trainer Glenn Randall Sr., "Ben Hur" live show exhibition—Corky Randall. Kelly Reno and Cass Olé, *The Black Stallion* (1979)—Photo by Tim Farley. **Inset and Background Images:** Library of Congress. © 1945 Metro-Goldwyn-Mayer (MGM) Studios Inc., all rights reserved.

BACK COVER

Photo restoration by Howard and Jill Levine, CDS PhotoGraphics, © 2004 by The Autry Qualified Interest Trust and the Autry Foundation.

FRONT MATTER

3: Photo restoration by Howard and Jill Levine, CDS PhotoGraphics, © 2004 by The Autry Qualified Interest Trust and the Autry Foundation.
4: Marc Wanamaker, Bison Archives. 6: Robert S. Birchard and Packy Smith. 7: © 1980 MGM Studios Inc., all rights reserved.

CHAPTER 1

8, 10: Library of Congress. 11: Buffalo Bill Historical Center, Cody Wyoming, P.69.1979. 12: ScreenSound Australia, the National Screen and Sound Archive. 13: Robert S. Birchard. 14: Marc Wanamaker, Bison Archives. 15: Diana Serra Cary.

CHAPTER 2

16, 27: The Museum of the American West, Autry National Center. 18–19, 21–22, 24, 26, 28, 30, 35: Robert S. Birchard. 25, 33: Marc Wanamaker, Bison Archives. 31: Eddie Brandt's Saturday Matinee. 32: Wilma Russell, Wilma Russell's Western Classics.

CHAPTER 3

36, 39, 41–44, 58: Photo restoration by Howard and Jill Levine, CDS PhotoGraphics, © 2004 by The Autry Qualified Interest Trust and the Autry Foundation. 38, 48, 53: The Museum of the American West, Autry National Center. 45, 50: Roy Rogers Museum. 49 (left): Marc Wanamaker, Bison Archives. 47, 54: Petrine Day Mitchum. 49 (right), 51: Corky Randall. 52: Douglas Green. 56, 59: Daryle Ann Lyndley.

CHAPTER 4

60, 62, 67 (right): Marc Wanamaker, Bison Archives. 63: Tap Canutt. 65 (left): American Humane Association. 65 (right), 68–69: John Hagner, Stuntmen's Hall of Fame. 67 (left): Jack Williams. 70: Kenneth Lee. 73: © 1999 Paramount Pictures, all rights reserved. 74: Photo by Elliott Marks, © 1998 Touchstone Pictures, Inc. all rights reserved. 75: Bruce Larsen. 76: Corky Randall. 79: Eddie Brandt's Saturday Matinee.

CHAPTER 5

80: Wilma Russell, Wilma Russell's Western Classics. 82, 85 (left), 87: Kenneth Lee. 83: © Warner Brothers Entertainment, Inc., all rights reserved. 85 (right), 101: Robert S. Birchard Collection. 86: © Paramount Pictures, all rights reserved, image provided by the Academy of Motion Picture Arts and Sciences (AMPAS). 88, 97: American Humane Association. 89, 90, 91 (right): National Cowboy & Western Heritage Museum. 91 (left), 93: Petrine Day Mitchum. 92: Marc Wanamaker, Bison Archives. 94: © 1946 Twentieth Century Fox, all rights reserved. 95 (left): The Museum of the American West, Autry National Center. 95 (right): © Disney Enterprises, Inc. 98: © Warner Brothers Entertainment, Inc., all rights reserved, image provided by AMPAS. 99: U.S. Television Office, Inc., Owner of Copyrights and Trademarks in and to the Hopalong Cassidy Motion Picture Film Library and the Hopalong Cassidy character. 100: Image provided by the International Museum of the Horse, Kentucky Horse Park. 102: Photo restoration by Howard and Jill Levine, CDS PhotoGraphics, © 2004 by The Autry Qualified Interest Trust and the Autry Foundation. 103: © 2005 Bonanza Ventures, Inc./NBC Universal, all rights reserved.

CHAPTER 6

104: Photo by Ernest Haas, image provided by Bison Archives. 106, 108 (left): Petrine Day Mitchum. 108 (right): Wilma Russell, Wilma Russell's Western Classics. 109: Geoff Burrowes, © by Snowy River Productions and courtesy of ScreenSound Australia, the National Screen and Sound Archive, Canberra.

110: © 1980 MGM Studios, Inc., all rights reserved, image provided by AMPAS. 113: Kenneth Lee. 114: © 1990 Tig Productions, Inc., all rights reserved. 115: © Warner Brothers Entertainment, Inc., all rights reserved. 116: John Scott Motion Picture Animals. 117: Photo by Elliott Marks, © 1998 Touchstone Pictures, Inc., all rights reserved. 119: Photo by Lisa Brown. 121: Photo by Deana Newcomb, © 2004 Touchstone Pictures, all rights reserved. 123: Photo by Chris Large, © 2003 Open Range Productions USA, Inc., all rights reserved.

CHAPTER 7

124: © Warner Brothers Entertainment, Inc., all rights reserved, image provided by AMPAS. 127: Kenneth Lee. 128, 132: Marc Wanamaker, Bison Archives. 129, 131: © Warner Brothers Entertainment, Inc., all rights reserved. 133: © 1943 Twentieth Century Fox, all rights reserved. 134: Petrine Day Mitchum. 137: Photo by Tim Farley. 138: © 1983 MGM Studios Inc., all rights reserved. 140 (left): Photo by David Gurr, © 2003 Disney Enterprises, Inc. 140 (right): Photo by Randi Clark. 142: American Humane Association. 143: © Columbia Tristar Motion Picture Group, all rights reserved. 145 (left): Photo by Petrine Day Mitchum. 145 (right): Photo from *Spirit: Stallion of the Cimarron* TM & © 2002 DreamWorks L.L.C., reprinted with permission of DreamWorks Animation.

CHAPTER 8

146, 157, 159: © Warner Brothers Entertainment, Inc., all rights reserved. **148:** Marc Wanamaker, Bison Archives. **150–151:** Photo by Jaap Buitendijk for *Gladiator* TM & © DreamWorks L.L.C. and Universal Pictures, reprinted with permission of DreamWorks L.L.C. **153:** Petrine Day Mitchum. **154:** American Humane Association. **155 (left):** Mario Luraschi/Cavalcade Productions. **155 (right):** Photo by Jonathan Hession, © 2004 Touchstone Pictures and Jerry Bruckheimer, Inc., all rights reserved. **160–163:** *The Lord of the Rings: The Return of the King* and *The Fellowship of the Ring* © MMIII, MMI, New Line Productions, Inc., TM The Saul Zaentz Co. d/b/a Tolkien Enterprises under license to New Line Productions, Inc., all rights reserved. Photo by Pierre Vinet. Photo appears courtesy of New Line Productions, Inc. **166–167:** Artwork by Jim Steranko, © by LucasFilm Ltd. **168:** W. K. Kellogg Arabian Horse Library, California Polytechnic University. **169:** Mary Jane Parkinson. **170:** Corky Randall. **171:** Tad Griffith.

CHAPTER 9

172, 186: © 2004 Touchstone Pictures, all rights reserved. **174:** Eddie Brandt's Saturday Matinee. **175, 185:** © Columbia Tristar Motion Picture Group, all rights reserved. **177–178:** David Parker and John Sexton Productions Ltd. **180, 182:** Photo from *Seabiscuit* TM & © 2003 DreamWorks L.L.C. and

Universal Pictures, reprinted with permission of DreamWorks L.L.C. **187:** Photo by Richard Cartwright, © by 2004 Touchstone Pictures, Inc. **189:** Photo by Tiffany Mitchum.

CHAPTER 10

190, 193 (right): © Columbia Tristar Motion Picture Group, all rights

reserved. **192, 193 (left):** Petrine Day Mitchum. **194–195:** American Humane Association. **196:** John Scott Motion Picture Animals. **197:** M.E.L. **198:** Marc Wanamaker, Bison Archives. **199, 200:** Alan Young. **201:** Corky Randall. **202:** © Warner Brothers Entertainment, Inc., all rights reserved.

BACK MATTER

205: Library of Congress. **207:** Baby Peggy (Diana Serra Cary) and Tim, in the 1921 Western parody *Peg of the Mounties*—Diana Serra Cary. **209:** *Pie*, painted by Henry Fonda—Michael McClean and Kelly Stewart. **211:** The Museum of the American West, Autry National Center.

Tom Mix and his famous horse Tony were immortalized as paper dolls.